Happy Birthday, Pops
with all our love —
Marc, Gina, Sydney and Lidia

November 2010

HISTORIC PHOTOS OF
GENERAL
GEORGE PATTON

TEXT AND CAPTIONS BY RUSS RODGERS

TURNER
PUBLISHING COMPANY
NASHVILLE, TENNESSEE PADUCAH, KENTUCKY

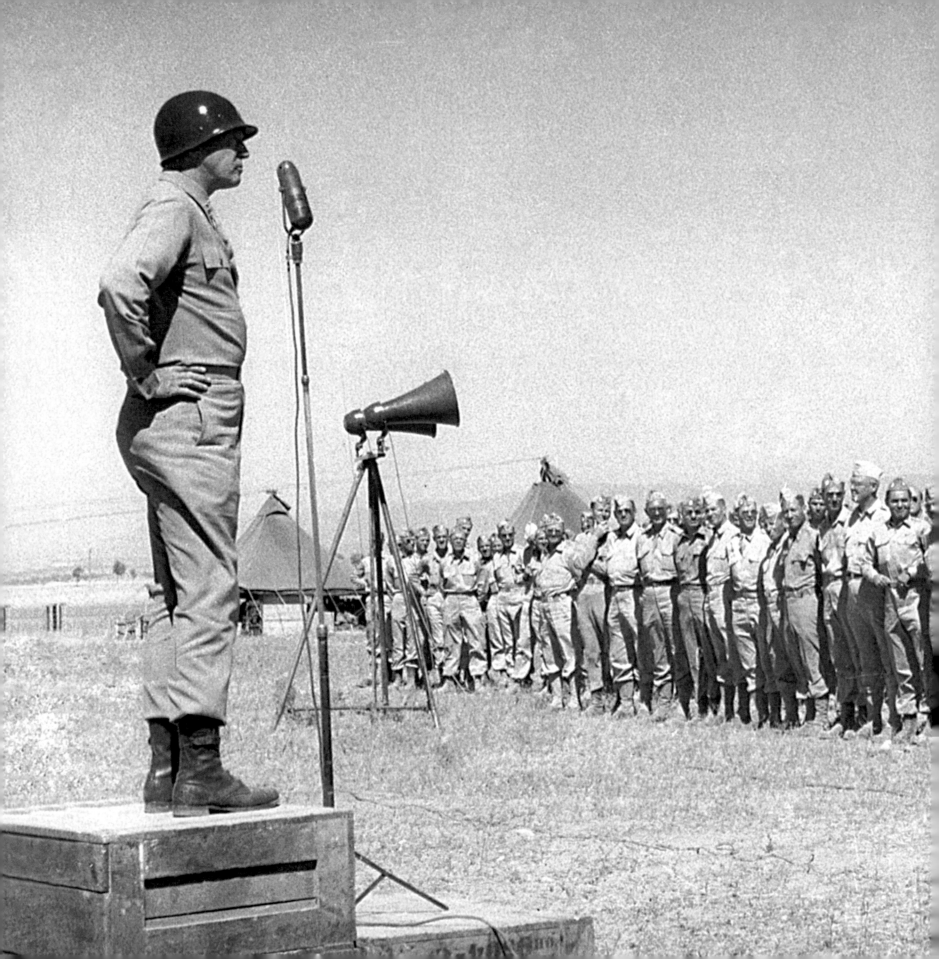

HISTORIC PHOTOS OF
GENERAL
GEORGE PATTON

Patton addresses officers of the 82nd Airborne Division, Oujda, Morocco, June 4, 1943, in preparation for Operation Husky, the invasion of Sicily. It is ironic that some of Patton's antiaircraft units would shoot down some of the planes carrying 82nd Airborne men during the invasion, causing the loss of more than 200 dead and wounded. Prior to the jump, Patton had expressed concern that both Army and Navy antiaircraft gunners were too nervous and that the jump should be canceled.

Turner Publishing Company
200 4th Avenue North • Suite 950 412 Broadway • P.O. Box 3101
Nashville, Tennessee 37219 Paducah, Kentucky 42002-3101
(615) 255-2665 (270) 443-0121

www.turnerpublishing.com

Historic Photos of General George Patton

Library of Congress Control Number: 2007933763

ISBN-13: 978-1-59652-408-8

Printed in the United States of America

07 08 09 10 11 12 13 14—0 9 8 7 6 5 4 3 2 1

CONTENTS

ACKNOWLEDGMENTS...VII

PREFACE ...VIII

THE PREPARATION OF A SOLDIER
(1885–1919) ...1

BETWEEN THE WARS
(1920–1941) ...31

MISSION IDENTIFIED: THE SECOND WORLD WAR
(1942–1943) ...59

THE RISE OF AN ICON
(1944–1945)...131

NOTES ON THE PHOTOGRAPHS ...200

FOR FURTHER READING...205

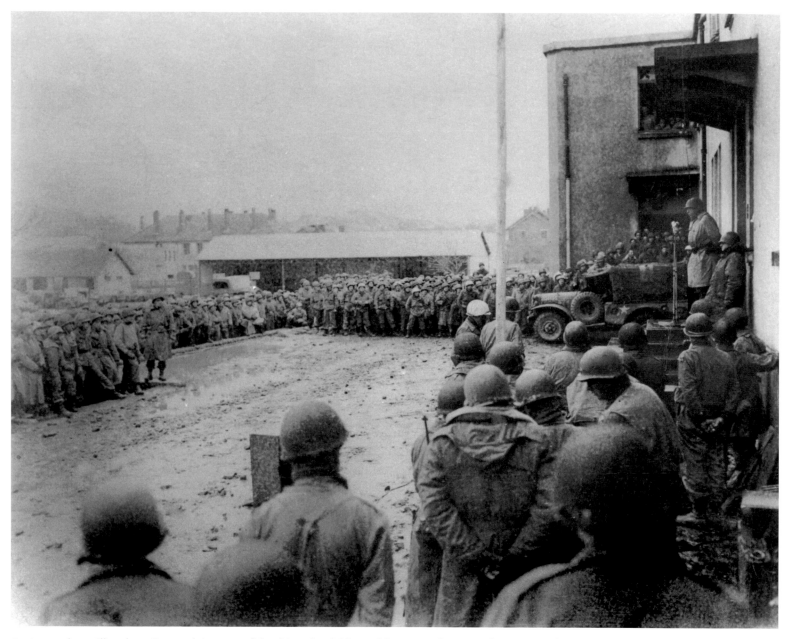

An image that will endure: Patton doing one of the things he did best, delivering a fiery speech to stir up the troops prior to battle. It is indeed the best known and remembered aspect of Patton. This photograph was probably taken during the rain and sleet of mid December 1944.

Acknowledgments

To Alina, wife and friend

… and to my brothers in arms, past, present, and future. May our people be always grateful.

———————

This volume, *Historic Photos of General George Patton,* is the result of the cooperation and efforts of many individuals and organizations. It is with great thanks that we acknowledge the valuable contribution of the following for their generous support:

The Library of Congress
Patton Museum of Cavalry and Armor
Russ Rodgers Collection

PREFACE

Why another book on General George S. Patton, Jr.? Although scores of books have been written on the man who could be considered America's greatest combat general, there are few books that provide an extensive photographic look at his life. Moreover, while some of the photographs in this volume have been published before, few have been properly researched to identify the other people within, or some of the equipment shown. Talented though Patton was, he could not have accomplished what he did without the abilities and determination of the soldiers and officers who served with him during two world wars.

Patton's name will be indelibly imprinted on the U.S. Army's World War II legacy, especially his leadership of the Third Army during the Battle of the Bulge in December 1944. Patton's career, however, was far more extensive. He cut his military teeth on combat operations during the Mexican Punitive Expedition of 1916, followed by service with the new Tank Corps in World War I. He continued to serve faithfully through the interwar years when promotions were virtually at a standstill, and at one point contemplated leaving the army. It was a good thing he did not. During his service in World War II, Patton demonstrated that he was by far one of the most imaginative, determined, and flamboyant generals ever to serve in a modern army. During the drive across France he wrote his son, quoting Rudyard Kipling's poem "If," that the entire art of war was to "fill the unforgiving minute with sixty seconds worth of distance run" (Martin Blumenson, *The Patton Papers,* vol. II [Boston: Houghton Mifflin Co., 1972], p. 523). It was with good reason that the German generals feared him far more than any other Allied general.

Though a profane soldier with his men, Patton was undeniably a deeply religious man as well. His diary is filled with entries about calling on God's help in times of distress, and thanking Him during times of success. This may appear to be contradictory to many today, but Patton seems to have experienced no tension here. The same can be said about the well-known slapping incidents during the Sicily campaign. Many are familiar with these events, largely from the movie *Patton,* but few know that Patton had tremendous sympathy and rapport with men wounded in combat. He himself nearly lost his life when wounded during World War I. Again, Patton saw nothing contradictory.

Often seen as blustering and threatening by the modern world, Patton was actually slow to act on impulse when it came to his officers and men. Indeed, generals like Eisenhower, Bradley, and Collins fired more of their commanders than Patton

even contemplated, and when Bradley was determined to have a deserter shot, Patton tried personally to intervene, though unsuccessfully, to prevent it. He firmly believed that the physical discipline of soldiers was better than a military justice with far more serious consequences. It is now known that soldiers who served under him considered it one of the greatest honors of their lives. This has been rarely said about any other modern combat general.

Many disagree today with his methods and how he led men in battle. But one thing cannot be denied. When it was necessary to get sixty seconds from the unforgiving minute and to save the U.S. Army from impending disaster, its senior leaders invariably turned to one man, and that man was General George S. Patton, Jr.

Attending the Virginia Military Institute had become a Patton family tradition, and Patton is here seen in his official VMI portrait for 1904. He was then 18. But while VMI may have been a part of Patton lore, it was no longer the fast track to military glory. This had been transferred to the Military Academy at West Point.

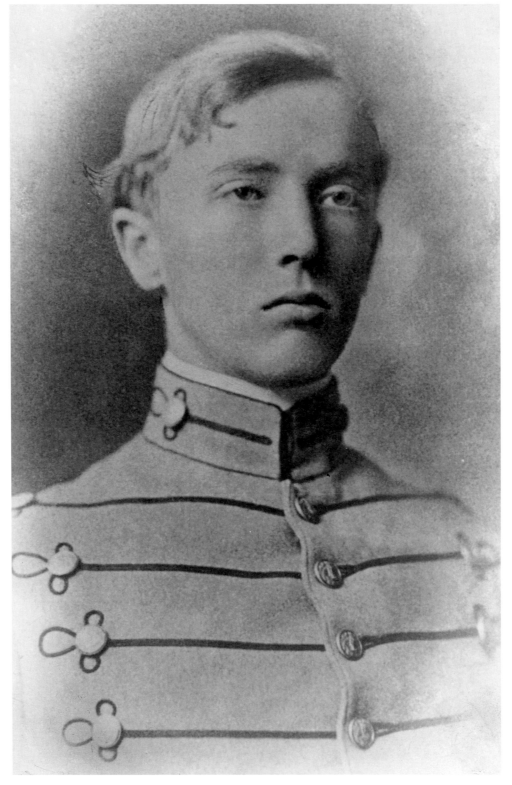

The Preparation of a Soldier

(1885–1919)

George S. Patton, Jr., was born November 11, 1885, to a well-to-do family in Southern California. Elite status was not always the case for the Pattons—the family had suffered near crushing poverty in post–Civil War Virginia. But once the family moved to California their fortunes changed. Georgie, as he was called by close family members, could have chosen to live the life of a well-to-do country gentleman. Instead, he singularly pursued the life of a professional soldier. Though raised with the wealth gained through family ties, Patton grew up on the tales of soldierly virtue. His grandfather had served, and died, for the South in the Civil War, and Patton readily compared him to the great warrior legends of the past. His passion for being a soldier most certainly drove the rest of his boyhood activities. He spent many summers swimming, sailing, fishing, and hunting on Catalina Island, yet he did these activities mostly as a loner. Of all the photographs we have of his boyhood, Patton is never seen with other boys. This penchant for being alone followed him through West Point, where he never built any close friendships. It was only later in life that he cultivated a few close friendships with fellow officers.

His focus on a military career almost kept him from marrying Beatrice Ayer, and he had to write lengthy letters to the girl's father to explain why he had chosen his particular career path. Beatrice had also grown up in wealth and privilege, and her father was naturally concerned for her future well-being. Once married, their first posting at Fort Sheridan, Illinois, became a severe trial for Beatrice, but she stayed devoted and committed to George, always working to promote his career. Military life was very difficult in the pre-war Army of 1910, but family money helped ease the Pattons' circumstances. Unable to find a war to fight in, Patton decided to compete in the 1912 Olympics, making a credible showing for one who had received little preparation for the games. But it was in World War I, then called the Great War, where Patton finally found his outlet for the one thing he desired most—military glory.

Colonel George S. Patton, Confederate States of America (CSA), 1833–1864, was George S. Patton, Jr.'s grandfather. He was devoutly religious, chivalrous toward women, a smart dresser, and a graduate of the Virginia Military Institute, class of 1852. He died from wounds he received at the Third Battle of Winchester, September 25, 1864, in Virginia's Shenandoah Valley. He provided a perfect role model for his grandson's preparations for a military career.

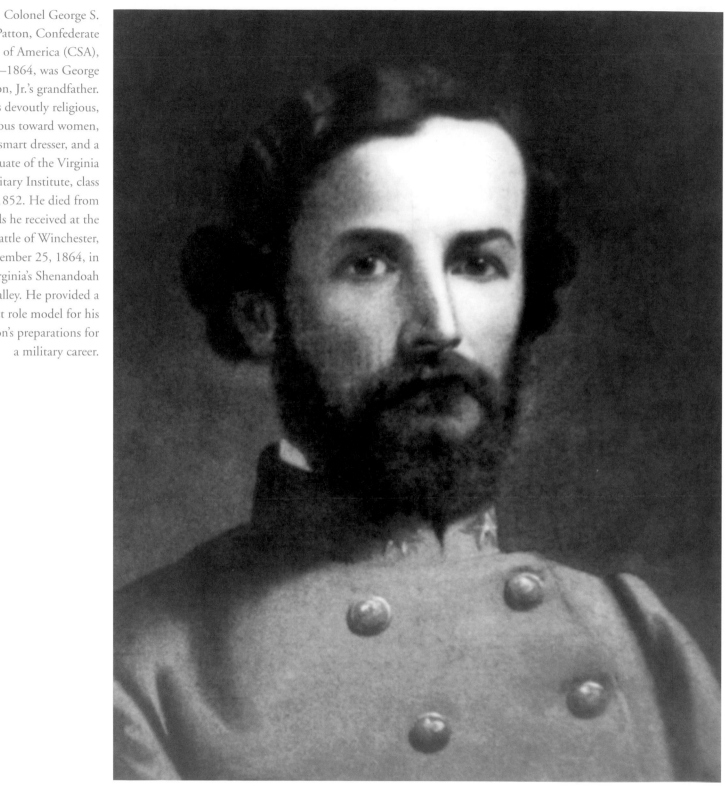

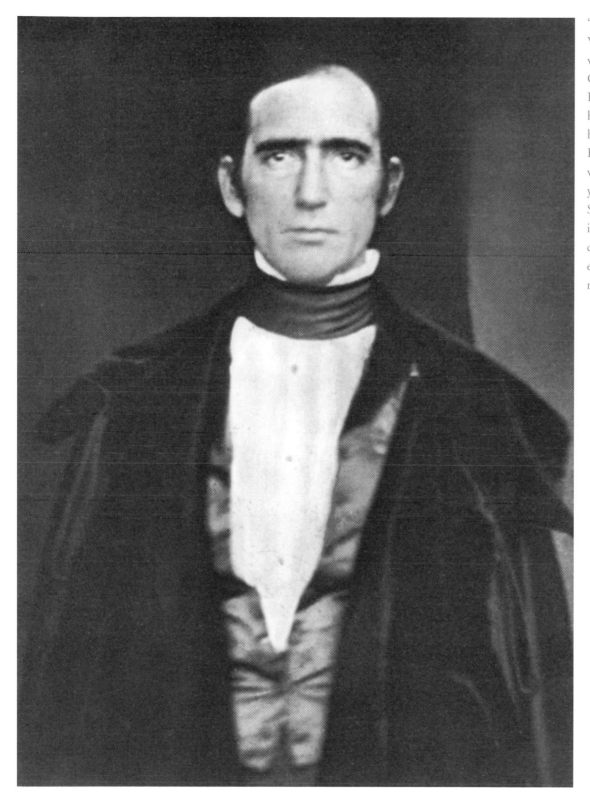

"Don Benito" Benjamin Wade Davis was one of the wealthiest men in Southern California in the late 1800s. He had not started out so, having been an adventurer himself in his younger years. His daughter, Ruth Wilson, would be courted by the young George S. Patton, Sr., and they would marry in 1884. Their marriage was considered the high-society event of the era by the local media.

Patton's father, George Smith Patton, Sr. After graduating from the Virginia Military Institute in 1877, he moved back to California where his oratorical skills and abilities in law and politics led him to be a vocal supporter of Grover Cleveland's candidacy for President. He originally wanted to pursue a life of adventure, and had even accepted a commission with the Egyptian pasha to accompany his army led by British general William Hicks. However, he was never able to get to Egypt, which was fortuitous since Hicks' command was virtually wiped out during the Mahdi uprising in the Sudan.

Even in infancy, one can distinguish the familiar features of the man who would someday be one of America's greatest generals.

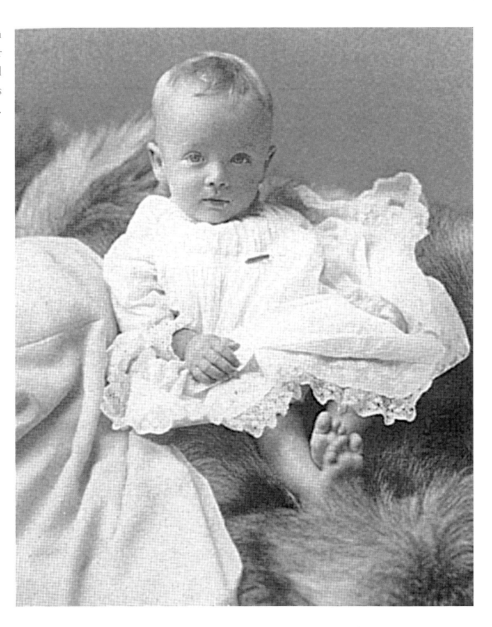

George S. Patton, Jr., aged seven in a sailor suit. The suit became more than costume—Patton later in life would come to love sailing. He was also beginning to dream of future military adventure. Close family members called him Georgie, but as an adult he would despise the nickname's application by anyone but family.

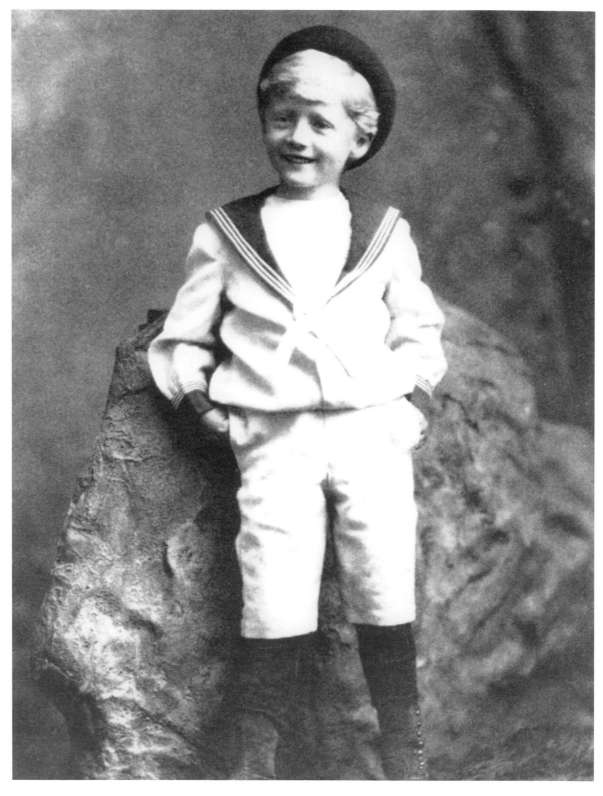

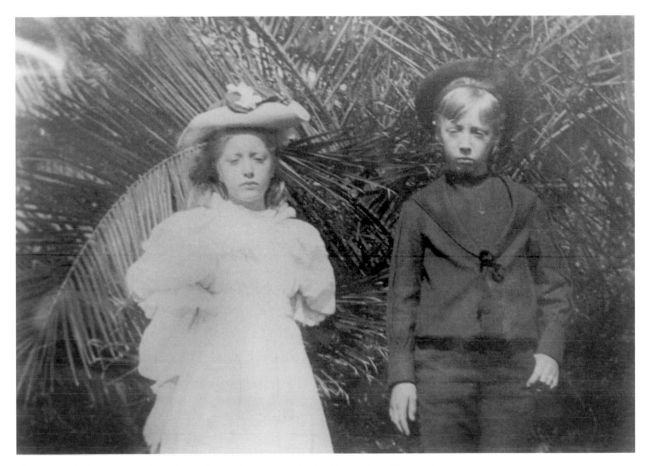

George and his younger sister Anne, better known to the family as Nita. She was born two years after George and never married, though she raised two adopted sons. Late in life, when it appeared that marriage plans for Patton's daughter Ruth Ellen would fall through, Nita told her to marry her suitor regardless of Patton's wishes, because "one sacrifice on the altar of family loyalty is enough" (Carlo D'Este, *Patton: A Genius for War* [New York: HarperCollins, 1995], p. 370).

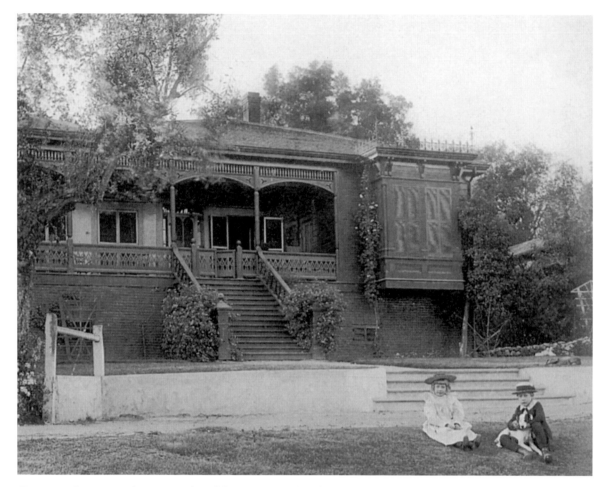

George and Nita at Lake Vineyard, California. Patton loved Lake Vineyard and retained fond memories of the place for many years until his father's death in 1927. At that point he decided that he could no longer relive the wonderful memories of Lake Vineyard and began to make plans with Beatrice to purchase the only home they ever owned, in Massachusetts.

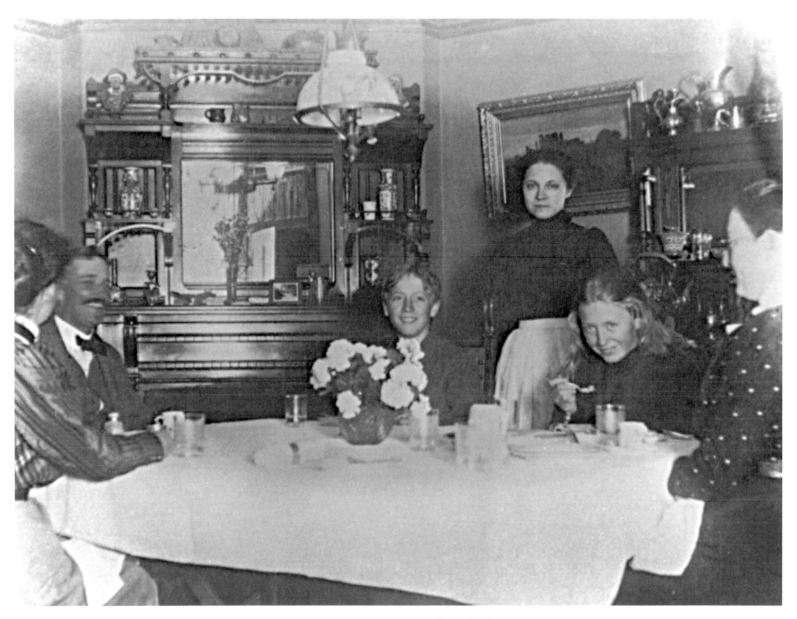

The Patton family at the dinner table. Aunt Susie, father, Patton, Nita (seated), and mother. The presence of a house servant (the woman standing) indicates the level of wealth the Patton family enjoyed.

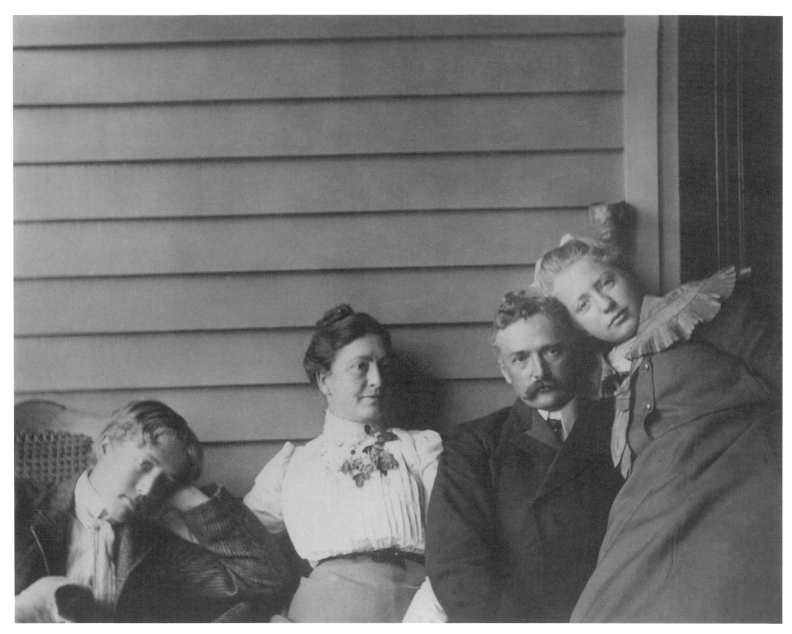

The Patton family at Lake Vineyard, San Gabriel, California. From left to right are Patton, mother Ruth Wilson Patton, father George S. Patton, Sr., and sister Nita.

The Patton, Ayer, and Banning families on vacation at Catalina Island, 1902. Patton, age 16, is seated at right. His future wife, Beatrice Ayer, also 16, is at far left, second row. Beatrice's parents are seated at center, while Patton's mother (with garland) and father are standing behind them slightly to the right.

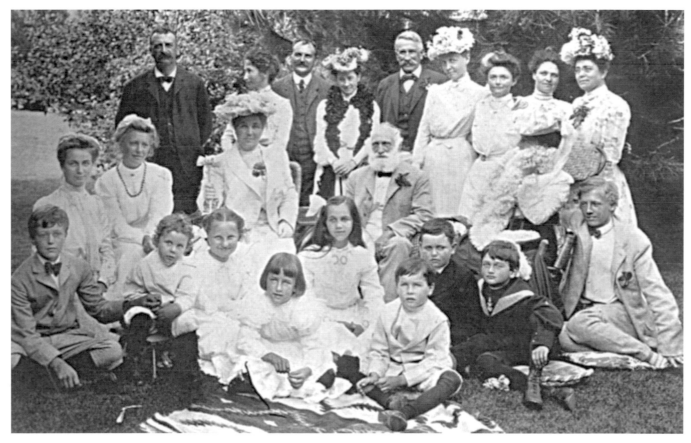

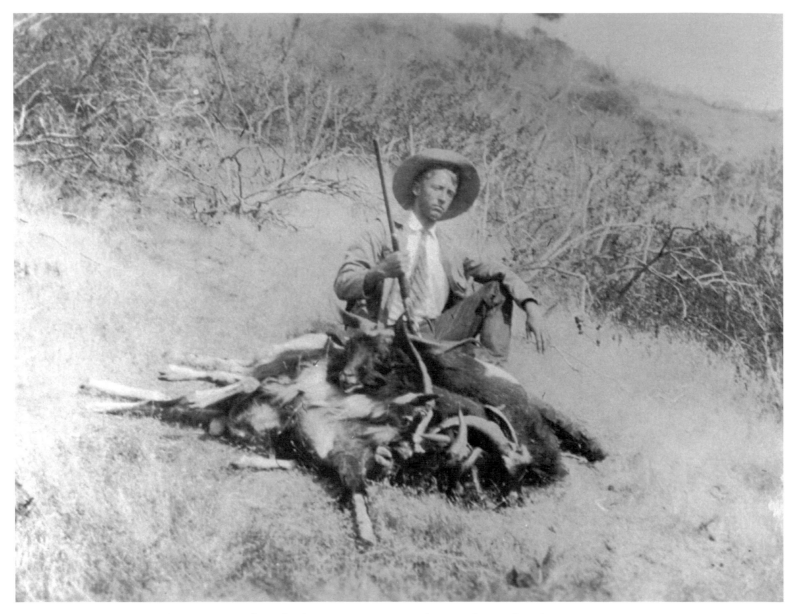

Patton, at age 17, engaged in hunting on Catalina Island. Many young men in the United States found hunting an exciting way to push beyond the limits of civilization toward adventure, and Patton was no exception. This was especially true when hunting dangerous animals.

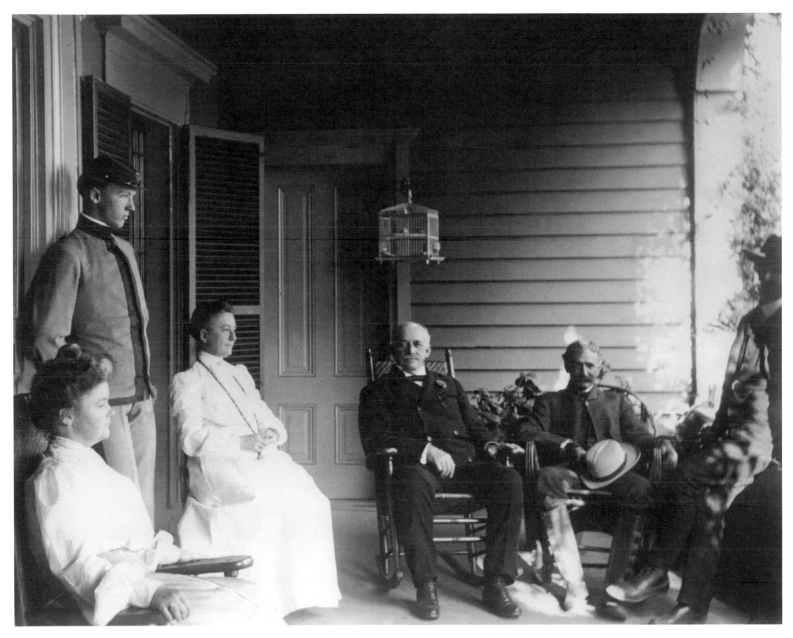

Patton was able to occasionally visit his parents during his one-year attendance at the Virginia Military Institute, shown here in 1904.

Patton, age 19, with a 184-pound black sea bass he has caught off Catalina Island. He loved fishing and swimming in this area, and after his graduation from West Point in 1909 he spent much of his summer at the island before reporting to his first duty assignment.

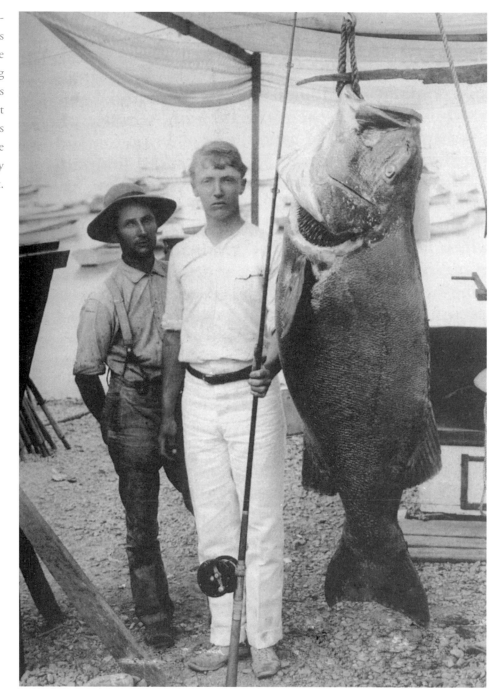

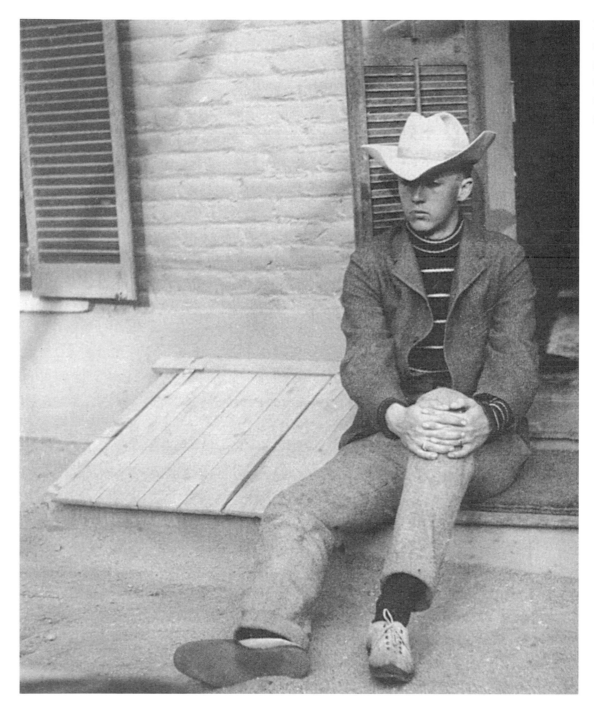

Patton, about 19 years old, dressed as a cowboy. The future general gives the appearance of being a typical teenager, but appearances mask his inner desire to press forward with a military career.

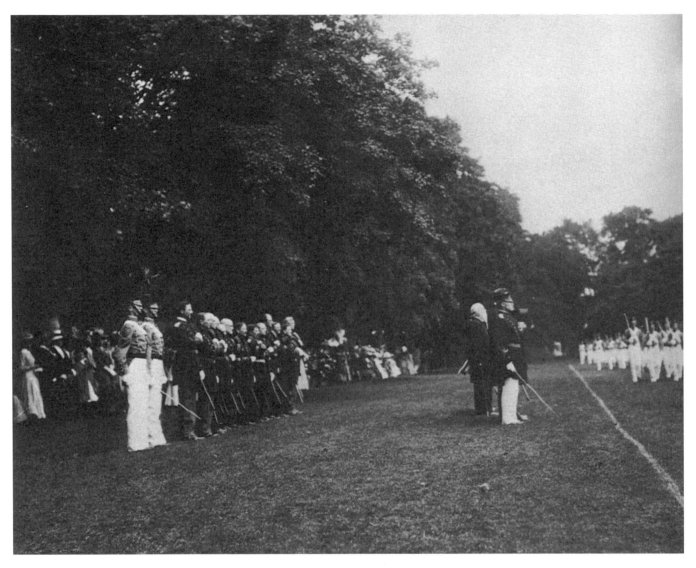

Patton's graduation at West Point, June 11, 1909. Patton, as the class adjutant, is standing at the end of the reviewing party on the left. He graduated 46 in a class of 103. Like Patton, three of his classmates would later rise to four stars: William Simpson, Jacob Loucks Devers, and Robert Eichelberger. Moreover, Courtney Hodges, who would later command the First Army during the drive across France and Germany in World War II, would have graduated from this class had he not dropped out in his plebe year.

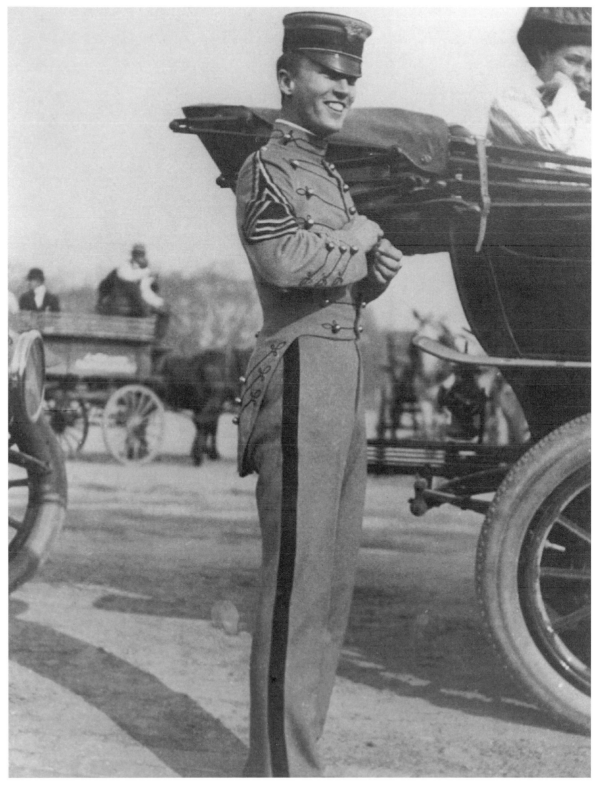

Class Adjutant Patton in 1909 prior to graduation. Patton was known by other classmates as a quilloid, a term coined by cadets to describe a fellow cadet who was merciless when citing them for the smallest infractions.

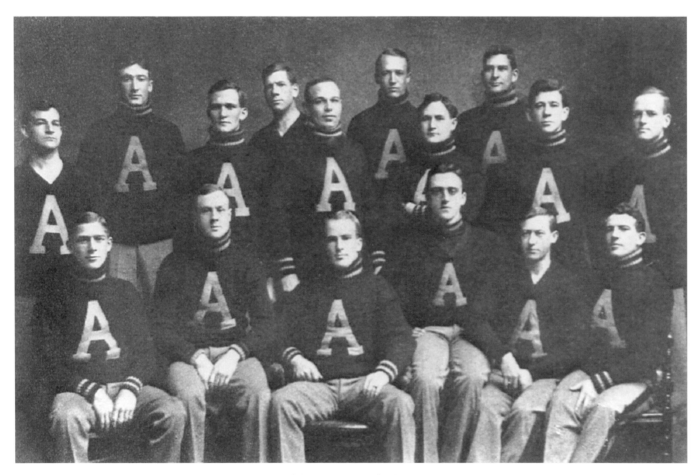

Patton, last row, fourth from the right, became part of the West Point football team in 1909. Though not a star player, there is no doubting his intense participation, attested to by several injuries during the year. In track and field, however, Patton excelled.

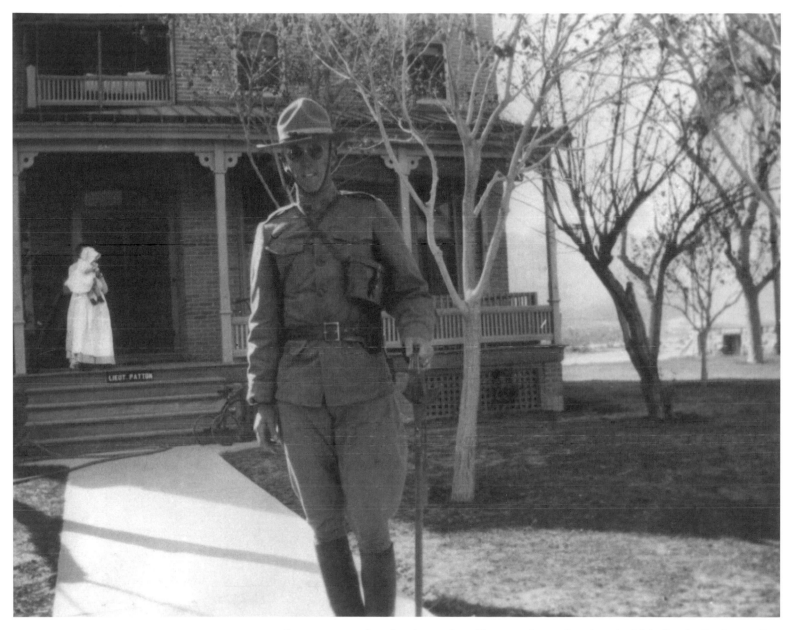

Patton, as a newlywed and a cavalry officer, was first assigned to the 15th Cavalry Regiment, Fort Sheridan, Illinois. His wife Beatrice hated the location, having once lived on the more pleasant and plush Ayer family estate in California. Her visit to the post just prior to marrying George was so traumatic to her senses and those of her mother that the latter offered to break the engagement.

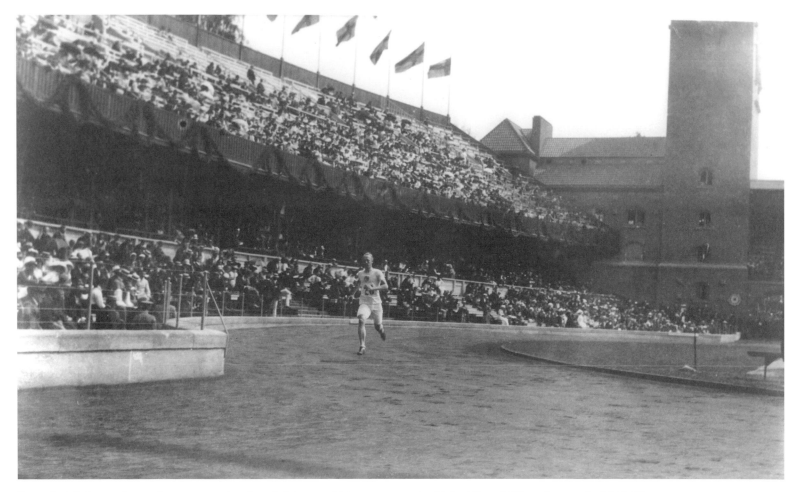

Patton's abilities on the track were exceptional, and this earned him a spot on the United States' Olympic team in 1912. The Fifth Olympiad was held in Sweden, where Patton participated in the Modern Pentathlon, a grueling five-event contest then open only to military personnel. In the pistol event, Patton apparently missed the target twice, while in swimming his efforts led him close to exhaustion. In the final cross-country run he passed out at the end in the torrid heat in which another runner actually died. His final standing was fifth place. Had he shot better, he would have won a medal.

Patton demonstrates the use of the saber in the dismounted form while at Fort Riley, Kansas, where he attended the Mounted Service School, a prized posting for cavalry officers, in October 1913. It was in fencing that Patton excelled, though he had never received formal training from a world-class teacher, and during the 1912 Olympics he had defeated twenty of twenty-nine contestants in the Pentathlon. A Swedish newspaper wrote of his fencing ability by saying that he "was skillful in exploiting his opponent's every weakness" (D'Este, *Patton,* p. 134).

Not only did Patton attend classes at the Mounted Service School, he also provided instruction, especially in the use of the saber, for which he wrote a popular manual.

The Punitive Expedition entered Mexico to track down the elusive Pancho Villa in 1916. Patton had to write several appeals to join the expedition to escape the boredom of peacetime garrison life, eventually landing a post as General John J. Pershing's aide. Here General Pershing and General Frederick Funston lead forces near El Valle. During the expedition Patton studied Pershing closely and chose to imitate his mannerisms.

Patton as General John J. Pershing's aide during the Punitive Expedition into Mexico to track down Pancho Villa. At a hacienda near Rubio, Patton, accompanied in three automobiles by ten infantrymen and two guides, discovered the hideout of one of Villa's men, Julio Cárdenes. A gunfight ensued in which Cárdenes and two of his men were killed. Patton placed the bodies on the hood of his car and drove back to Pershing's headquarters.

Patton was always accident-prone, and during the Mexican operation he accidentally burned himself when he tried to light a lamp in his tent. Although it ultimately left no scarring, it caused him significant distress. Five days after the incident he wrote Beatrice that "you are indeed fortunate in not being able to kiss me right now. My face looks like an old after-birth of a Mexican cow" (Blumenson, *Patton Papers,* I, p. 352).

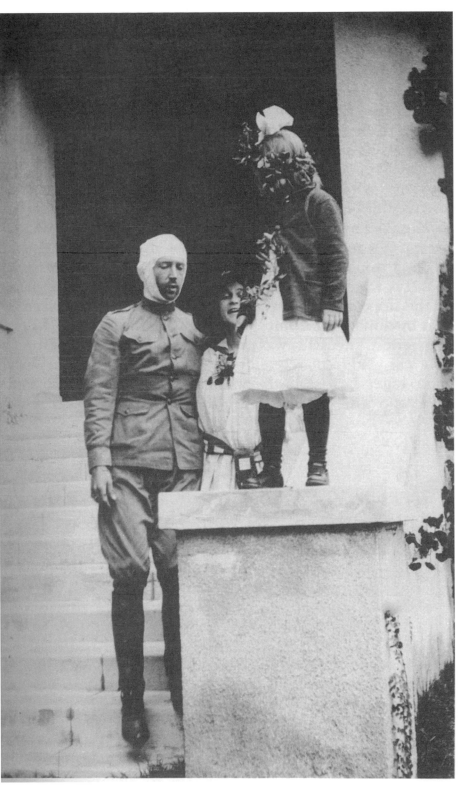

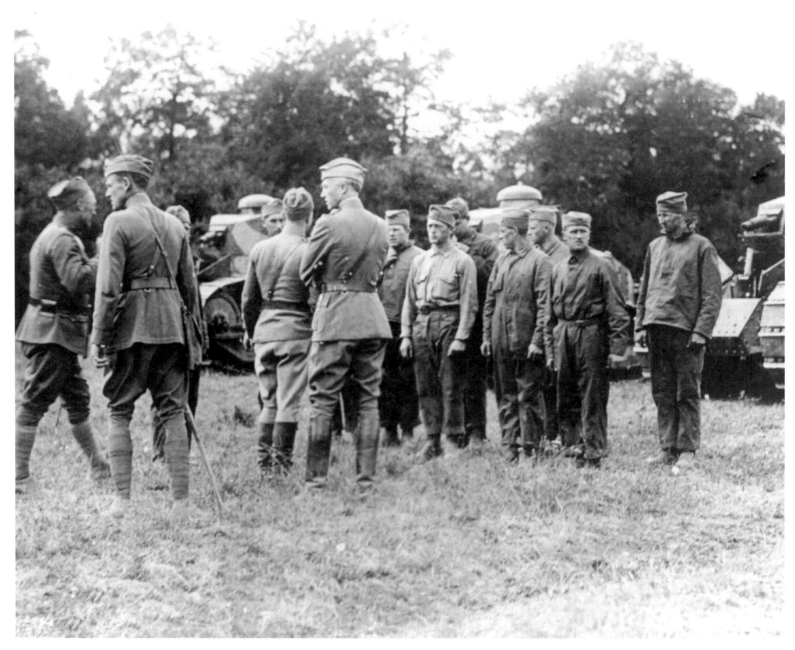

When the United States entered World War I, Patton chose to go into the newly formed Tank Corps. He chose the light French Renault tank for his men, and began to train his officers at the United States Tank School in Bourg, France, during the summer of 1918. Patton is at center with his back to the camera, while Captain Ranulf Compton, his chief instructor, is at left with his head turned to the left.

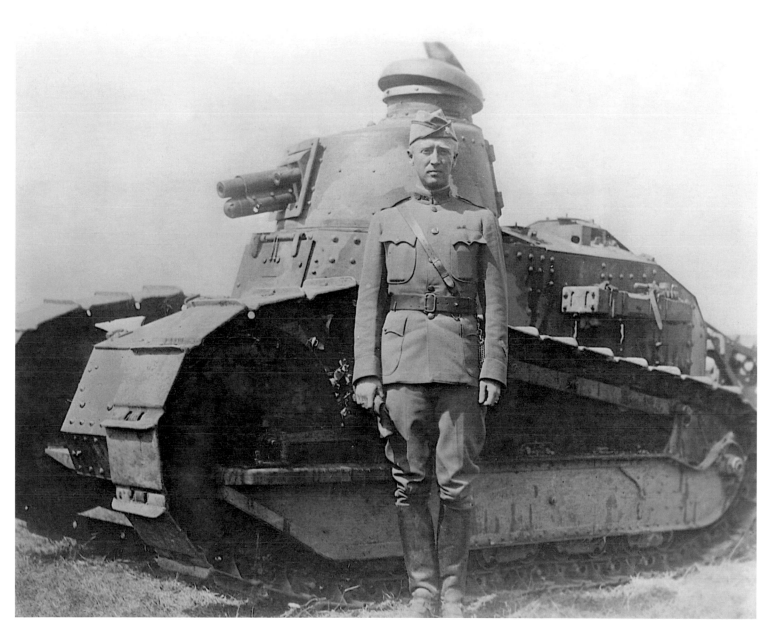

Colonel George S. Patton, Jr., at the Tank School in Bourg, France, summer 1918. He is standing before a French-built Renault Char FT17 light tank. This vehicle weighed 6.5 tons, had a crew of two (driver and gunner-commander), and was armed with a 37mm cannon and 8mm Hotchkiss machine gun. Its maximum speed was less than 5 m.p.h., but it was considered by Patton to be a better tank than the huge British vehicles, being lighter and more maneuverable.

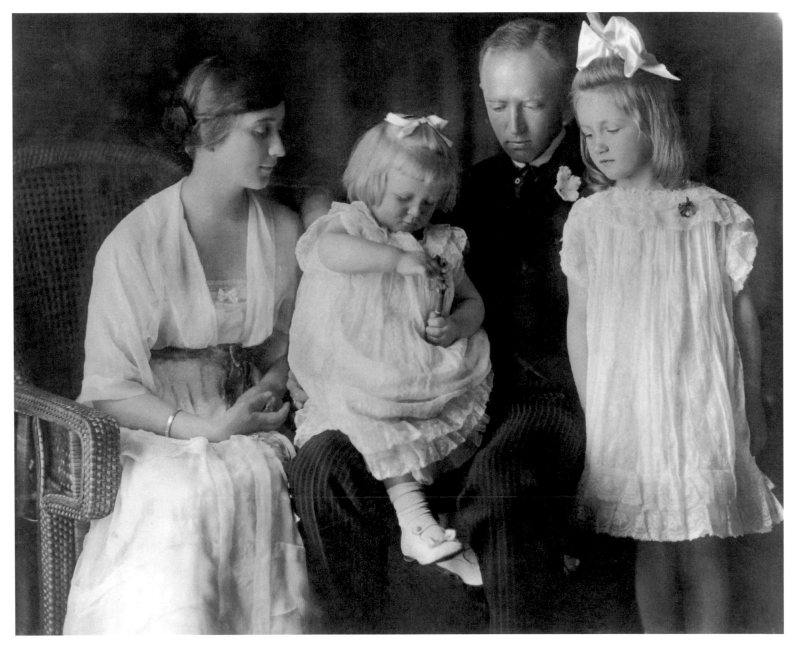

The Patton family in 1919: wife Beatrice Ayer Patton, daughter Ruth Ellen, Patton, and daughter Beatrice "Little Bee." Ruth Ellen was about four years old at this time, while Beatrice was eight. Patton seemed to be on a professional fast track, having not only been wounded in battle leading his men, but having received the Distinguished Service Cross for his efforts.

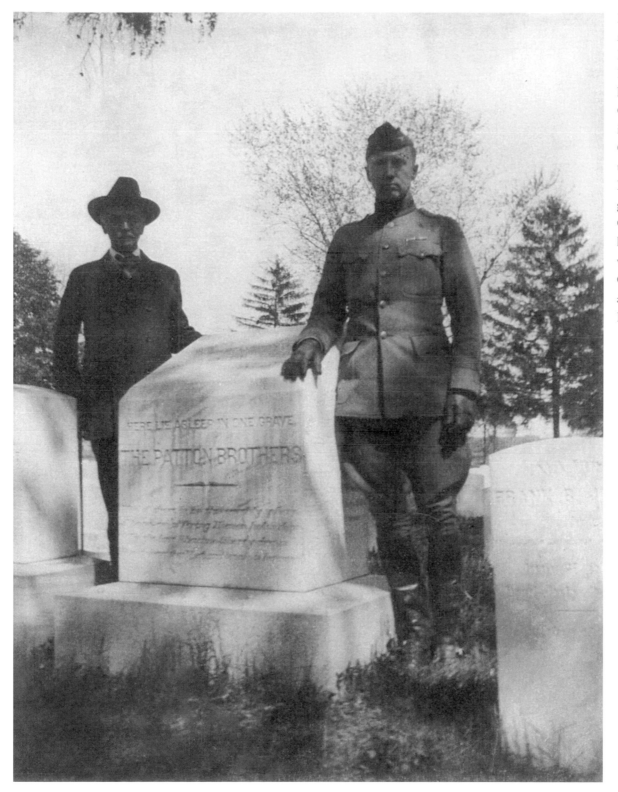

Patton was a firm believer in remembering one's heritage. In 1919, with the war in Europe ended, he accompanied his father to the Stonewall Confederate Cemetery, which is part of the Mount Hebron Confederate Cemeteries in the Winchester, Virginia, area. It is here that the common grave of his grandfather, Colonel George Patton, and his granduncle Waller Tazewell, who was mortally wounded at Gettysburg, is located. "Here lie asleep in one grave the Patton Brothers" reads the headstone.

By 1919, Patton had achieved a measure of fame for his exploits in France, including being promoted to colonel and receiving the Distinguished Service Cross for his actions in combat. Although this decoration came with some controversy, for it had initially been downgraded to the Distinguished Service Medal, it was not unknown for personnel to lobby superiors regarding awards, nor was it uncommon for superiors to botch such awards recommendations when first made.

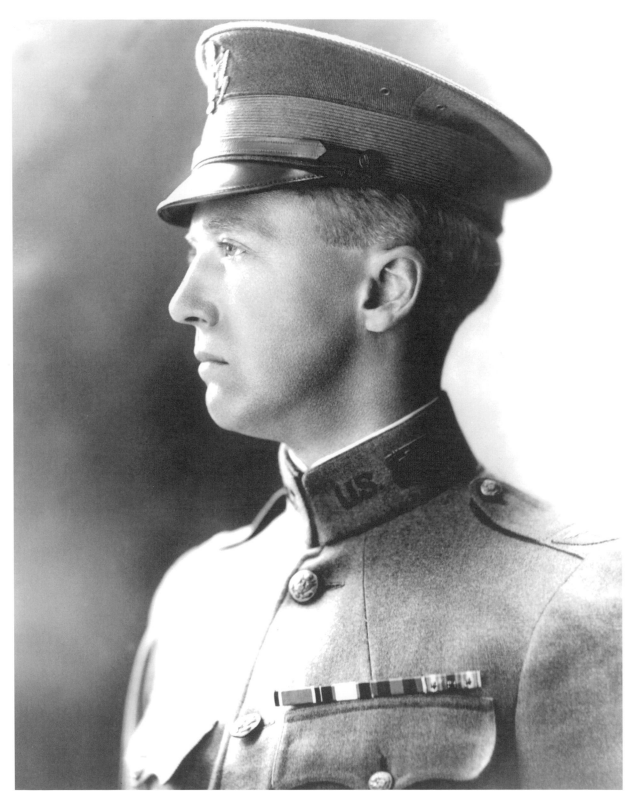

Between the Wars

(1920–1941)

Patton almost left the Army. After many years seemingly frozen at the rank of major, there seemed to be no future for a warrior in the peacetime force. He experienced plenty of frustration at this time, but tried to ameliorate the trouble by staying constantly active. He spent a great deal of time collecting, studying, and annotating an extensive library of military works, and these years were truly formative in shaping his philosophy of war. Moreover, Patton's constant drive to learn more about his profession kept him from stagnating mentally, a problem that often afflicts senior officer leadership in all armies throughout history.

With tanks being relegated to the infantry, Patton decided to return to his first love, the cavalry. Living the life of a cavalry officer was better than most other assignments, for the cavalry enjoyed a certain elite status. This engendered much hostility from some of the other branches, especially the infantry. Throughout the 1920s and 1930s, the infantry and cavalry would argue over status, newfangled doctrine, and slender budgets. Patton entered this fray by writing articles for the *Cavalry Journal*. More a practitioner, not a theorist, he disagreed with some of his more nonconformist friends like Bradford Chynoweth and Adna Chaffee, Jr., about the future of tanks. As a good practitioner with a firm grasp of military history, however, he could recognize something valuable when made demonstrably clear, and by the 1930s his interest in tanks and mechanization had grown.

With war clouds in Europe and the Pacific now looming on the horizon, Patton finally saw his career accelerate. Although not a glad-hander like Jacob Devers, Omar Bradley, and Dwight Eisenhower, he had built a friendly relationship of mutual respect with George C. Marshall. When Marshall was appointed Chief of Staff of the Army in 1939, he proceeded to clean out the service of its older generals, including virtually all of Patton's peers from the Academy. He spared Patton, who was then 54 years old, for Marshall saw in him a general of both experience and vitality unmarred by his older age. When Marshall secured Patton's assignment to command an armored brigade, he wrote that "no one could do that particular job better" (Larry I. Bland, ed., *The Papers of George C. Marshall,* vol. 2 [Baltimore: Johns Hopkins University Press, 1981], p. 272). By 1941, Patton was commanding an armored division and preparing for the greatest war in history.

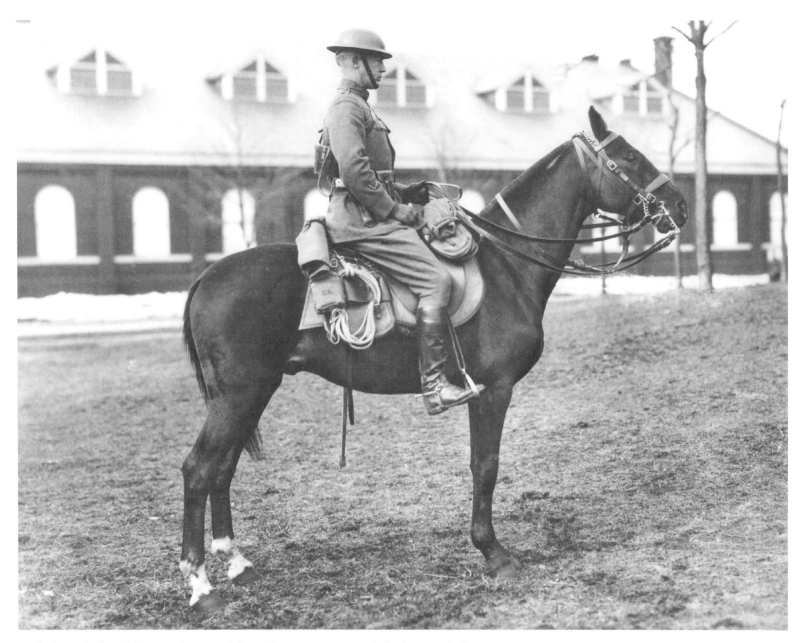

With the end of World War I, the United States Congress reorganized the Army with the National Defense Act of 1920, which placed tanks in the infantry branch. Patton, loath to put himself in the infantry, decided to return to his first love, the cavalry. At the same time, like many other officers in the war, he was reverted to his prewar permanent rank as a captain. He was promoted to major soon thereafter.

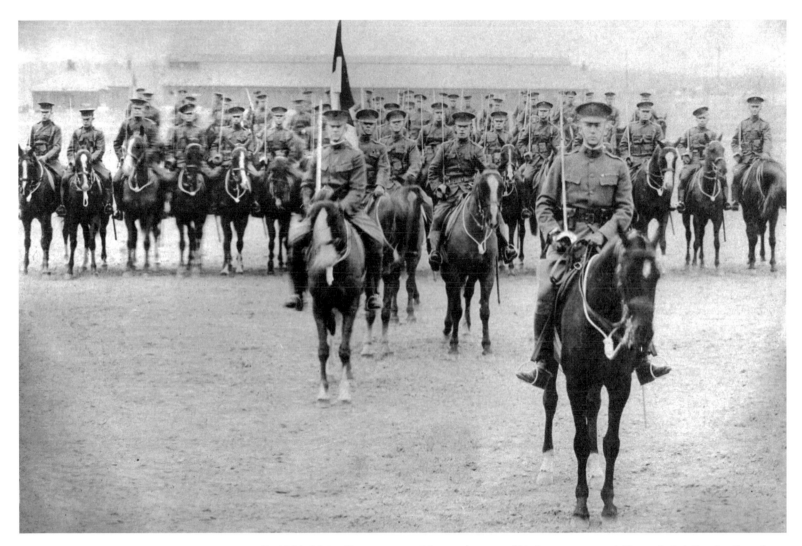

In 1921, Major Patton poses with one element of his latest command, Troop I, 3rd Cavalry Squadron, 3rd Cavalry Regiment at Fort Myer, Virginia. For Beatrice and the children, Fort Myer was a significant advance in living arrangements. Patton drilled his squadron intensely to devise new maneuvers, innovations, and tactics that could meet the challenges of modern warfare. Few as yet understood that the machine gun had already doomed horse cavalry to the dustbin of history.

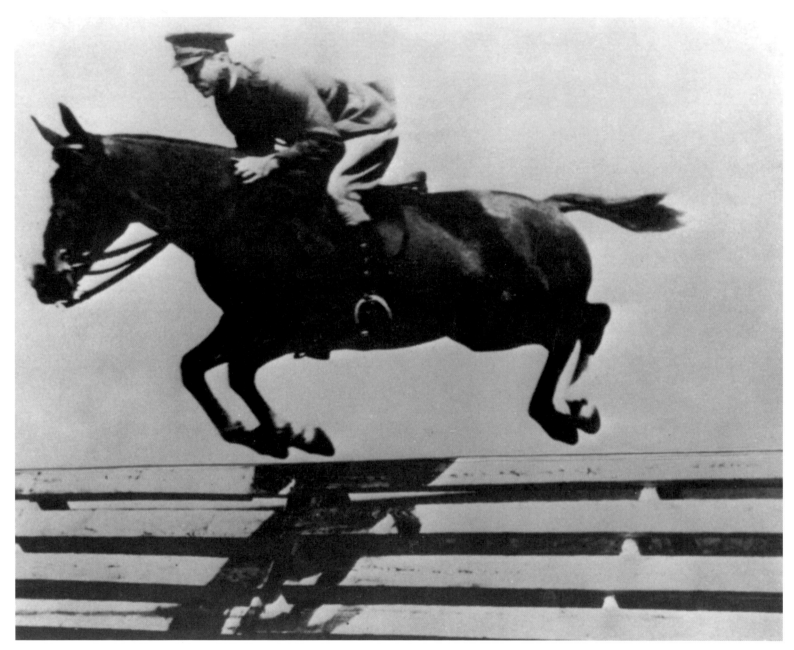

One of the things that made Patton immensely happy was horseback riding. He enjoyed all aspects of equestrian sports, here displaying his abilities at Fort Riley, Kansas, in 1923. At this time Fort Riley was the home of the cavalry, and is still today the home of the U.S. Army's Cavalry Museum.

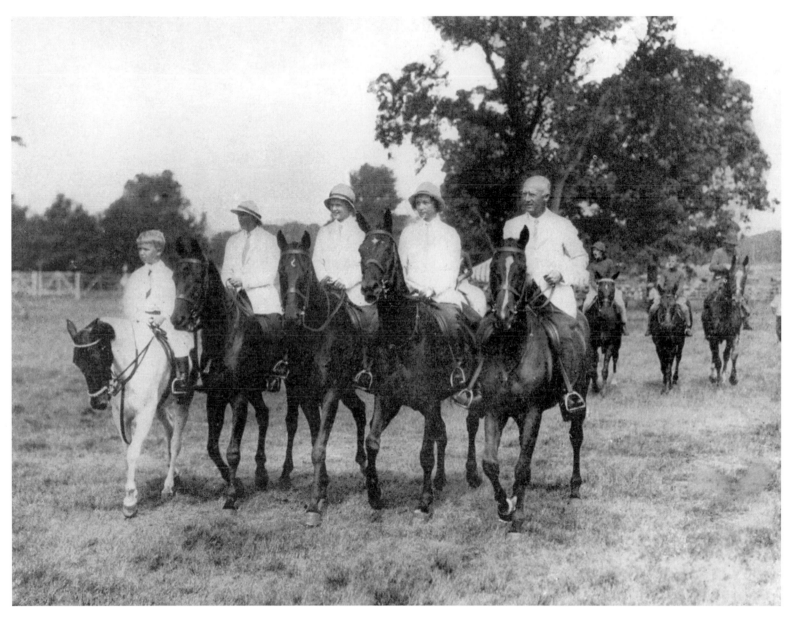

Patton extended his love for horseback riding to his entire family. Here he is with his family at South Hamilton, Massachusetts, in 1929. On the left is George IV, later a U.S. Army major general, wife Beatrice, Ruth Ellen, and daughter Beatrice. The children's equestrian skills did not come without difficulty—Patton proved to be a hard taskmaster when teaching them the finer points of riding, often swearing at them.

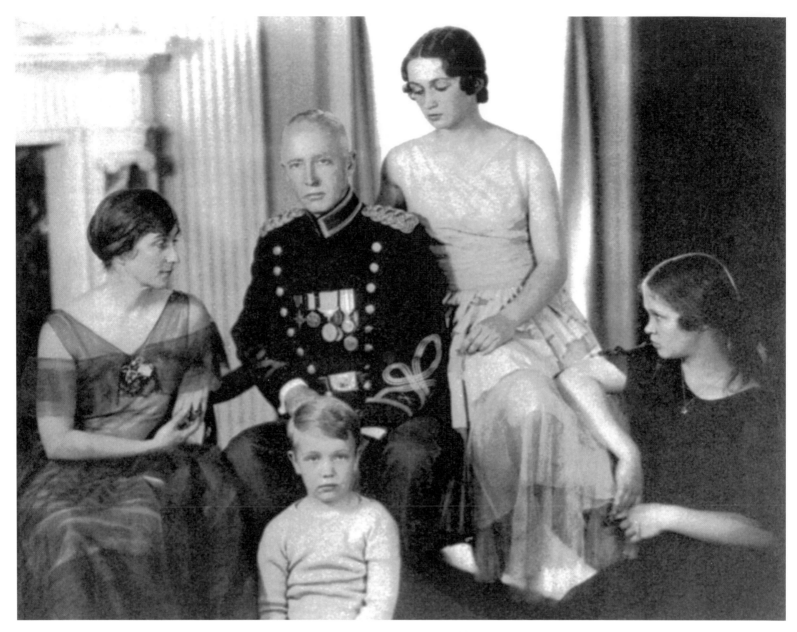

A Patton family portrait while at Fort Myer, Virginia, in 1929. At this point he was still a major, trapped in the doldrums of a peacetime army whose budget was slashed to the bone. He would not be promoted to Lieutenant Colonel until 1934, having served as a major for 14 years. From left to right, back to front, his wife Beatrice, daughter Beatrice, George IV, and Ruth Ellen. George IV was about six years old at this time.

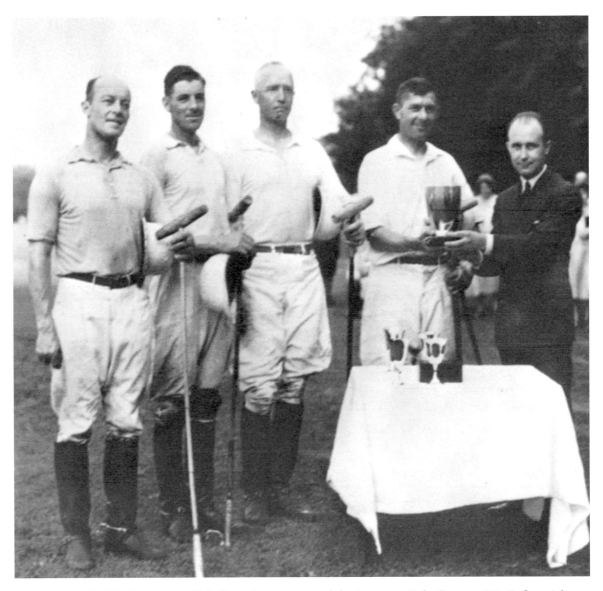

The War Department Polo Team being presented the Argentine Polo Cup in 1931. Left to right are John Edgars, Gordon B. Rogers, Patton, and Jacob Lucks Devers. Devers would later head up the Armored Force Center at Fort Knox, Kentucky, after the untimely death of Major General Adna Chafee, Jr., in 1941. During World War II he would command the 6th Army Group in France.

Patton as a student at the U.S. Army War College, September 1931. Although not a remarkable student at West Point, Patton graduated the War College with a superior rating. Having completed his course work, his peaceful life at Fort Myer, Virginia, was interrupted during the summer of 1932 by the Bonus March in Washington, D.C., where the 3rd Cavalry Regiment, of which Patton was the executive officer, was involved with dispersing protesting World War I veterans.

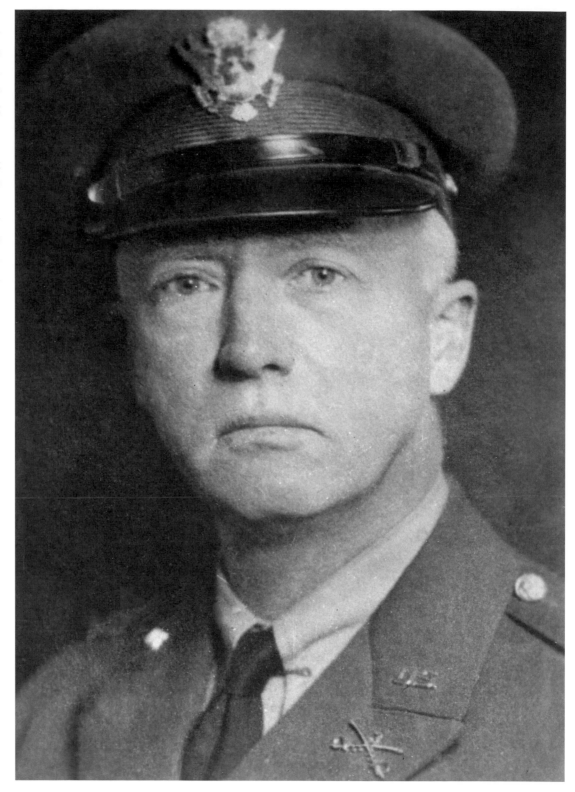

Patton giving daughter Beatrice away to Lieutenant John Knight Walters on their wedding day, June 27, 1934, in South Hampton, Massachusetts. Walters would become a lieutenant colonel in the Armored Force assigned with the 1st Armored Division operating in Tunisia in 1943, where he would be captured during the Allied defeat at Kasserine Pass.

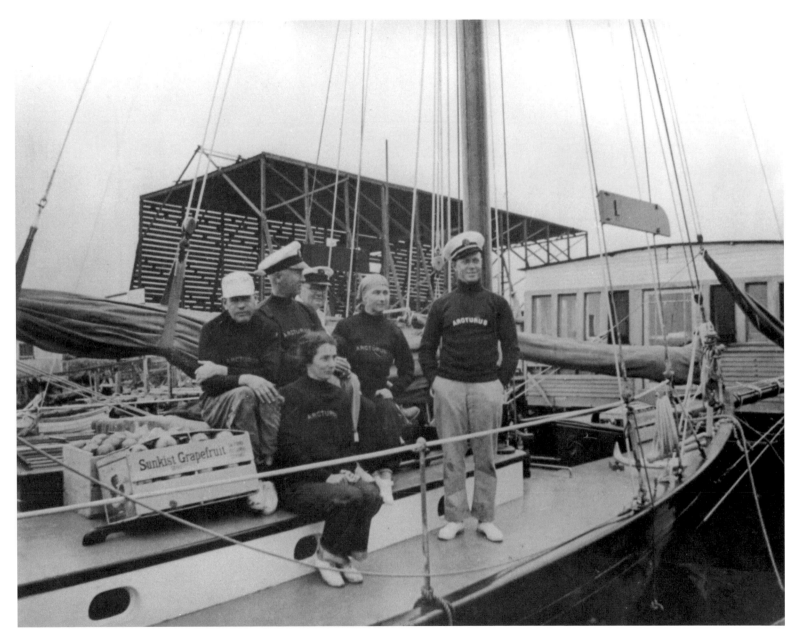

In 1935, Lieutenant Colonel and Mrs. Patton sailed on their boat *Arcturus* from San Francisco to their new post in Hawaii, along with their friends Gordon Prince, Doc Graves, Anna Prince, and Joe Ekeland. Patton was 49 years old at the time.

Newly promoted Colonel Patton as Commander of the 5th Cavalry Regiment, 1st Cavalry Division, Fort Clark, Texas, in 1938. Patton still loved the horse cavalry but could now see that mechanization would play a significant role in a future war. In a letter to Major General Daniel Van Voorhis, who had commanded the experimental mechanized brigade and later was the post commandant at Fort Knox, Kentucky, Patton wrote that "the more people decry Cavalry, horse or mechanized, the more we will bust them up next time" (Blumenson, *Patton Papers,* I, p. 930).

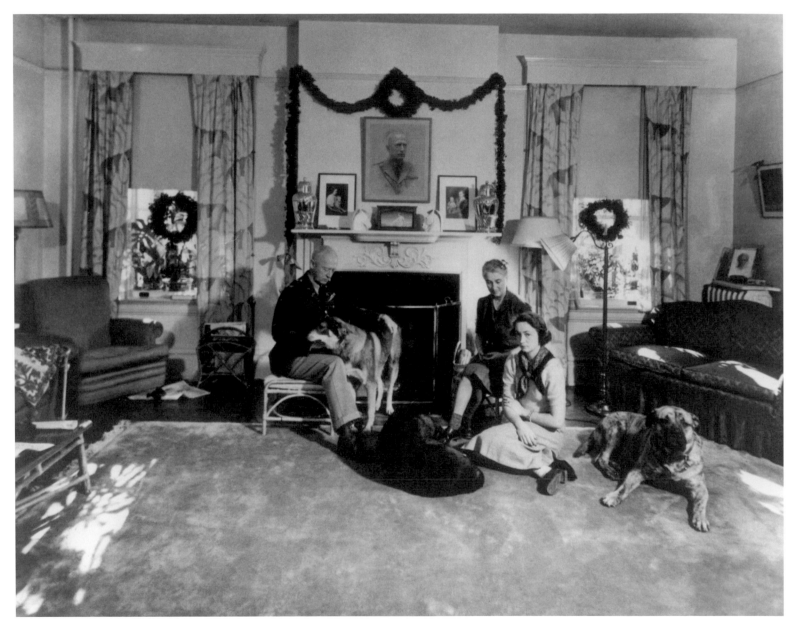

The Patton family at Quarters #8, Fort Myer, Virginia. Although not dated, this image was probably recorded during Patton's command of the 3rd Cavalry Regiment in 1940. From left to right are Colonel Patton, Mrs. Patton, and Beatrice Patton Waters.

Brigadier General Maxwell Murray and Colonel Patton review the 16th Field Artillery during an event held in honor of General Murray, April 6, 1940. Much of the time spent by the inter-war Army was for parades and a mind-numbing array of menial activities, because there was little money for real training.

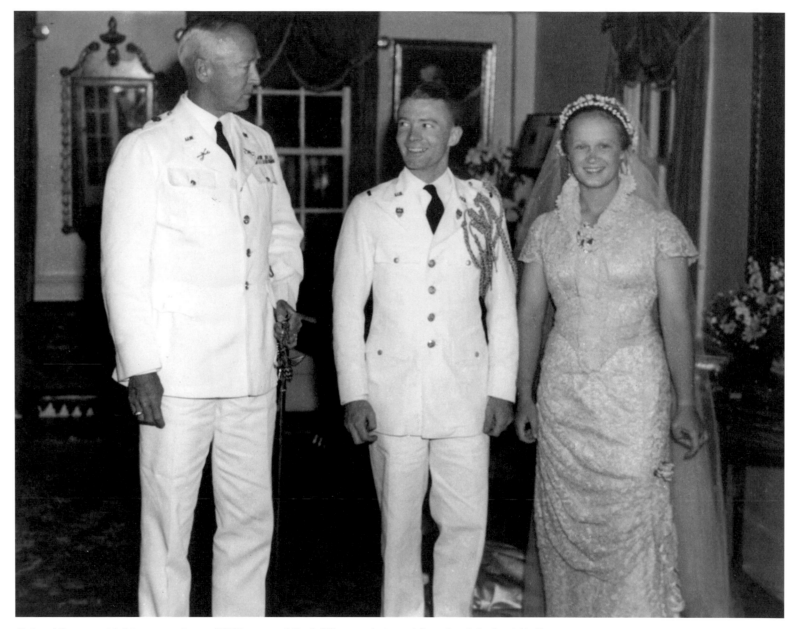

Colonel Patton with Lieutenant James W. Totten and Ruth Ellen on their wedding day, July 6, 1940. Patton first said she couldn't marry him, for "he's too short; he's a field artilleryman; and he's a Catholic!" (D'Este *Patton,* p. 370). Beatrice protested as well, hoping he had at least been an Episcopalian. Nevertheless, the Pattons were won over and the marriage took place. A week later Patton got the news he was reassigned to command the 2nd Armored Brigade, 2nd Armored Division, at Fort Benning, Georgia.

With Patton's reassignment to the 2nd Armored Division came promotion to brigadier general. His rank as a one-star general was short-lived—he was promoted to major general five months later, April 4, 1941, as the division's new commander.

Major General Patton as the Commander, 2nd Armored Division during the Louisiana Maneuvers, September 1941. The vehicle behind him is the M1 Light Tank, with one .50-caliber and two .30-caliber machine guns and little more than 16mm of armor. He is wearing the tank coveralls with the new Armored Force symbol that he helped design on his left breast pocket. The Armored Force patch signified a combined arms approach to warfare, bringing together tanks, infantry, and artillery in one mechanized force.

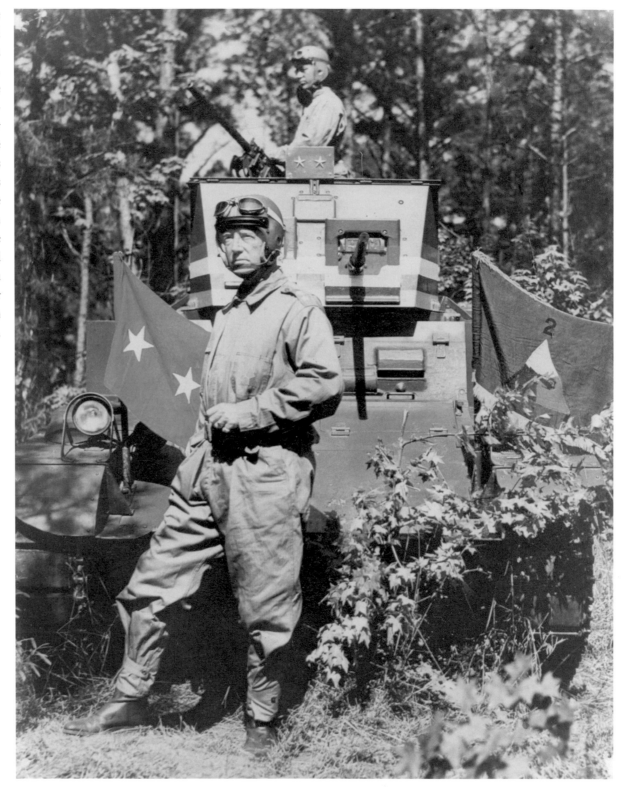

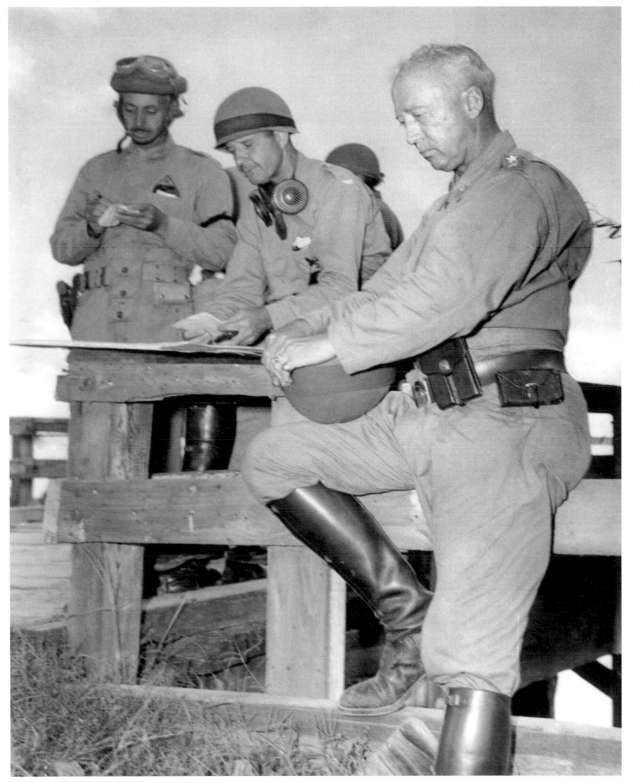

Patton studies a map during the Louisiana maneuvers, September 22, 1941. The officer at left wears the Armored Force triangle patch of the 2nd Armored Division on his left pocket. The tradition of the 2nd Armored Division to wear their unit patch over the left pocket of their field uniforms continued until the division was deactivated in the 1990s.

Patton discusses the Louisiana maneuvers with Lieutenant Colonel Mark Clark in September 1941. Clark would go on to command the Fifth Army during the campaign in Italy, 1943-44.

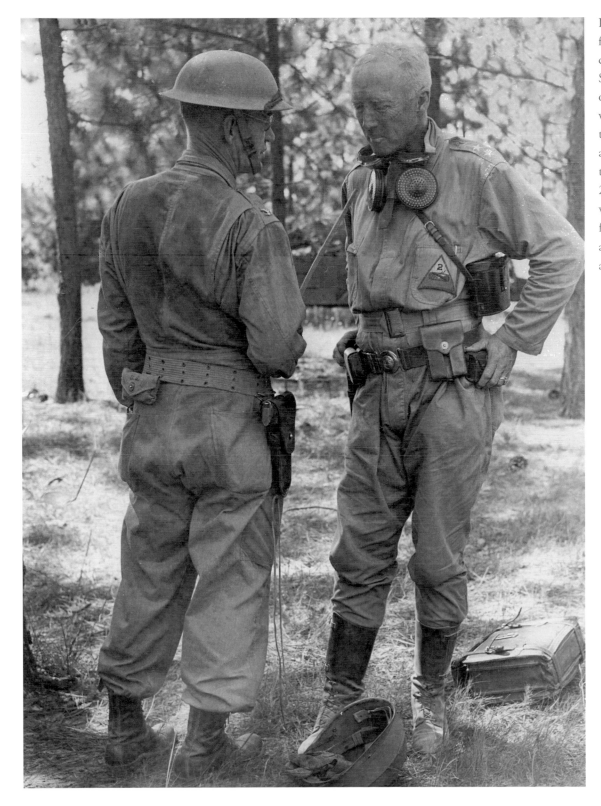

Patton receives an impromptu report from Colonel Harry "Paddy" Flint during the Louisiana maneuvers in September 1941. Flint is wearing the older World War I–era helmet that was still widely issued to troops at this time. Patton is wearing a dust mask around his neck, soon discarded by tank crews as too uncomfortable. His 2nd Armored Division patch is clearly visible on his pocket. The tracks stood for mobility, the cannon for firepower, and the lightning bolt for shock action.

Patton sports a few interesting items in this photograph taken in the early stages of the Louisiana maneuvers, September 8, 1941. Along with his traditional cavalry boots, he is wearing the newly issued M-1 Helmet. Patton was particularly fond of the new helmet, since it had a light-weight liner within a steel shell. The liner could be used for parades and other garrison activities, and he soon devised the means to paint and polish one for everyday use.

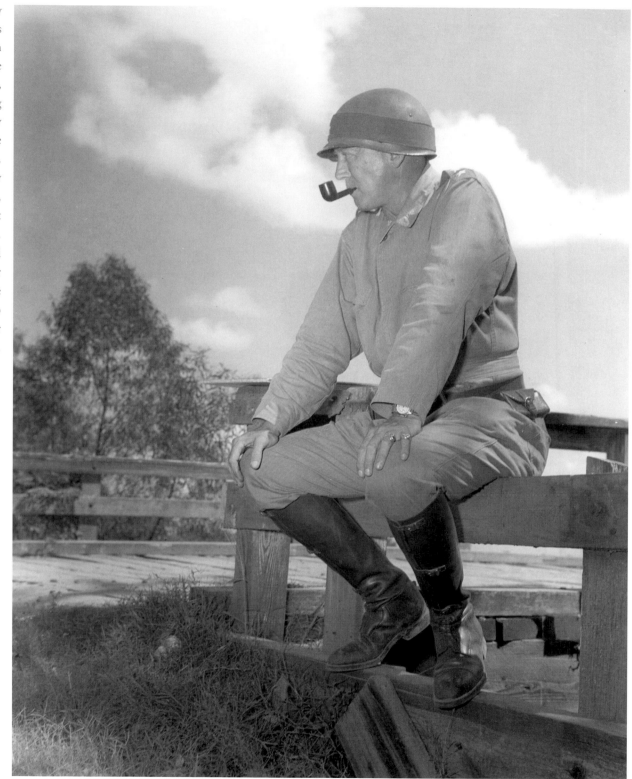

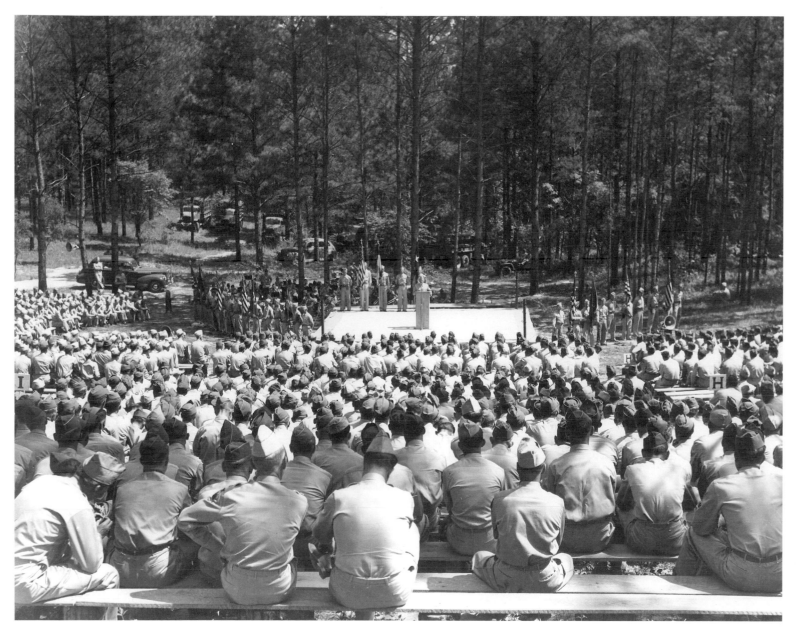

The original caption with this photograph states that Patton is addressing men of the 4th Infantry Division. Close examination of the photo and others like it, however, reveals that the men are wearing an Armored Force patch, and are therefore members of his 2nd Armored Division, probably just after he took command of the division in the spring of 1941.

Patton addresses 2nd Armored Division personnel, probably upon taking command of the division sometime in the spring of 1941. Patton's 2nd Armored Division patch does not seem to be properly sewn on, indicating that it was hastily attached to the uniform prior to the rally.

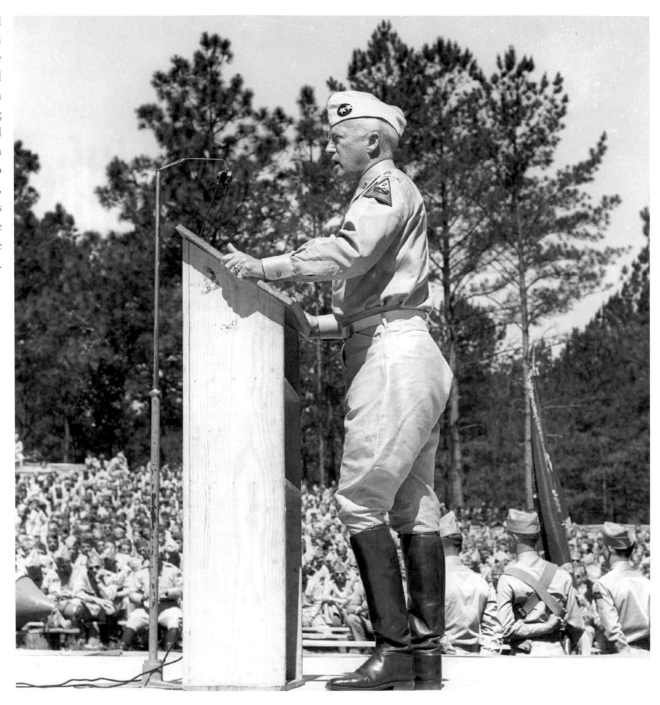

Patton attending an Armored Force conference at Fort Knox, Kentucky, in 1941. At 56 years of age, he maintained superb physical fitness, one of the reasons why the Chief of Staff of the Army, General George C. Marshall, did not have him retired. Meanwhile, most of Patton's contemporaries still in uniform found themselves gradually pushed out of the Army to make room for younger and more vigorous leaders.

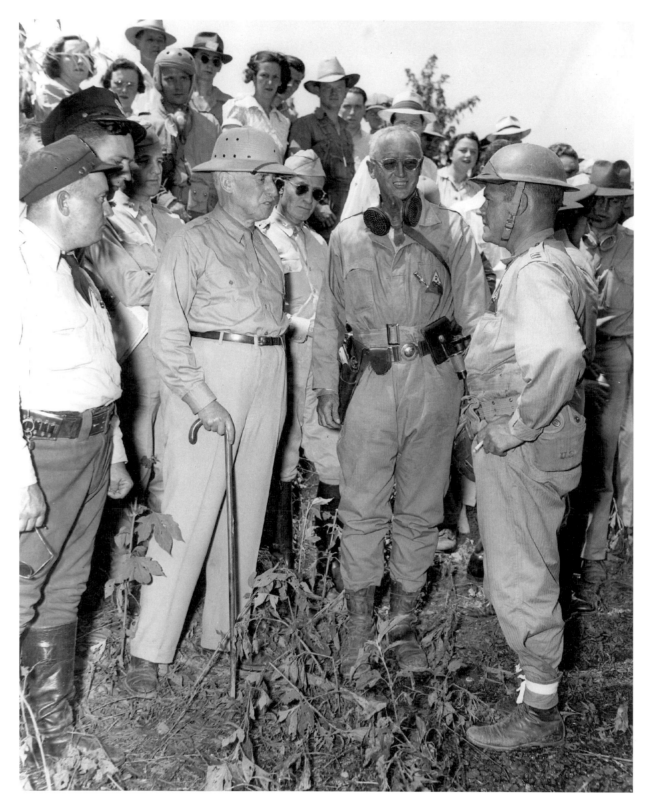

Patton and one of his junior officers (right) discuss the Louisiana maneuvers with Secretary of War Henry Stimson (with cane). Patton is wearing the new tank coveralls with the 2nd Armored Division patch. He had already obtained his Colt .45 and Smith and Wesson .357 revolvers, but the pistol he is carrying here is an M-1911 .45 automatic engraved with his initials, a sidearm he received during World War I. The .45 remained standard issue to U.S. Army tankers until the 1990s.

Patton watches the construction of a pontoon bridge during the Louisiana maneuvers in September 1941. One of the early concepts of mechanized warfare was for an armored force to have its own organic support elements, such as fuel and pontoon bridges. During the maneuvers, however, these assets were controlled by higher headquarters, which limited the independent mobility of Patton's 2nd Armored Division. During World War II, the same methods were used to keep Patton's Third Army on a logistical leash.

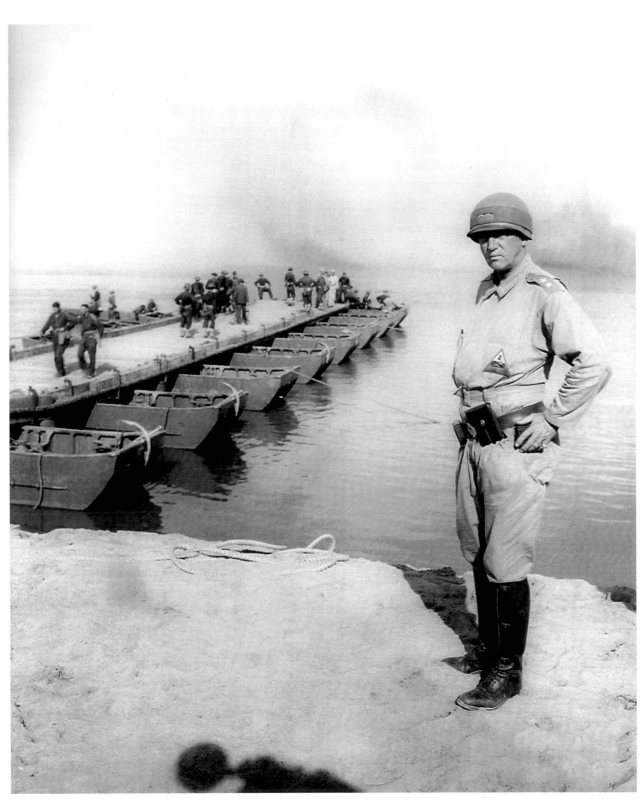

After the Louisiana maneuvers, Patton briefs his men at Fort Benning, Georgia, on their wide maneuver through Texas to attack into the enemy rear in northern Louisiana (October 25, 1941). Contrary to popular perception, mobile forces in the maneuvers, including Patton's, were often forced to correlate movement with infantry units and could therefore not properly engage in all-out mobile warfare training.

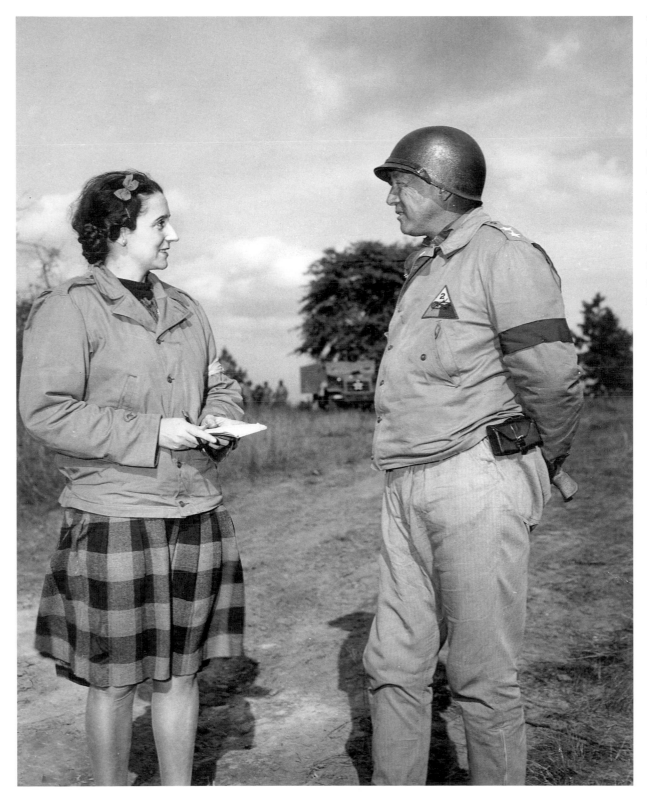

With war just a month away, the next heavy maneuver took place in the Carolinas, November 6, 1941. Patton is being interviewed by Elizabeth Vaughan, news correspondent of the Chattanooga, Tennessee, *News Free Press*. This interview came moments after Patton's forces captured nearly 50 "Blue" enemy vehicles in the IV Corps Maneuvers in South Carolina.

A classic photograph of Patton as the commander of the 2nd Armored Division during the Louisiana maneuvers. He is wearing the tanker coveralls with a pistol belt and ammunition pouches for the M-1911 .45 automatic pistol. His helmet is adapted from a football helmet, and was not the same as the standard issue tanker's helmet worn by the crewman behind him.

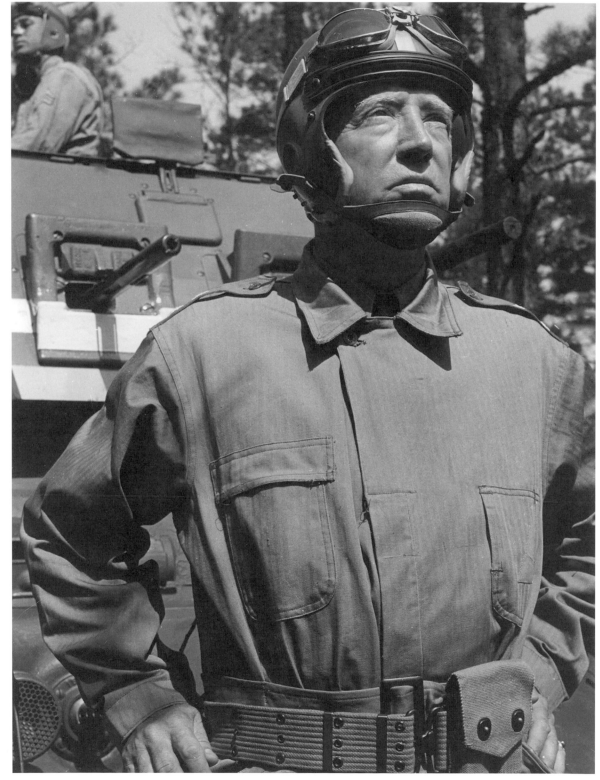

Mission Identified: The Second World War

(1942–1943)

Maneuvers are one thing, combat is another, and there were few generals who understood this better than Patton. After the Japanese attack on Pearl Harbor, Patton trained his men mercilessly, and by late 1942 had been granted a corps command and leadership of the Western Task Force to invade North Africa. En route to North Africa, Patton read through the Koran to better understand the people of Morocco where his forces would be landing. He also had a serious desire to defeat Field Marshal Erwin Rommel, the vaunted commander of Axis forces in North Africa. He had studied Rommel's methods, but he was unable to read his book *Infantry Attacks* until a hasty wartime translation came out in 1943. Nevertheless, he believed he could best the Desert Fox.

While the invasion of North Africa went reasonably well, the campaign in Tunisia was a different matter. Poor planning by senior generals and staff meant that the forces pushing on Tunis were weak and poorly supplied. Meanwhile, Patton was forced to play diplomat in Morocco, among other things hosting the Casablanca Conference between President Roosevelt and Britain's Prime Minister Churchill, and attending one parade after another to appease the French. The debacle at Kasserine Pass in February 1943 threw Patton into the spotlight. Patton was actually not General Eisenhower's first choice to take over II Corps from Major General Lloyd Fredendall, but with nobody else available, he was compelled to relent. Patton made the most of it, and in a whirlwind of activity transformed the corps into a battle-hardened outfit. By the end of the campaign, Patton was back in Morocco, now planning for the invasion of Sicily while his subordinate Major General Bradley led the corps into Tunis.

With the end in North Africa, the decision was made to push into Sicily, and Patton was selected to lead the newly organized Seventh Army. The landing in Sicily, on July 10, 1943, was more difficult than often realized, and when Patton himself arrived on the Gela Beach, the area was under a counterattack by the elite German Hermann Göring Panzer Division. With the beachhead secured, Patton proceeded to launch a wide-flanking operation that took his troops through Palermo and then eastward to Messina in an effort to cut off the German escape route from the Island. Contrary to the movie *Patton,* he was not so much interested in beating Montgomery to Messina as he was in the prestige of the U.S. Army. On August 17, 1943, Patton's troops took Messina, ending the Sicily campaign.

With the United States now at war with Germany and Japan, Patton knew he would get a chance to lead his men into battle. However, it was not to be the 2nd Armored Division. In January 1942, he was assigned to command the I Armored Corps, and as a result handed over his division to Major General Willis Crittenberger in February. Here Crittenberger and Patton in their dress blues discuss the details of the change of command ceremony.

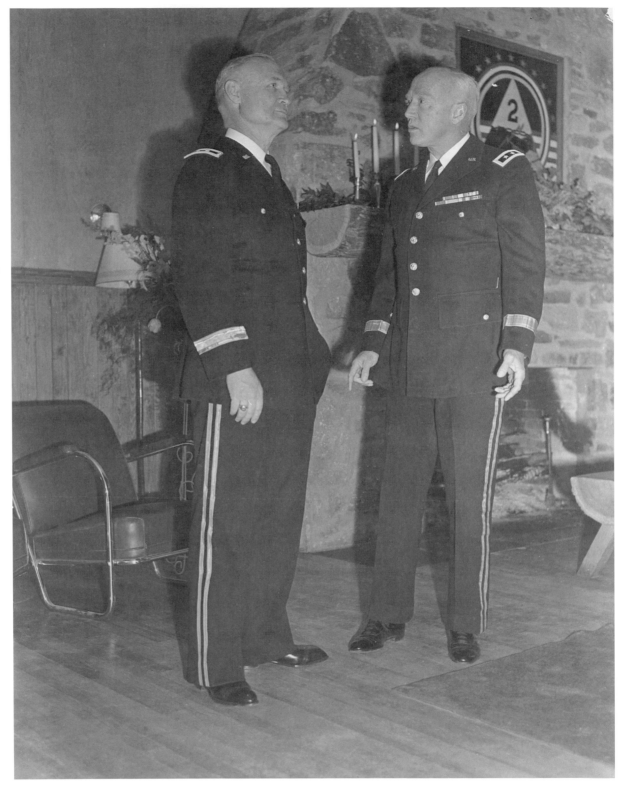

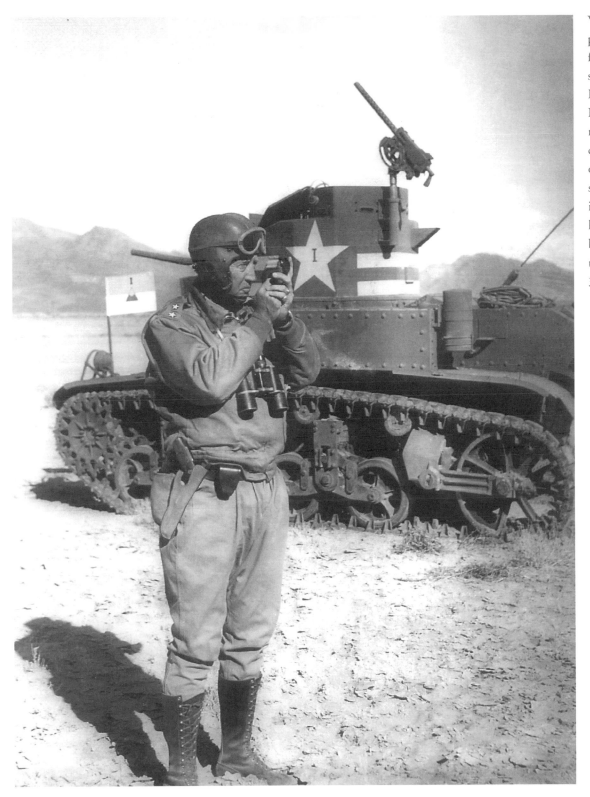

With the nation now at war, planners in Washington, D.C., following the "Germany first" strategy set by President Franklin Roosevelt, determined to invade North Africa. As a result, Patton, now as the I Armored Corps commander, was assigned to organize a desert training site in southern California. Here Patton is "shooting an azimuth" with his lensatic compass while standing before a new M-3 Stuart light tank. The Stuart was armed with a 37mm cannon.

Patton was always a tough trainer, and training in the desert was even tougher. He pushed his men to go without water for lengthy periods of time and taught them how to navigate in the featureless terrain. Here Patton and the commander of the newly forming 3rd Armored Division, Major General Walton Walker, review a demonstration of a reinforced tactical battalion attack at the Desert Training Center on June 4, 1942.

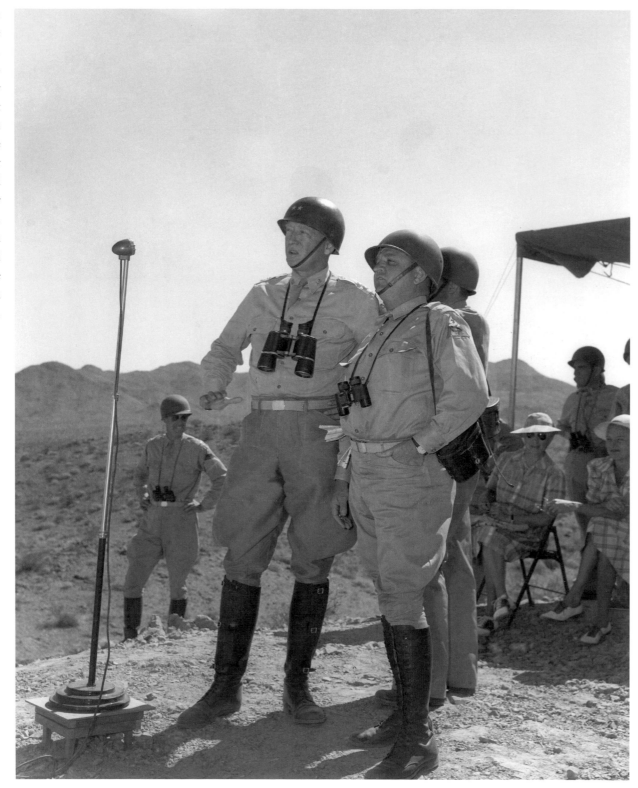

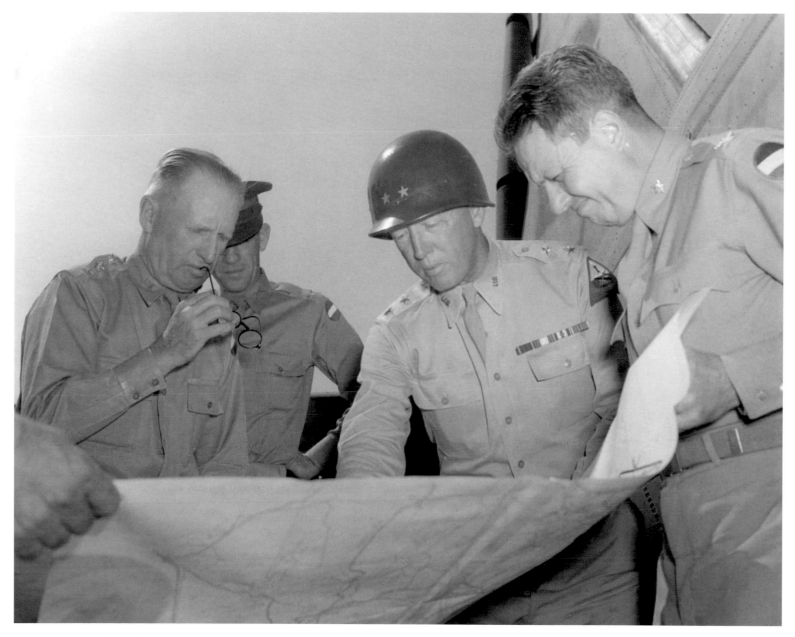

Lieutenant General Lesley McNair, Commander of Army Ground Forces, receives a map briefing from Patton at the Palm Springs, California, airport regarding the training operations at the Desert Training Center, in July 1942. Patton considered McNair a friend and was deeply moved when the latter was killed by Allied bombs during the opening phases of the Cobra operation to break out from Normandy in July 1944.

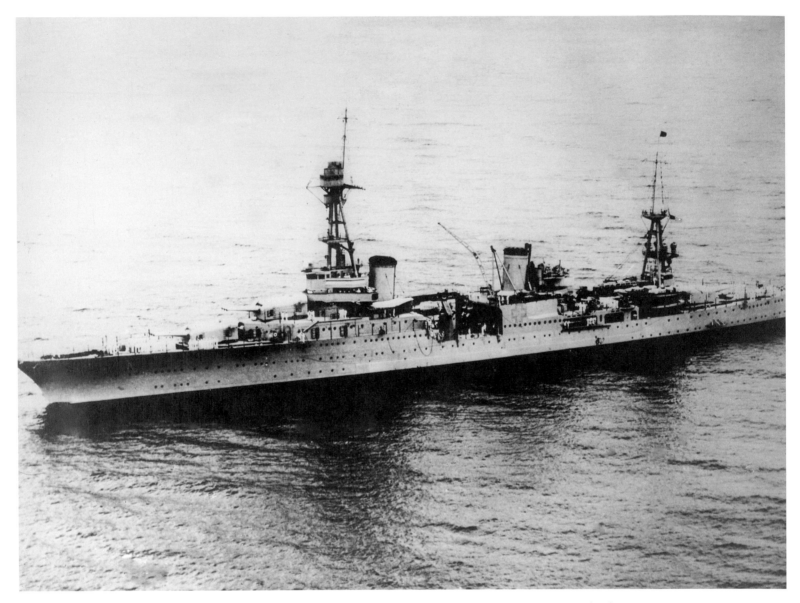

For the invasion of North Africa, Patton was placed in command of the Western Task Force. Its mission was to land on the coast of Morocco while other Allied forces landed on the coast of Algeria. Patton's flagship for the operation was the USS *Augusta*, which was a Northampton class cruiser that continued in service through the 1950s. It was broken up in 1960. Displacement: 11,420 tons; guns: nine 8-inch; speed: 32 knots.

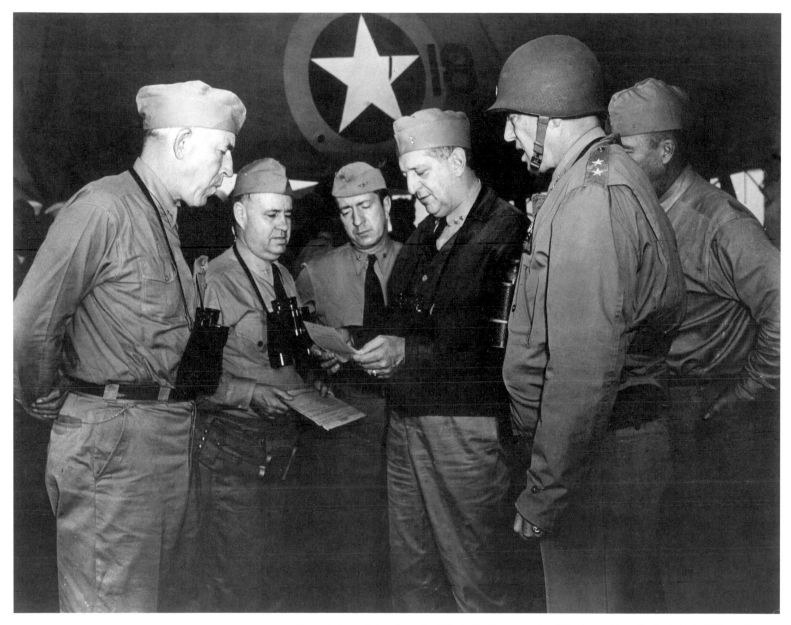

From left to right, Captain Mitchell, Commander Woods, unidentified, Admiral Kent Hewitt, Patton, and Lieutenant Commander Phillips review initial reports coming in from the forces making the initial landing on the Moroccan coast during Operation Torch, November 8, 1942.

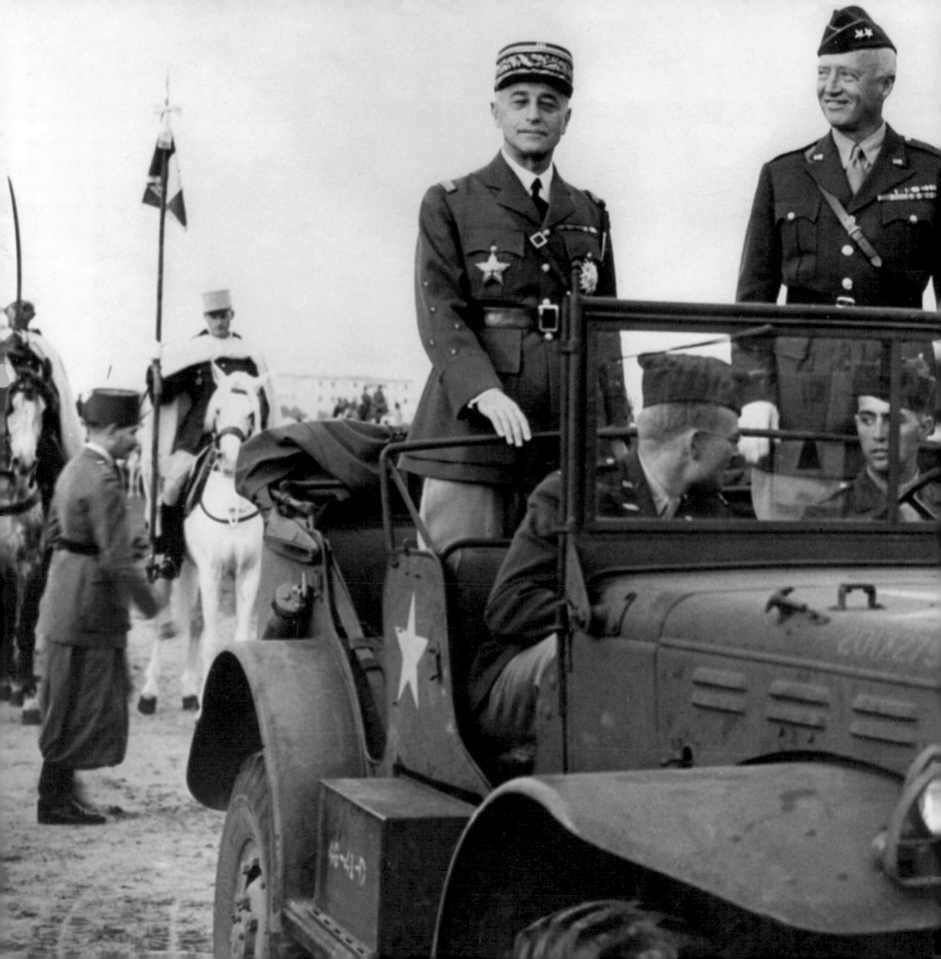

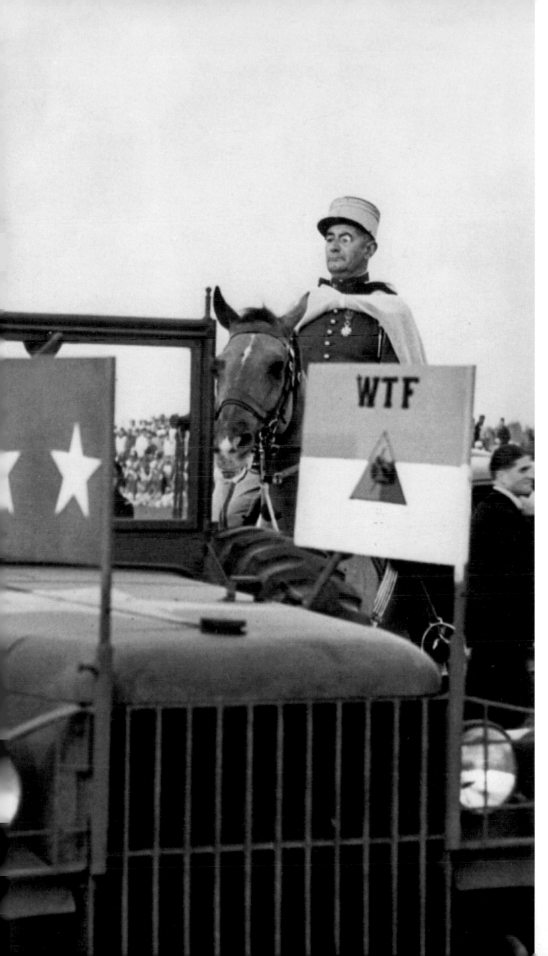

Once the landings were complete, Patton found himself playing diplomat, not only to the Moroccans, but also to the French, who controlled the area before the war. Here Patton and General Auguste Paul Nogues, the French governor of Morocco, review American and French troops, December 20, 1942.

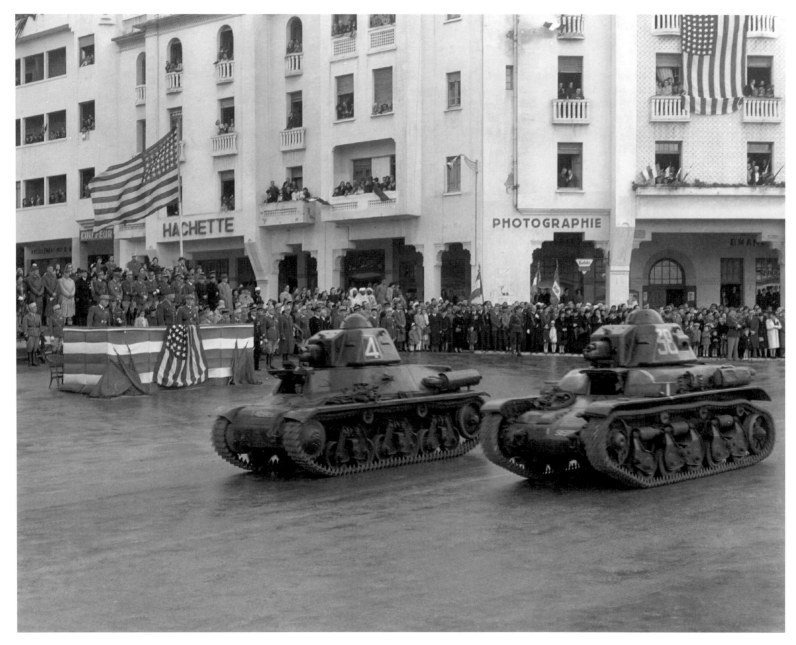

Patton and General Auguste Paul Nogues, French governor of Morocco, watch a parade in celebration of the Muslim Id holiday, December 18, 1942. The tank on the left is a Hotchkiss Char Leger H-38 light tank, and the one on the right is a Renault Char Leger R-35 light tank. Both models were armed with 37mm guns, and had a crew of two.

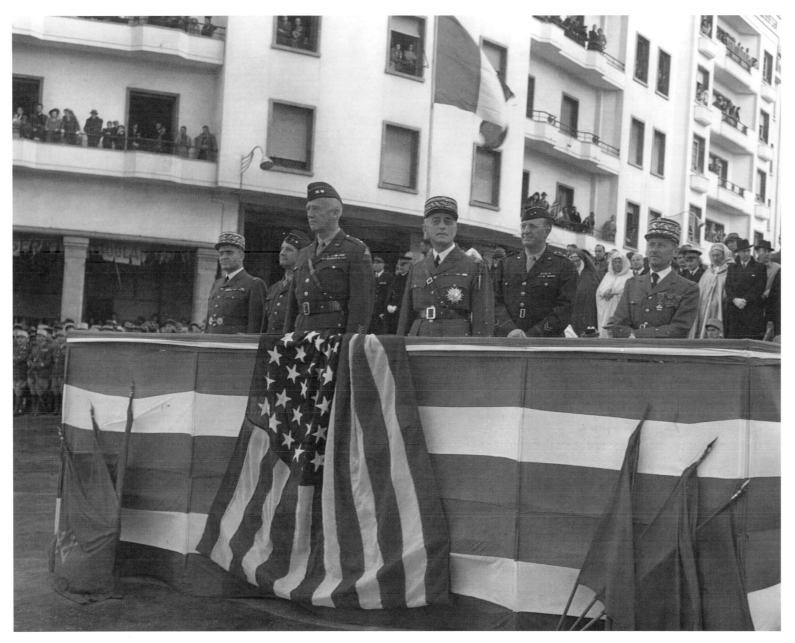

Patton and General Nogues in the reviewing box for a parade celebrating the Muslim Id holiday, December 18, 1942, in Rabat, French Morocco. To the left of Patton is Major General Geoffrey Keyes, and to the right of Nogues is Major General Manton Eddy, the commander of the newly arrived 9th Infantry Division. Eddy's division was forced to remain near the Moroccan beachhead for weeks after it was stripped of its transport to provide logistical support for the Allied race for Tunis.

French general Nogues and Patton pass a guard of honor at Nogues's headquarters. Instead of disarming the French, Patton kept them for security purposes to prevent a local uprising. Patton found Morocco fascinating, and when he and Keyes drove through Casablanca he noted that it was "a city which combines Hollywood and the Bible" (Blumenson, *Patton Papers,* II, p. 120). Despite this fascination, Patton really wanted to be at the front fighting the German and Italian troops still holding out in Tunisia.

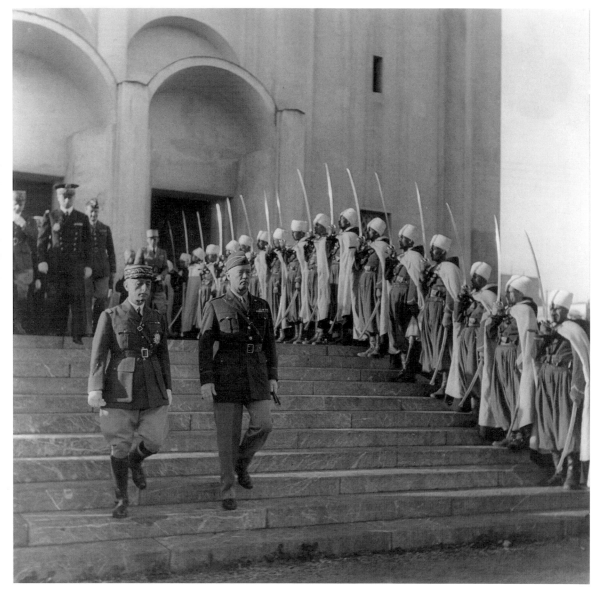

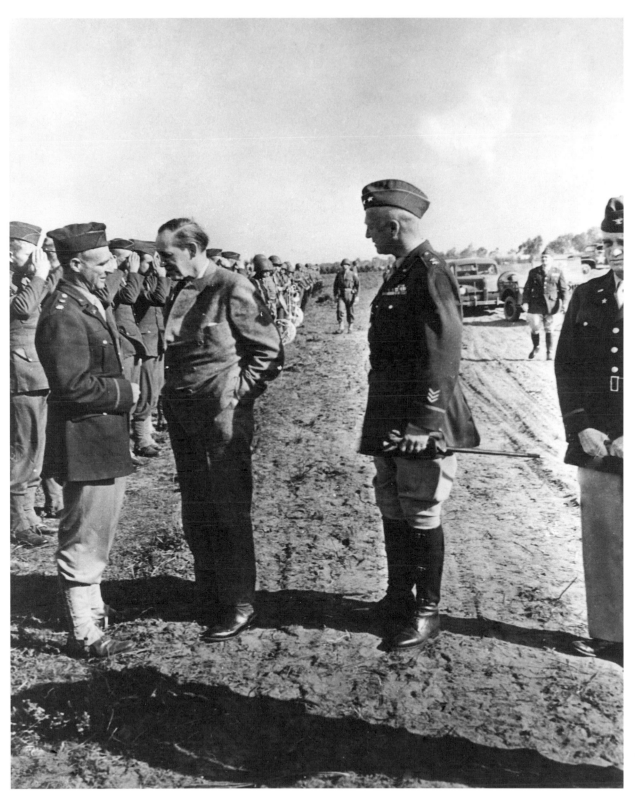

After the success of the Torch landings, Patton found himself engaged in occupation duties in Morocco. He also provided the security for the Casablanca Conference attended by President Roosevelt and Prime Minister Churchill in January 1943. Here one of Roosevelt's cabinet members, Harry Hopkins, talks with an officer while Patton looks on.

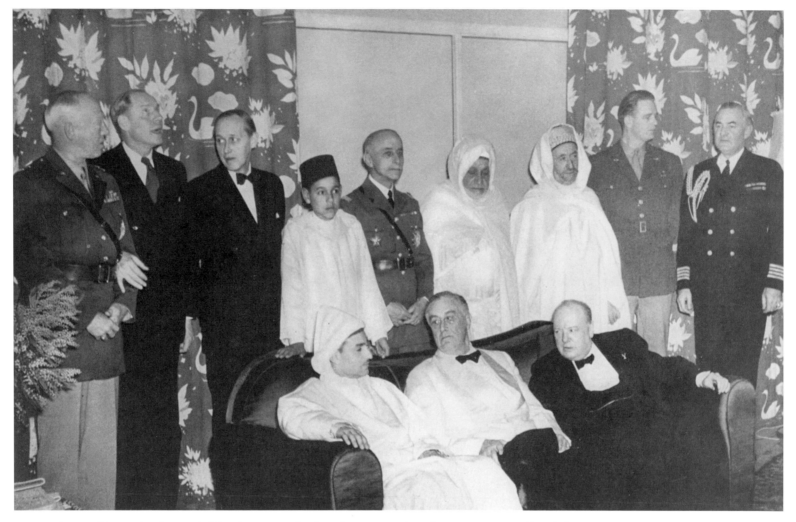

During the Casablanca Conference held in January 1943, President Roosevelt and Prime Minister Churchill met with the Sultan of Morocco. From left to right (standing) are Patton, Robert Murphy, Harry Hopkins, the Crown Prince of Morocco, French general Nogues, the Grand Vizier of Morocco, the Chief of Protocol for Morocco, the President's son and aide Colonel Elliott Roosevelt, and an unidentified naval officer.

Lieutenant General Mark Clark (second from right) took command in Morocco on January 10, 1943. After a brief inspection of the honor guard, Clark and Patton went into a private room where "for one hour he spent his time cutting Ike's throat." Patton noted that Clark's "whole mind is on Clark," and that he had come to Morocco to stay away from the debacle that was looming in Tunisia (Blumenson, *Patton Papers,* II, p. 150). Accompanying Clark and Patton is Major General Geoffrey Keyes and Brigadier General Alfred Greunther (second and third from left).

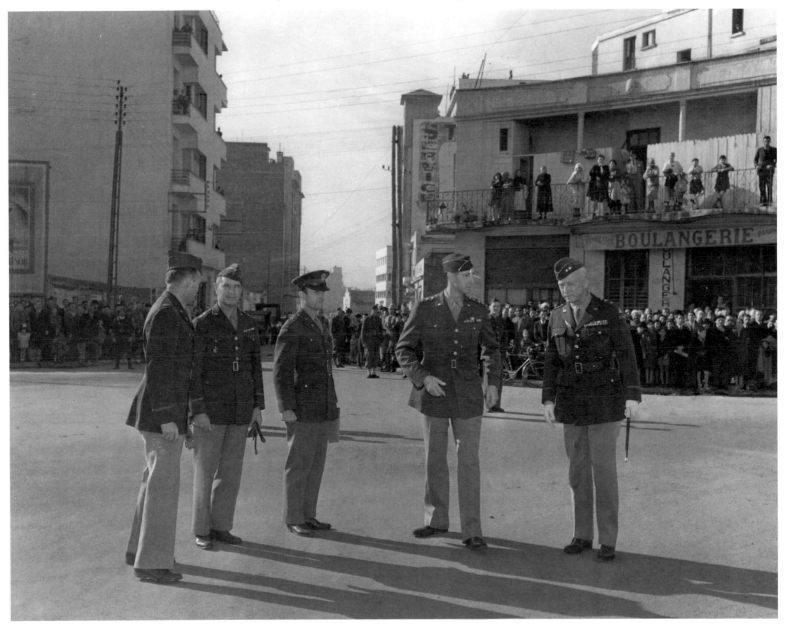

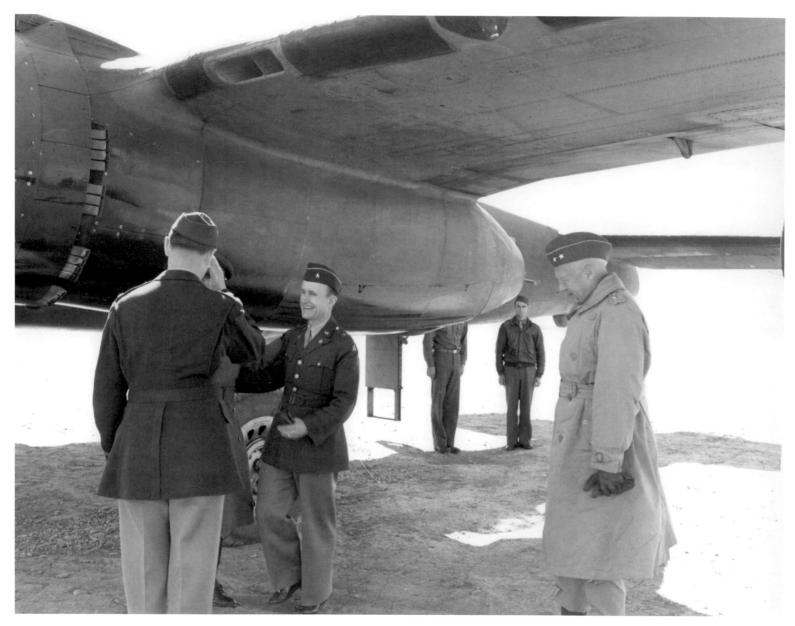

Major E. F. Ball (his back to the camera), Brigadier General Alfred Greunther, and Patton at the North African airfield of Oujda, on February 13, 1943. The aircraft is a B-25 Mitchell bomber, which was occasionally used for transporting personnel.

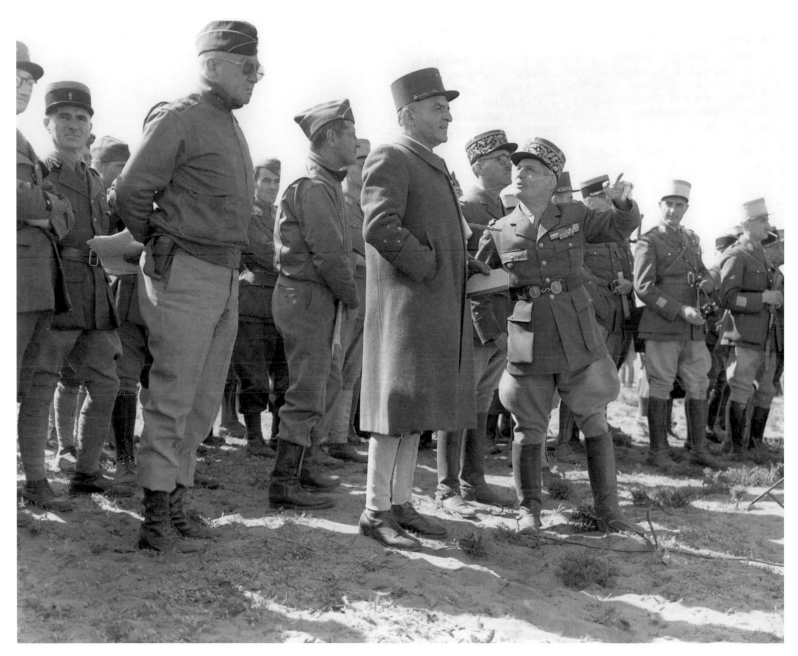

Patton and Major General Geoffrey Keyes (to the right of Patton), along with other American and French officers, near Port Lyautey, French Morocco. The original caption states that this is March 17, 1943, which seems unlikely since Patton was in Tunisia at the time, directing the II Corps' actions against the Germans. Furthermore, he is a major general in the photograph, but was promoted to lieutenant general on March 12. This photograph was probably taken not long after the Torch landings. The leading French general in the center is probably Alphonse Juin.

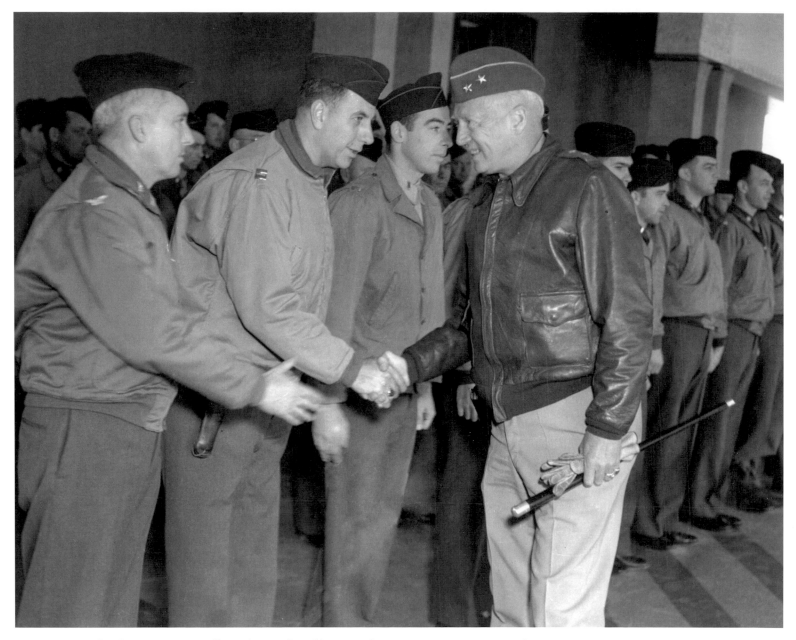

Patton was very loyal to competent staff members and could at times be quite magnanimous. Here he is saying good-bye to officers of his I Armored Corps and the Western Task Force as he prepares to take command of the II Corps in Tunisia, in early March 1943. As he prepared to lead the corps, he noted in his diary that "I think I will have more trouble with the British than with the Boches" (Blumenson, *Patton Papers,* II, p. 178).

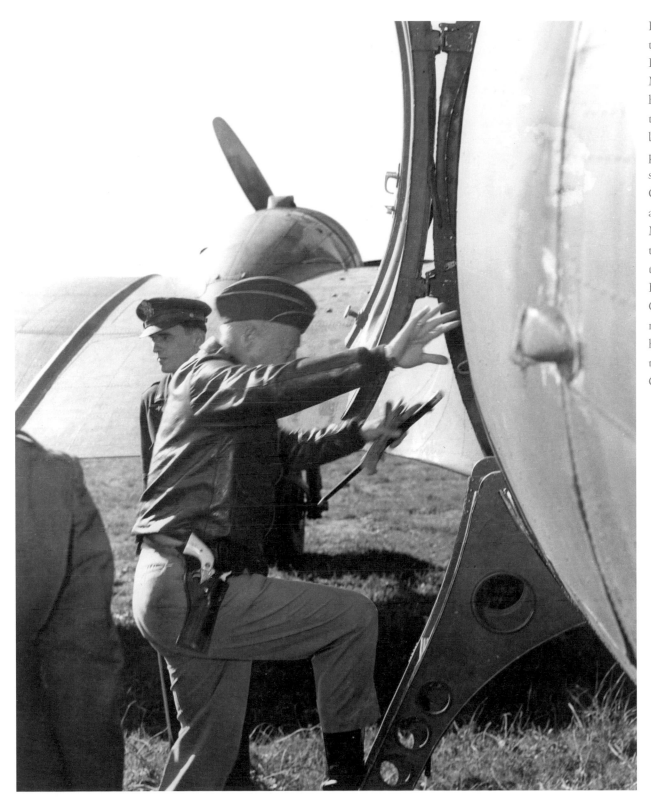

Patton on his way to take command of the II Corps in Tunisia, March 7, 1943. Here he is boarding a C-47 transport at Rabat airfield bound for the front. The plan was for Patton to simply rehabilitate the II Corps after its pounding at Kasserine Pass, while Major General Keyes held temporary command of the I Armored Corps. Patton is carrying his Colt .45 ivory-handled revolver inscribed with his initials. He was at last to have a real crack at the German army.

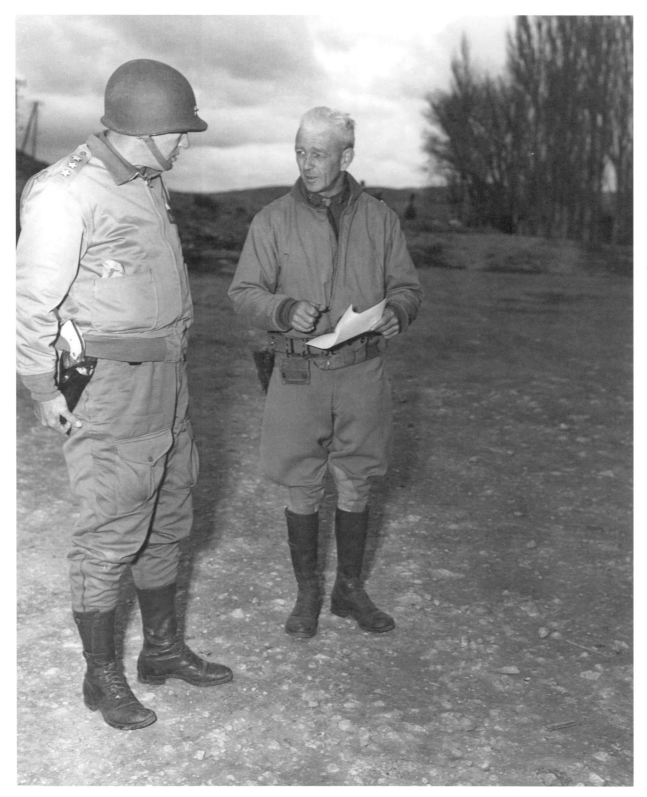

Patton now at the front near Feriana, Tunisia, conferring with Brigadier General Hugh Gaffey, his Chief of Staff, II Corps, on March 17, 1943. Patton considered Gaffey to be a first-rate officer, both in staff and command positions. Gaffey would later command the 2nd Armored and 4th Armored divisions, and would command a corps near the end of the war.

During the fighting for El Guettar, Tunisia, Patton confers with General Eisenhower (left) and British General Harold Alexander, who commanded all British forces in the Mediterranean Theater (Feriana, Tunisia, March 17, 1943). "Ike and Alex were both here telling me to stay back, which cramped my style, but any how this high command keeps me out of the real front line stuff, and honestly I rather resent it. But when one is fighting Erwin [Rommel], one has to be near the radio" (Blumenson, *Patton Papers,* II, p. 193).

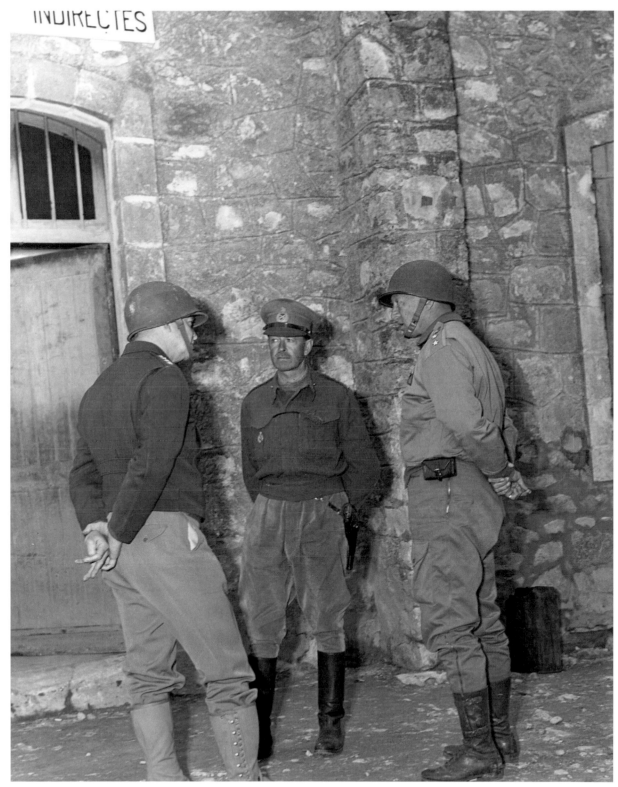

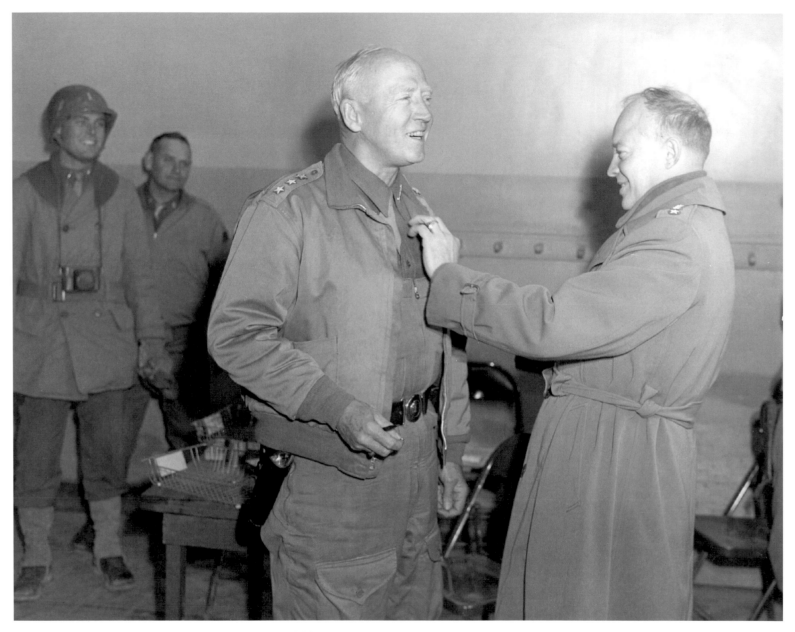

Patton was becoming increasingly frustrated with his old friend General Eisenhower, especially in the way that he coddled the British. Here the Commander of Allied Forces officially promotes Patton to lieutenant general, March 18, 1943. "I spent the night with Ike. . . . He is nothing but a Popinjay—a stuffed doll. The British are running the show" (Blumenson, *Patton Papers,* II, p. 222).

Lieutenant General George S. Patton, Jr., displays his signature war face south of El Guettar, Tunisia. Patton actually spent time in front of a mirror practicing this expression, and he once noted that a great part of combat command was acting.

Patton in an M3A1 scout car turned mobile command post, south of Gafsa, March 30, 1943. While he liked to visit the front often, in particular to control the fear of enemy fire that would rear its ugly head within him, Patton fought the temptation to micromanage his subordinates. "The hardest thing I have to do is to do nothing. There is a terrible temptation to interfere" (Blumenson, *Patton Papers,* II, p. 202). One of the secrets of Patton's success as a commander was that he refused to over-supervise his subordinates.

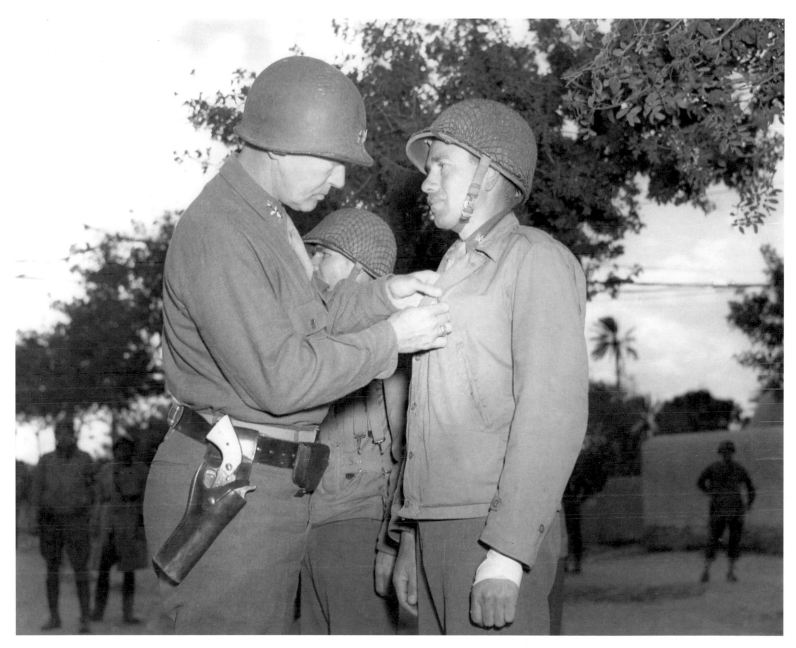

Lieutenant Leon Coralins, a chaplain with the 1st Armored Division, receives the Silver Star for gallantry in action for destroying military materiel while under enemy fire at Sbeitla during the actions centered on Kasserine Pass, May 4, 1943. Patton is wearing his now signature Colt .45 revolver.

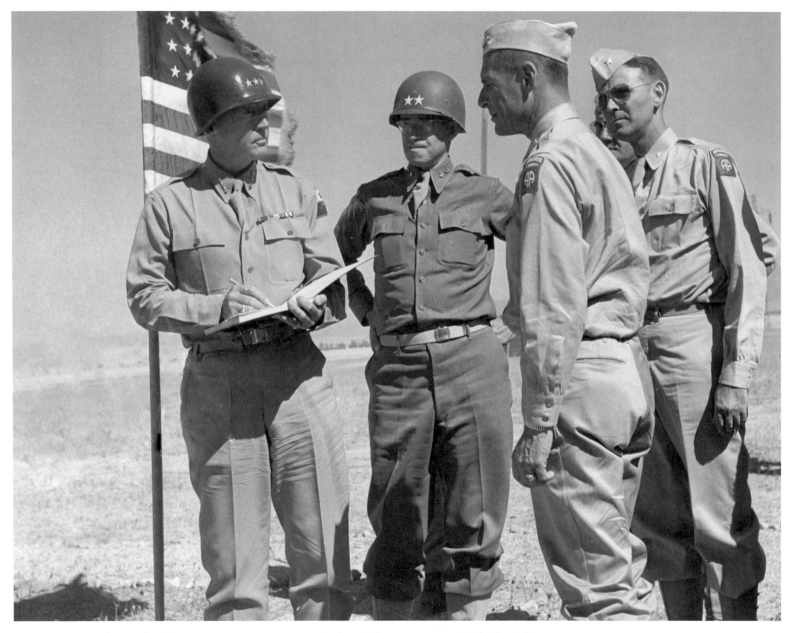

During a visit to the 82nd Airborne Division, Patton signs the division's guest register. With him is Major General Omar Bradley, Major General Matthew Ridgeway, the division's commanding general, and Brigadier General Charles Keerans, Ridgeway's deputy. Patton was once more wearing his I Armored Corps patch as he prepared his command for the invasion of Sicily. Keerans was listed missing in action and presumed dead when the C-47 he was in went down over Sicily after being hit by friendly antiaircraft fire.

From left to right, the British Secretary of State for War, Sir James Crigg, Lieutenant General Mark Clark, Britain's King George VI, and Patton, have lunch in Oran, Algeria, June 14, 1943. Note the standard issue mess kits and canteens on the table. Although Patton's antipathy for the British is well known today, it was a fairly well-kept secret then—he kept his views very private. Of interest is that Patton is wearing a generic Armored Force patch without unit designation.

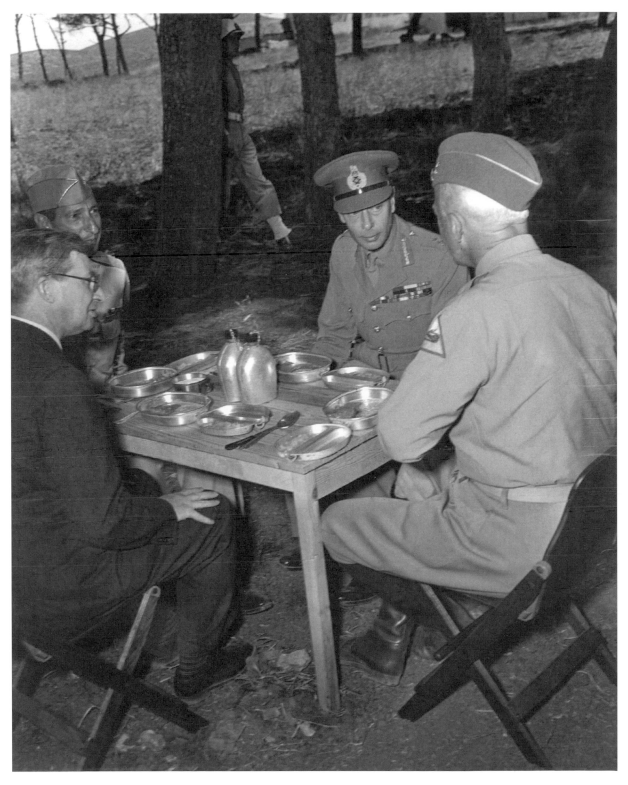

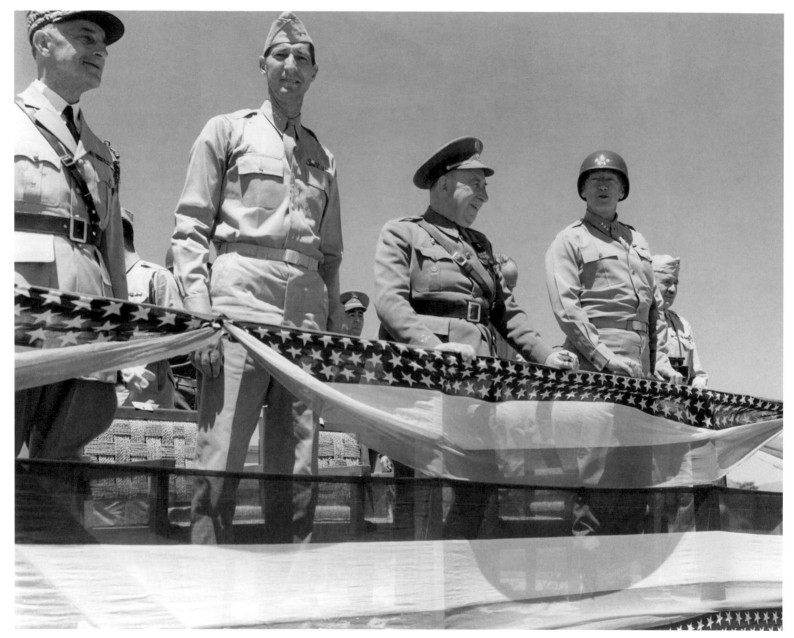

French general Nogues, Lieutenant General Mark Clark, French general Orgas, and Patton during Orgas's inspection of French troops, June 3, 1943. Patton would certainly have enjoyed the fact that the reflection on his helmet made it appear that he was a five-star general!

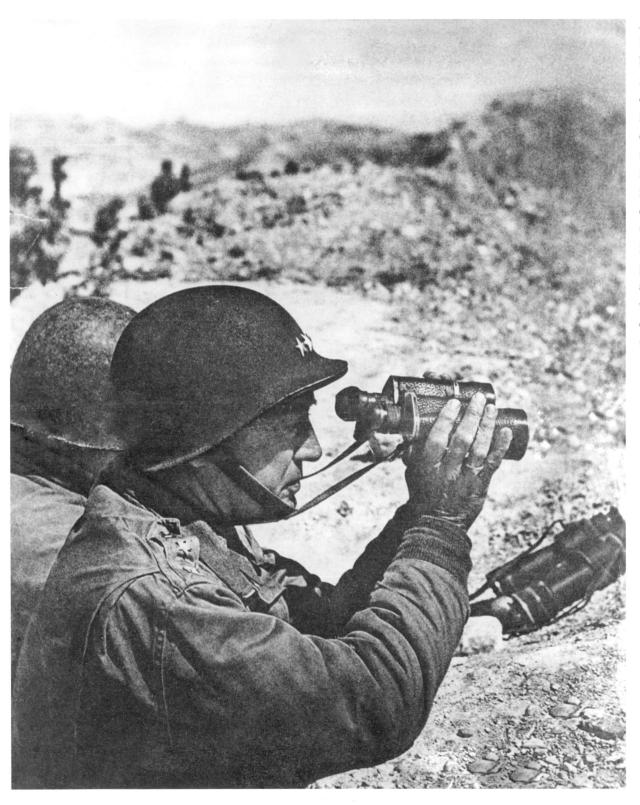

A signature image of Patton up front during a battle in Tunisia. He often made comments in his diary that he was afraid he would lose his nerve in combat, and thus he made frequent trips to the front in order to keep himself familiar with the intensity of battle. To underscore the obvious, soldiering is dangerous, even in peacetime, and is typically a young man's game. It was not uncommon for older soldiers to become too cautious under fire.

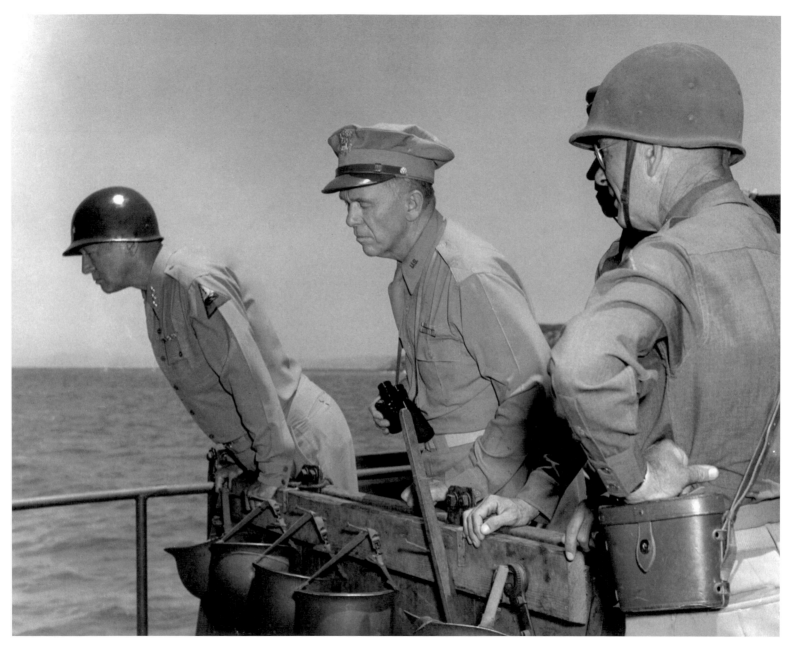

Patton prepares for the Sicily invasion in June 1943, here on board a ship with General George C. Marshall, Army Chief of Staff. The officer to the right is Major General Troy Middleton, Commander of the 45th Infantry Division who was given a key role in the landing east of Gela.

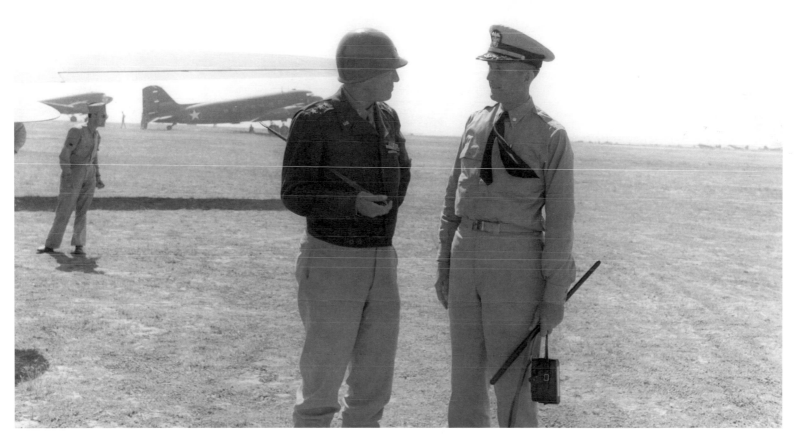

Patton with Commander Harry Butcher, Oujda, North Africa, June 17, 1943. Butcher was General Eisenhower's naval advisor and kept a detailed diary throughout the war. "Patton is a good fellow, curses like a trooper, and boasts that while he is stupid in many particulars (his own description) there is one quality he knows he has—the ability to exercise mass hypnotism. 'In a week's time,' he said, 'I can spur any outfit to a high state of morale'" (Capt. Harry C. Butcher, *My Three Years with Eisenhower, 1942 to 1945* [New York: Simon and Schuster, 1946], p. 47).

Patton being presented with the Seventh Army flag by Admiral Hewitt aboard the USS *Monrovia* while en route to Sicily, July 1943. Watching the informal ceremony is Brigadier General Hobart Gay, Patton's Chief of Staff (left) and Major General Geoffrey Keyes, Patton's Deputy Commander. An inscription in Patton's hand reads: "Army and Navy forever, GS Patton, Jr." Patton's handwriting was notoriously difficult to read. Regarding Hewitt, Patton was friendly outwardly, but inwardly he cringed. After one visit to the admiral, Patton wrote that "he was very affable and in his usual mental fog" (Blumenson, *Patton Papers,* II, p. 233).

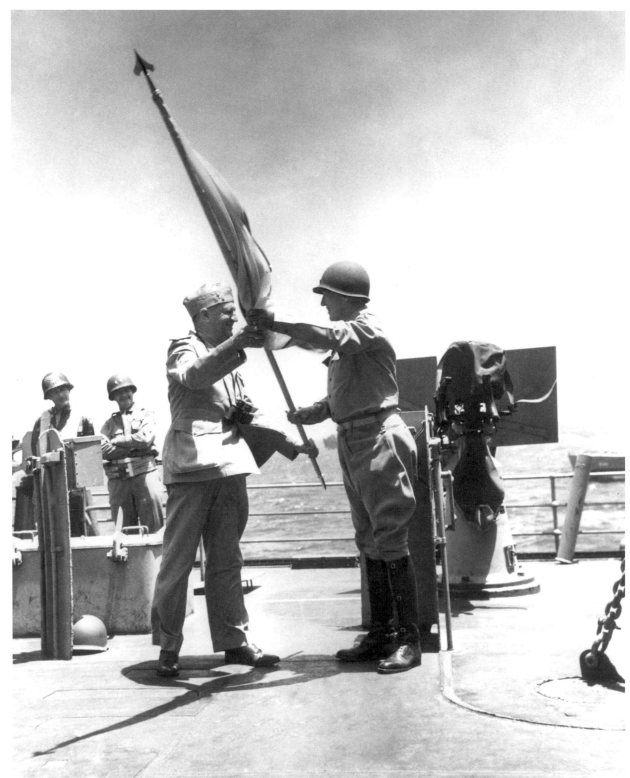

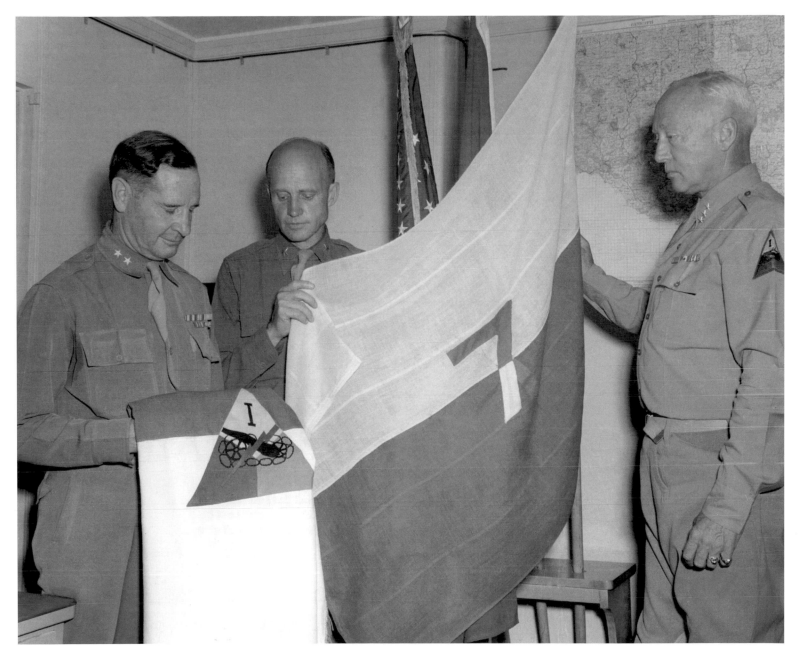

En route to Sicily on the USS *Monrovia,* July 7, 1943, Patton conducts a small ceremony in preparation for the official activation of the Seventh Army, which he was to command. Major General Geoffrey Keyes (left) was to be his Deputy Commander, while Brigadier General Hobart "Hap" Gay (center) was to be Chief of Staff. Concurrently they are folding the standard for the I Armored Corps, which was officially deactivated on July 10.

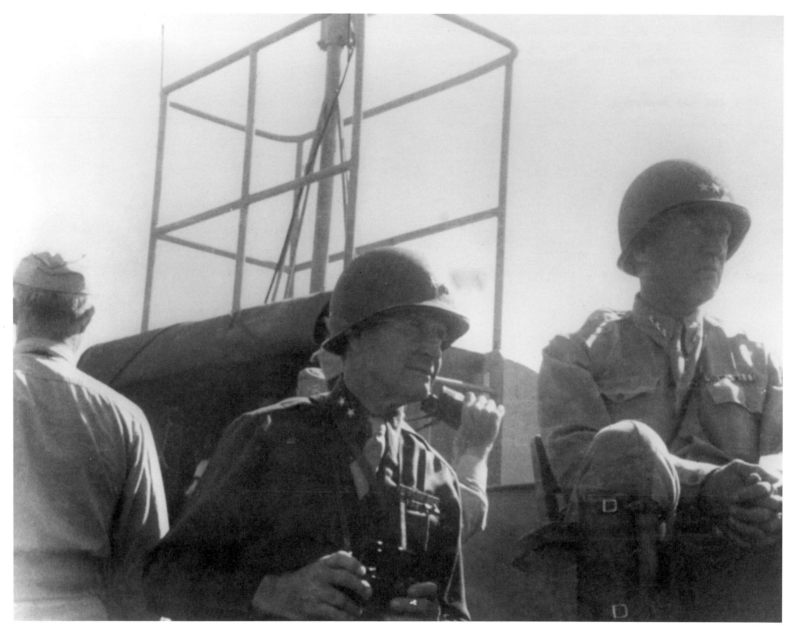

Tense moments on the USS *Monrovia* as troops of Patton's new Seventh Army prepare to land on the beaches near Gela, Sicily, July 10, 1943. Major General Geoffrey Keyes (left) was Patton's Deputy Commander. The *Monrovia,* APA-31, was an attack transport used as Admiral Henry Hewitt's flagship. Displacement: 14,247 tons; speed: 16 knots. The *Monrovia* was decommissioned in 1947, re-commissioned in 1950 with the outbreak of the Korean War, and again decommissioned and sold for scrap in 1968.

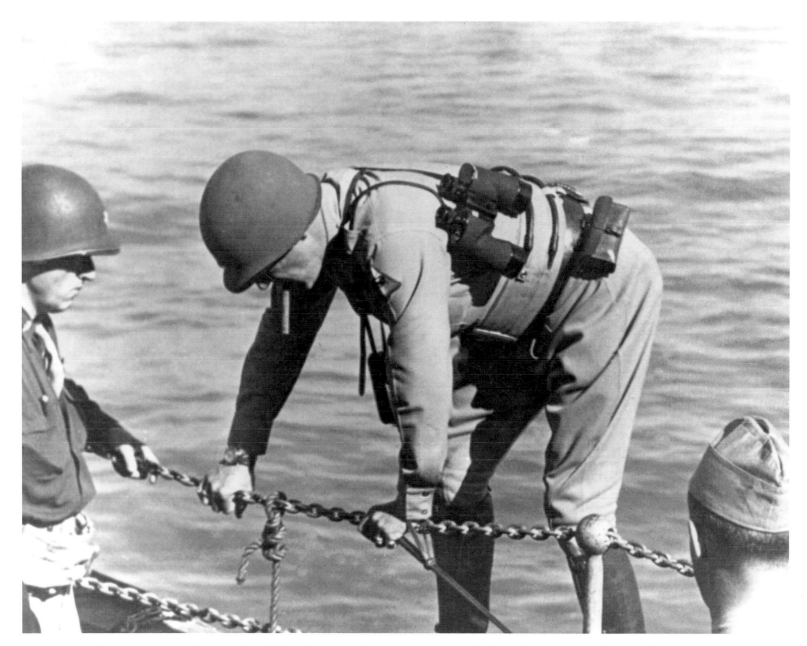

Patton prepares to board Admiral Hewitt's personal barge to go ashore at Gela, Sicily, on the second day of the invasion, July 11, 1943. The officer to the left is Lieutenant Colonel Charles Codman, Patton's aide. In a letter to his wife during the breakout in France, Codman noted that "the General knows exactly what he is doing, and if at times the higher staffs turn green around the gills when across their maps flash the prongs of seemingly unprotected spearheads launched deep into enemy territory, it is only because they have yet properly to gauge the man's resourcefulness" (Col. Charles R. Codman, *Drive* [Boston: Little, Brown and Co., 1957], p. 160).

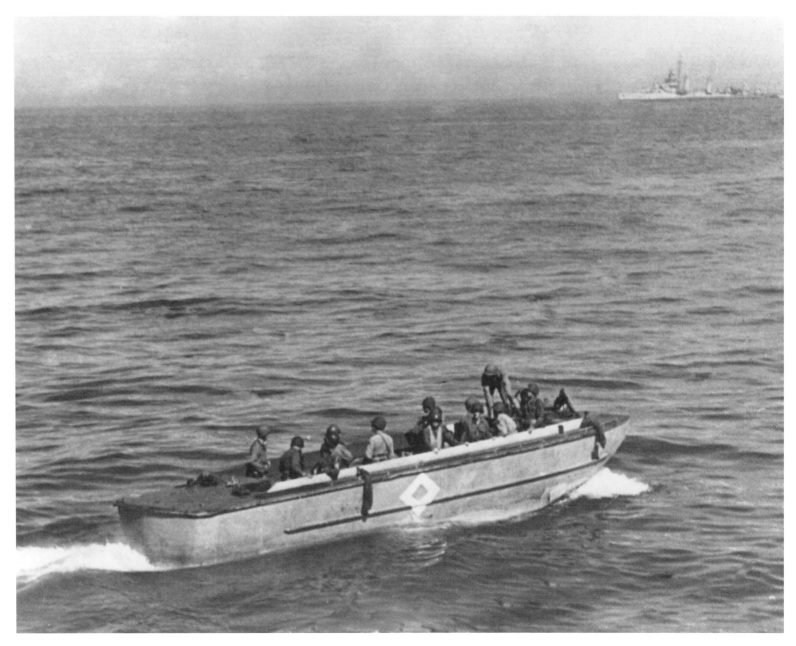

The barge carrying Patton and his staff speeds ashore to the beaches at Gela, Sicily, July 11, 1943. Patton is just left of the diamond on the side of the boat, while Chief of Staff Hobart Gay is to the right facing the camera. The photograph was taken from the USS *Monrovia*. The vessel in the background is a Benson-class destroyer providing escort for the transports.

Brigadier General Hobart Gay, Patton's Chief of Staff, and Patton head in toward the Gela Beach, July 11, 1943. The ship in the background is the USS *Monrovia*, Patton's transport for the invasion.

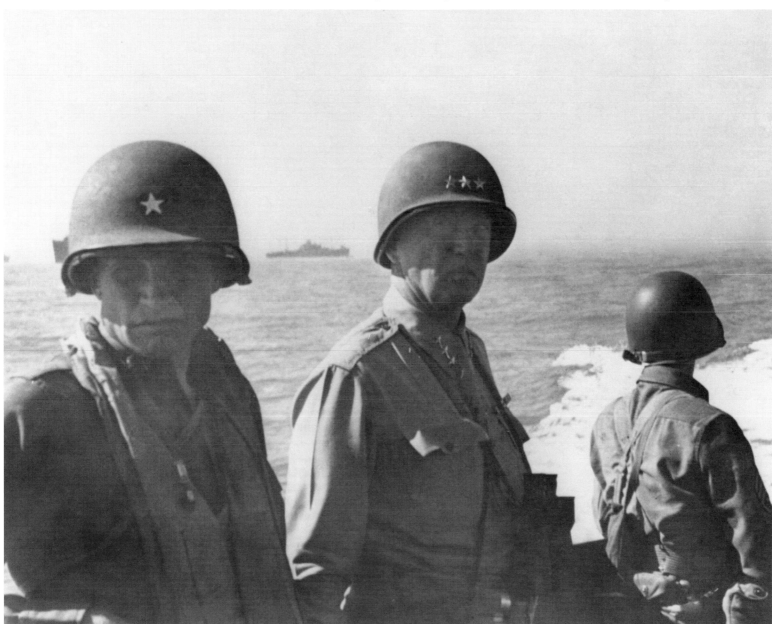

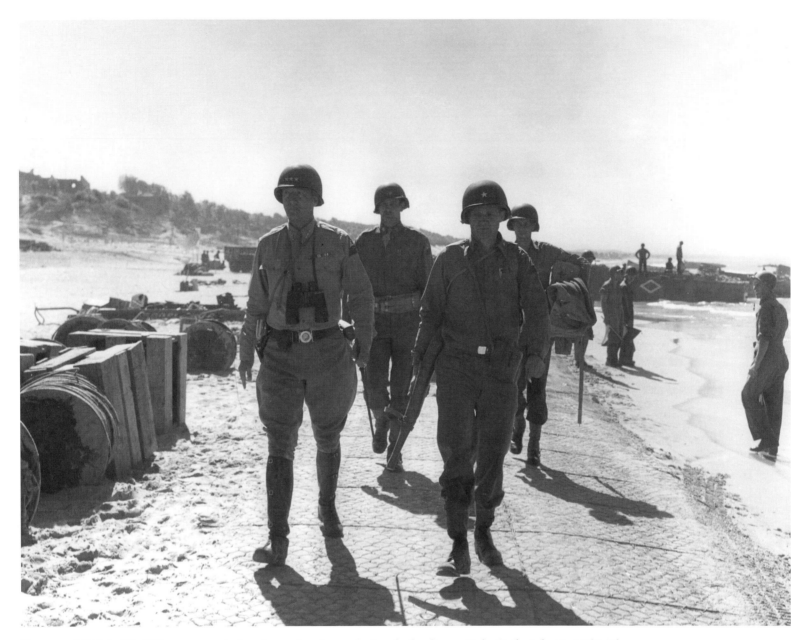

Patton and Chief of Staff Gay traverse the beach on a beach mat during the landing at Gela, Sicily, July 11, 1943. The situation may appear calm, but around the time that Patton landed, the German Hermann Göring Panzer Division was launching a counterattack against the eastern edge of the bridgehead. At one point Patton climbed to the roof of a building to observe the fighting, and could see the enemy maneuvering about 800 yards away. He had to specifically order a Navy liaison officer to put naval gunfire on the coastal road to break up the attack.

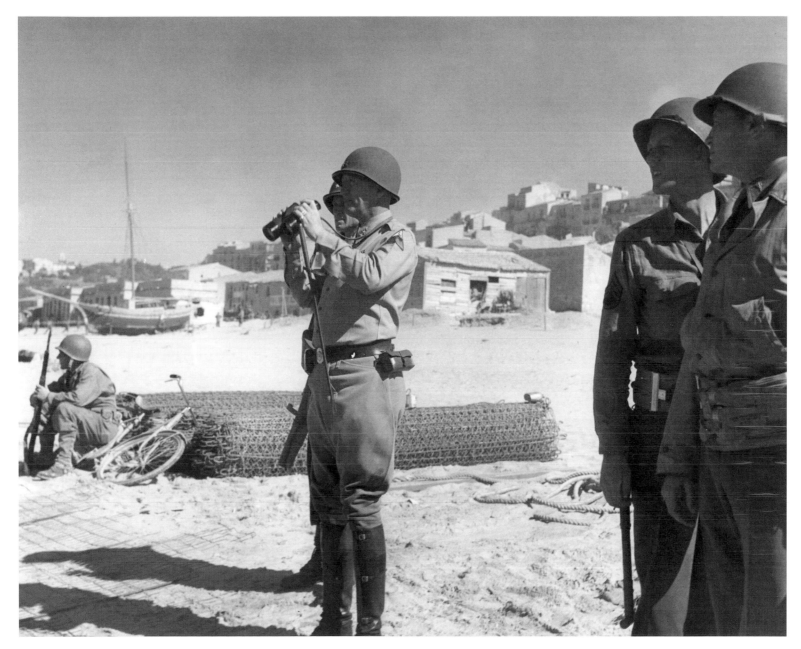

Patton with Brigadier General Hobart Gay (over his right shoulder) on the Gela Beach, Sicily, July 11, 1943. Although Patton was certainly cognizant of the photographer and was posing, his presence on the beach demonstrates his understanding of leadership. Elements of the Hermann Göring Panzer Division were forming to launch a counterattack. Patton believed it was essential to morale for commanders to be close to the battle—men needed to see their leaders risking death or injury the same as they were.

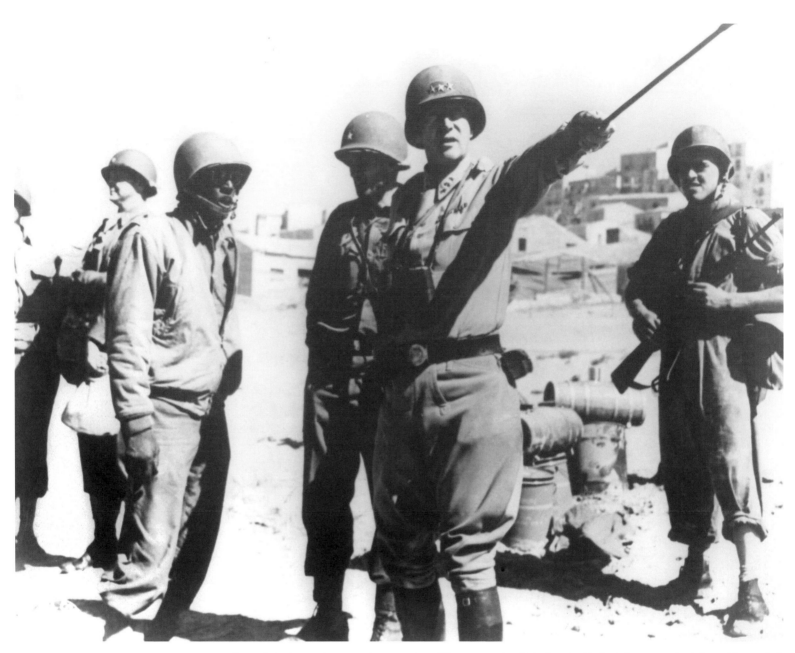

One of the better-known photographs of Patton on the Gela Beach, Sicily, July 11, 1943. The soldier at left appears to be one of the black, or "colored," troops assigned to one of the ordnance units that landed early in the invasion. Although Patton could be a man of strong prejudice, he kept these opinions mostly to himself, instead always praising black units assigned to his commands.

Patton moving through Gela, Sicily, in his command car, along with his Chief of Staff, Major General Hobart Gay, in July 1943. Even during battle Patton would often go off in his command car to "sightsee."

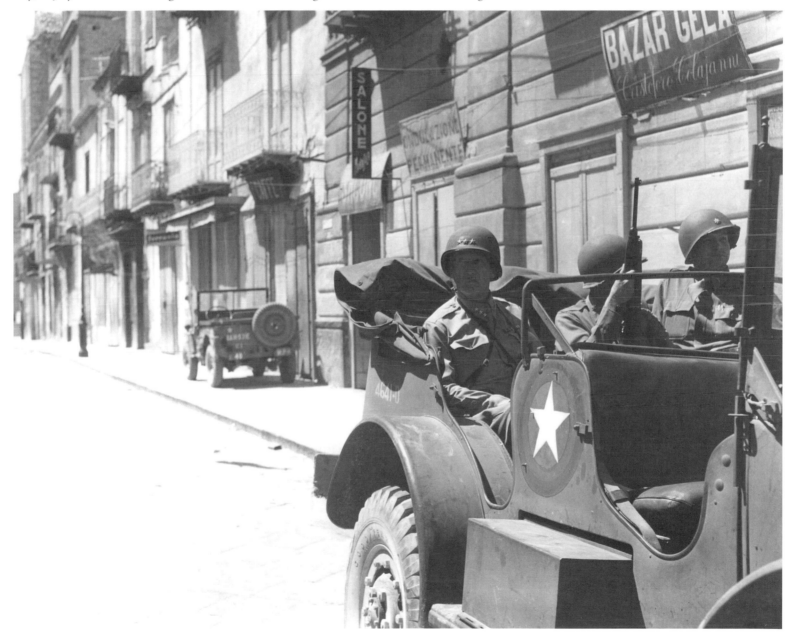

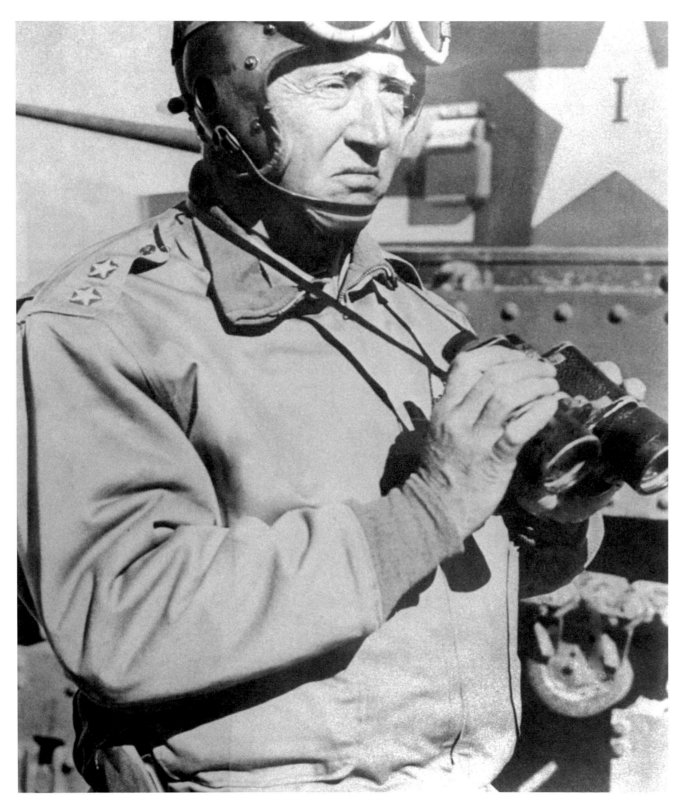

An earlier photograph of Patton, at that time a major general, in a promotional piece about him as the American ground forces commander in Sicily, July 1943. The image was one of a series of shots taken during the Louisiana maneuvers when he commanded the 2nd Armored Division.

Patton discusses the capture of Palermo with his staff and the commander of the 3rd Infantry Division, Major General Lucian Truscott (lower left with goggles), July 23, 1943. Patton had made a bet with a British air officer that his army would capture Palermo by midnight of the 23rd. Instead they took the city on the 22nd. In the backseat is Colonel Paul Harkins, Patton's Chief of Staff for Operations, and Major General Keyes, Patton's Deputy Commander. Keyes is already wearing the patch of the newly forming 9th Armored Division that he had just been assigned to command. He would soon depart for the United States.

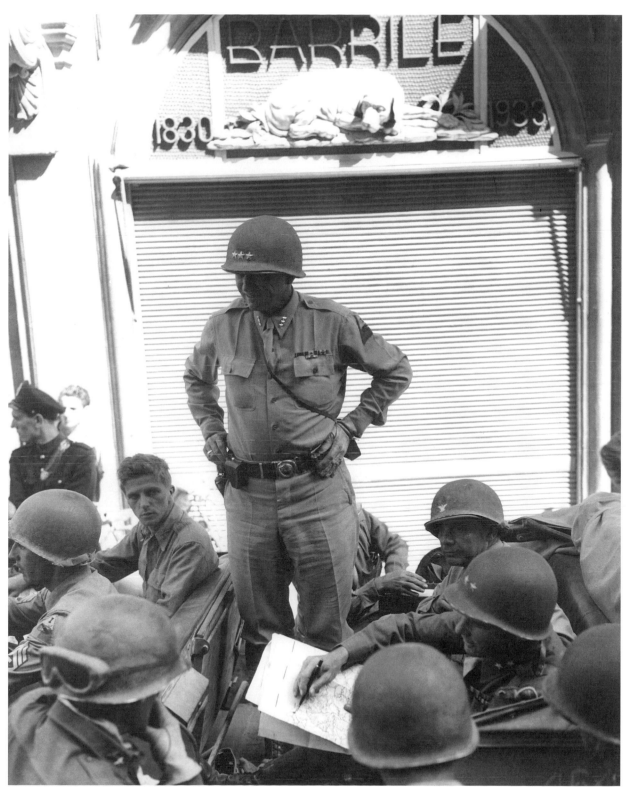

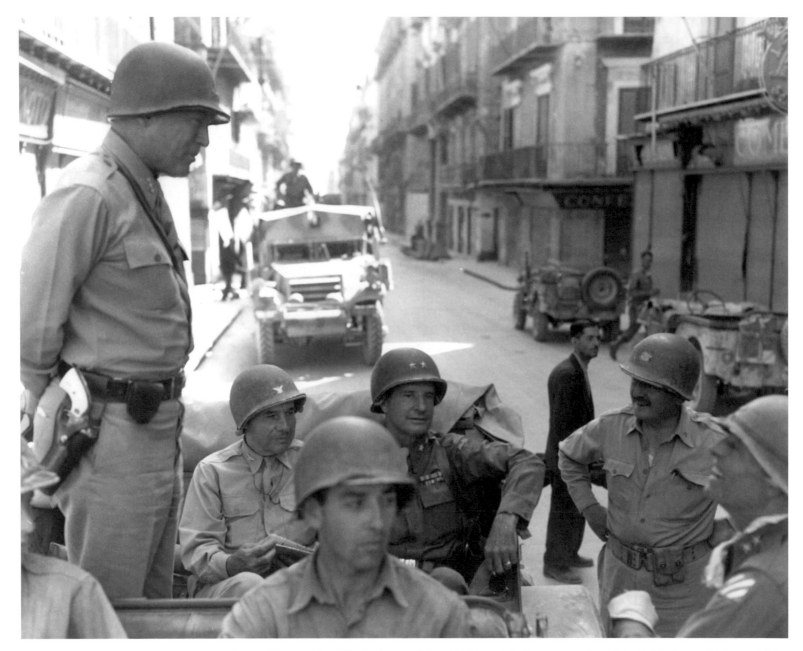

Patton discusses the fall of Palermo, July 23, 1943, with the commander of the 3rd Infantry Division, Major General Lucian Truscott (far right). Truscott was one of the best combat leaders in the U.S. Army, rising to command the Fifth Army in Italy by the end of the war. Truscott, who was Patton's friend, later wrote that Patton "was perhaps the most colorful, as he was certainly the most outstanding, battle leader of World War II" (Lucian K. Truscott, *Command Missions: A Personal Story* [Novato, Calif.: Presidio, repr. 1990], p. 509).

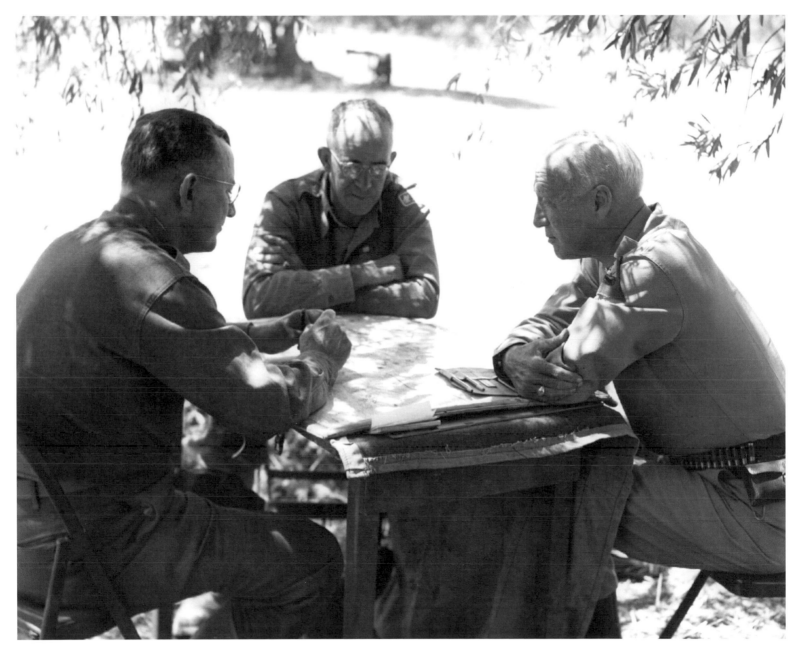

Major General Troy Middleton, Commanding General 45th Infantry Division, and Major General Omar Bradley, Commanding General II Corps, discuss operations with Patton in an olive grove in Sicily, July 25, 1943. The map is in a zippered soft acetate case, which allowed a commander to mark with grease pencils, in this instance in the small case beside Patton's right hand.

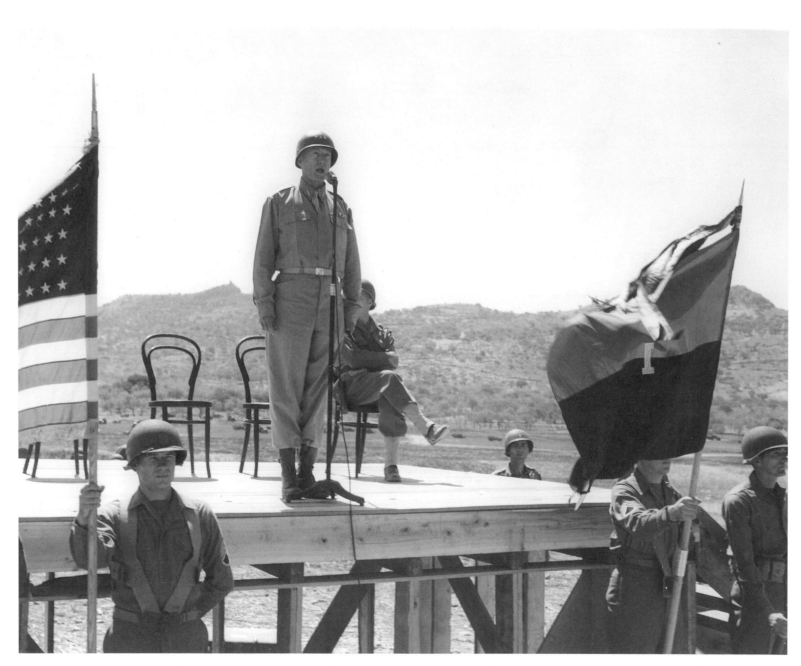

Patton addresses 1st Infantry Division troops somewhere in Sicily. Patton admitted that he was very effective in stirring up men to fight, and there were few in senior leadership who disagreed with him. This was an element of Patton's aggressiveness as a commander. As General Eisenhower once wrote, "Patton's strength is that he thinks only in terms of attack as long as there is a single battalion that can keep advancing" (Alfred D. Chandler, Jr., ed., *The Papers of Dwight David Eisenhower,* vol. III [Baltimore: Johns Hopkins Press, 1971], pp. 1439-40).

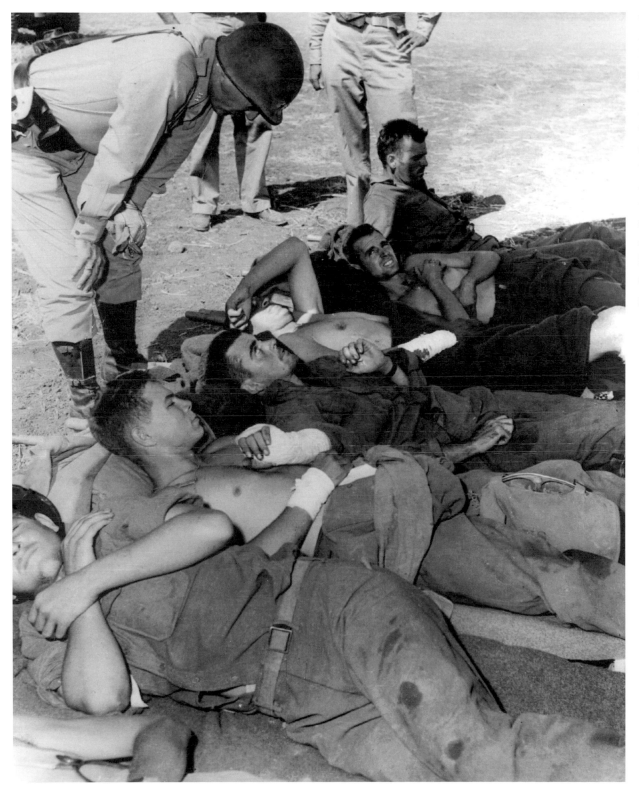

Contrary to the often-noted slapping incidents, Patton felt real concern for wounded soldiers, here talking with wounded men in Sicily, July 25, 1943. Omar Bradley claimed after the war that Patton, who was wounded in battle in World War I, did not understand the psychology of the average combat soldier—a harsh assessment by a man who was never shot at until he was a general in North Africa.

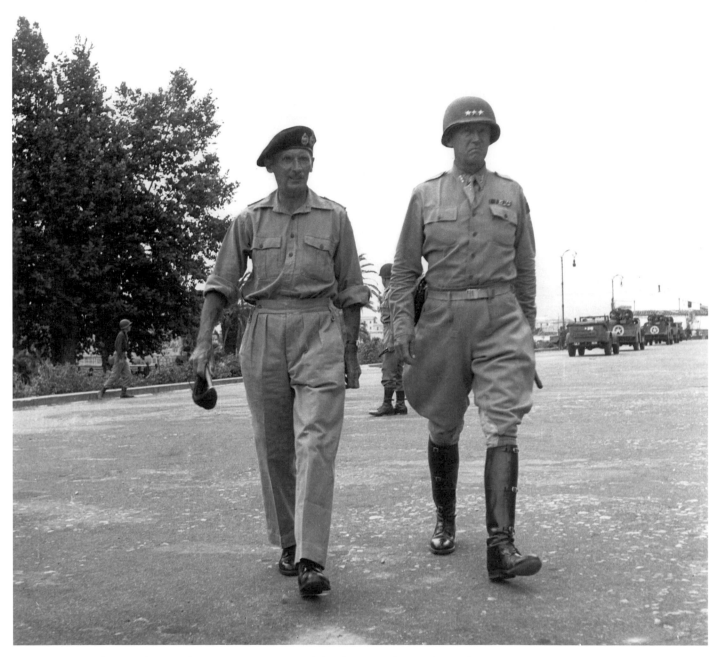

Patton and British general Bernard Montgomery at Patton's headquarters during the Sicily campaign, July 28, 1943. Both men hid their dislike for each other, and Patton believed that some in the U.S. Army were nursing the British to keep such men as Montgomery, who was a hero to the British for defeating Rommel in North Africa, from looking incompetent.

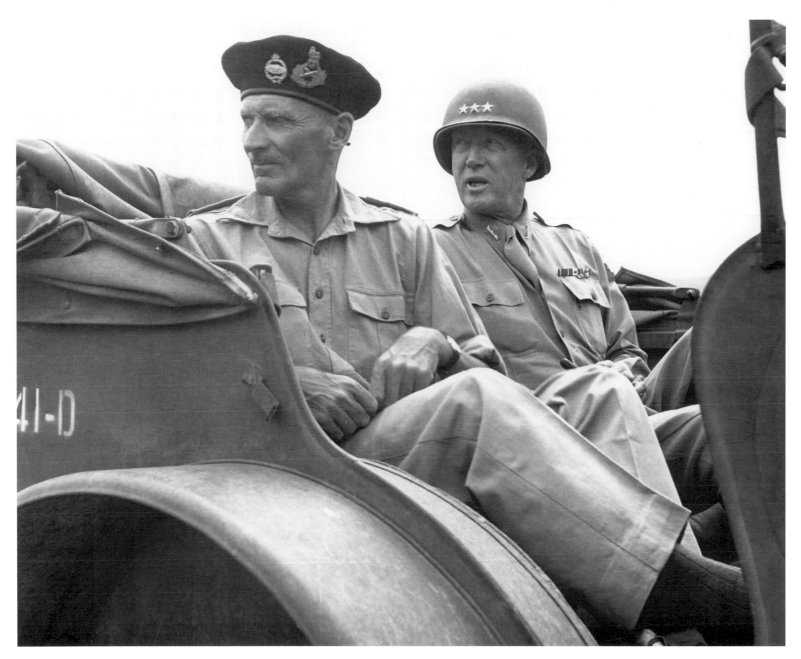

Patton and Montgomery leave for an airfield after the latter's visit to Patton's headquarters, July 28, 1943. Montgomery is improperly wearing the tanker black beret of the British Army. Although many in the United States have associated the black beret with the U.S. Rangers, in fact this beret was the symbol of the tank corps in most countries, which later included the United States up until the late 1970s.

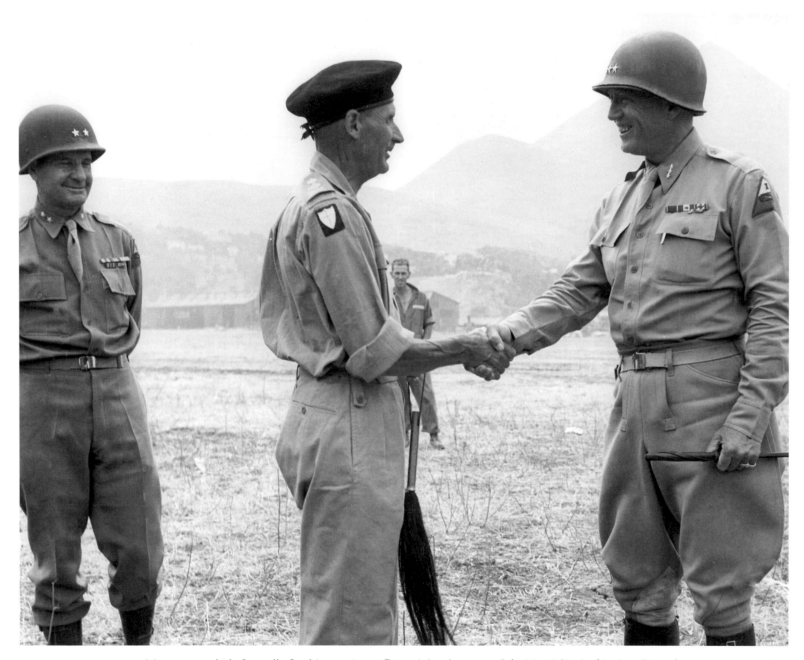

Montgomery bids farewell after his meeting at Patton's headquarters, July 28, 1943. At this time Patton's troops were pressing east toward Messina, while Montgomery's forces were stalled before Catania. Patton was determined to beat Montgomery to Messina, not so much for personal pride but more important for the honor of American arms. As he wrote to Major General Middleton, Commanding General 45th Infantry Division, "This is a horse race, in which the prestige of the US Army is at stake. We must take Messina before the British" (Blumenson, *Patton Papers,* II, p. 306).

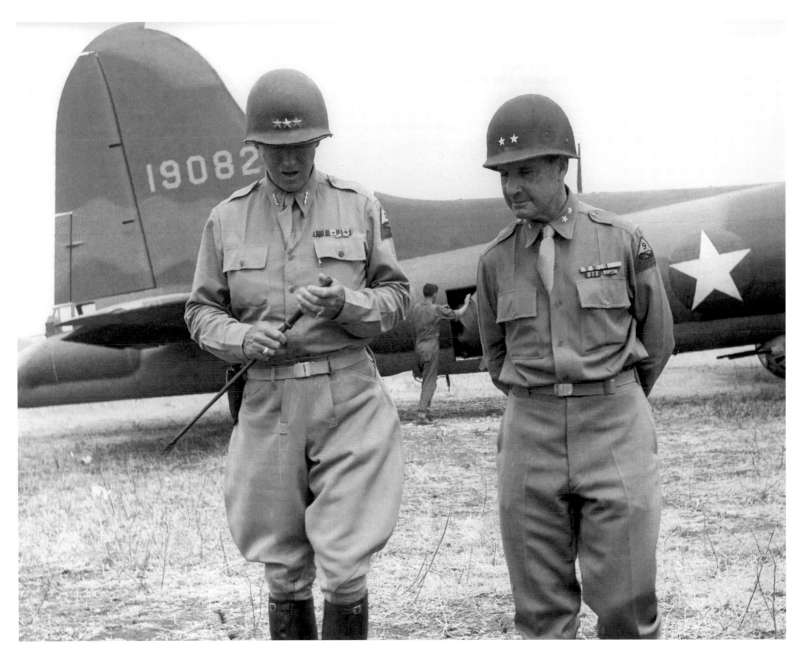

This is a good study of differing uniforms, following the good-byes of Patton and Major General Geoffrey Keyes to British general Bernard Montgomery, July 28, 1943. Patton is wearing the khaki shirt, riding breeches, and cavalry boots, while Keyes is in the olive drab dress shirt and slacks. Keyes had just received his assignment to command the newly forming 9th Armored Division at Fort Riley, Kansas, and already wears the divisional patch. The aircraft is a B-17F bomber, which was occasionally used as a transport.

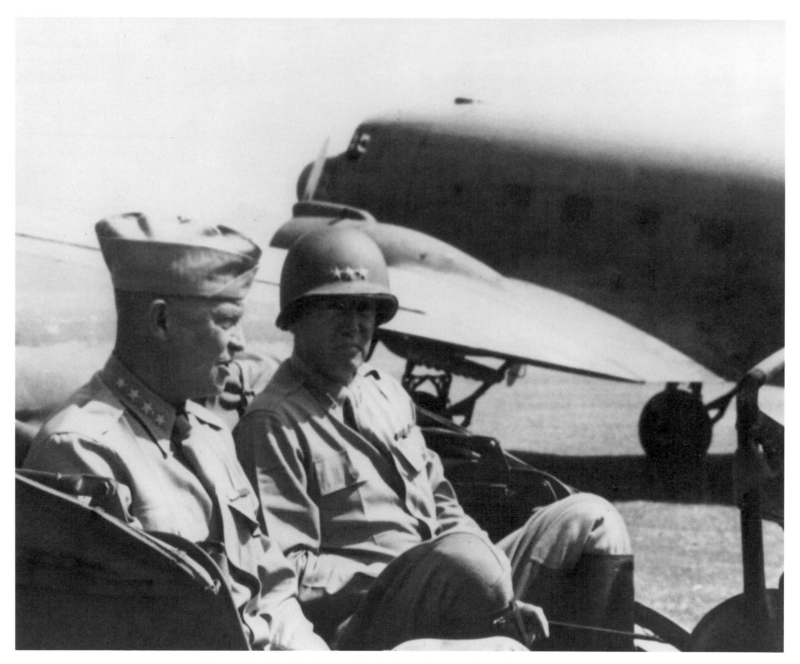

General Dwight Eisenhower, Allied Forces Commander, visits Patton's headquarters near Palermo, July 21, 1943. It was during the Sicily campaign that Patton began to think Eisenhower was growing jealous of him, noting that Eisenhower did not once offer any praise for Patton's work, even though Patton issued a press release praising Major General Keyes for his performance as his deputy. It was also during this campaign that Patton began to call Eisenhower "destiny" in his diary, in reference to how Eisenhower held Patton's future in his hands.

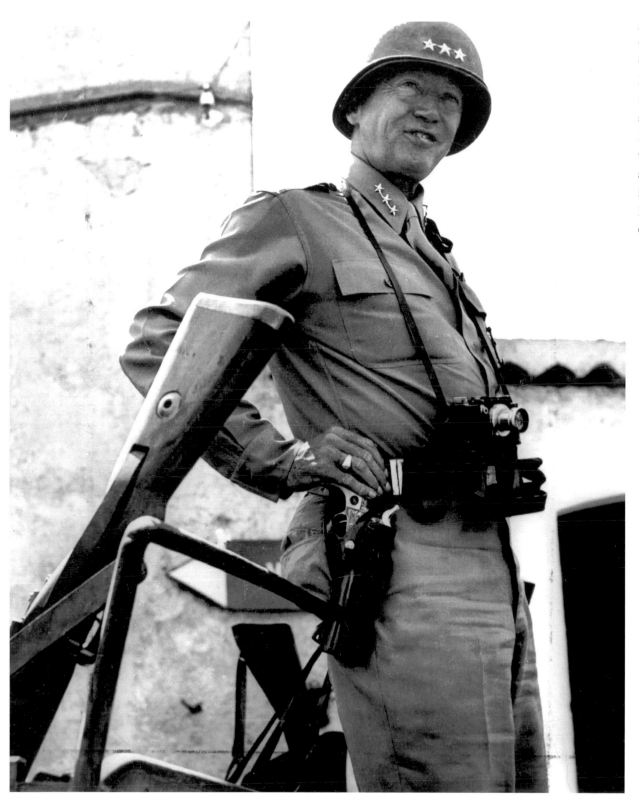

A classic view of Patton with his ivory-handled Colt .45 revolver and his camera. Like his nemesis in the German army, Field Marshal Erwin Rommel, Patton was a reasonably good amateur photographer and ironically used a German Leica from Wetzlar, Germany.

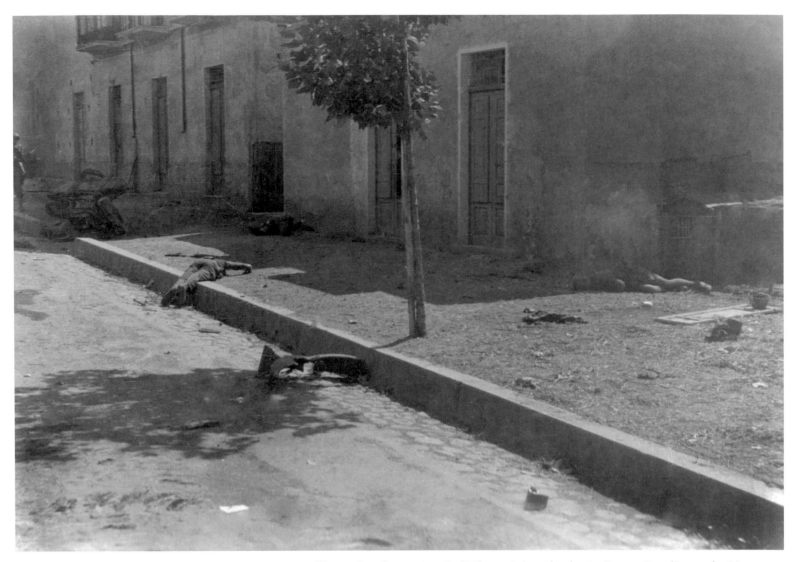

The results of operations in Sicily carried out by the 1st Ranger Battalion under Lieutenant Colonel William Darby, July 1943. Patton took this photograph while following the advance of his men. Darby was mortally wounded while leading an action of the 10th Mountain Division in Italy, April 30, 1945, two days before an armistice was signed to end the fighting in Italy.

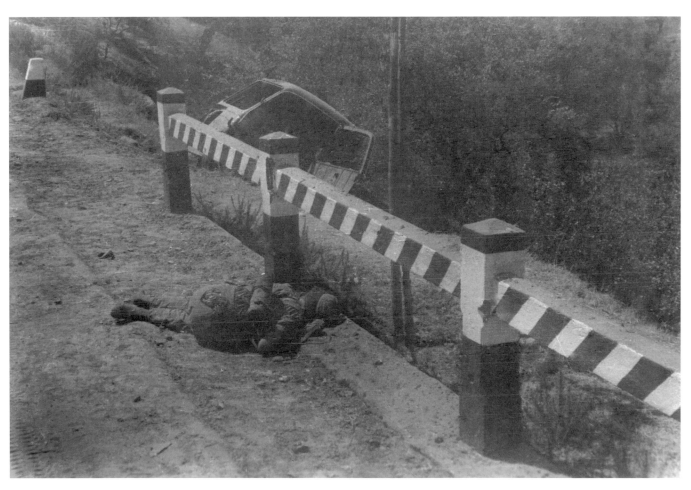

Patton's photograph of a dead Italian soldier in Sicily, July 1943. It is noteworthy that Patton and Rommel, both consummate professional soldiers, found it of interest to take photographs of dead enemy personnel.

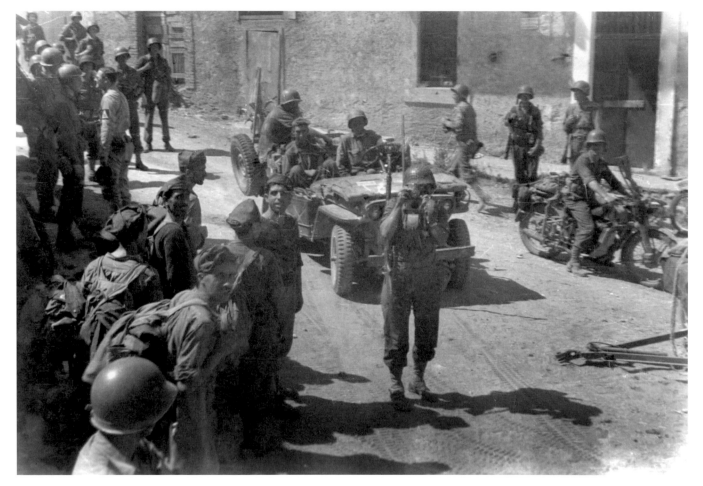

Patton took this photograph of elements of the 2nd Armored Division in
Sicily, passing Italian prisoners of war, in July 1943.

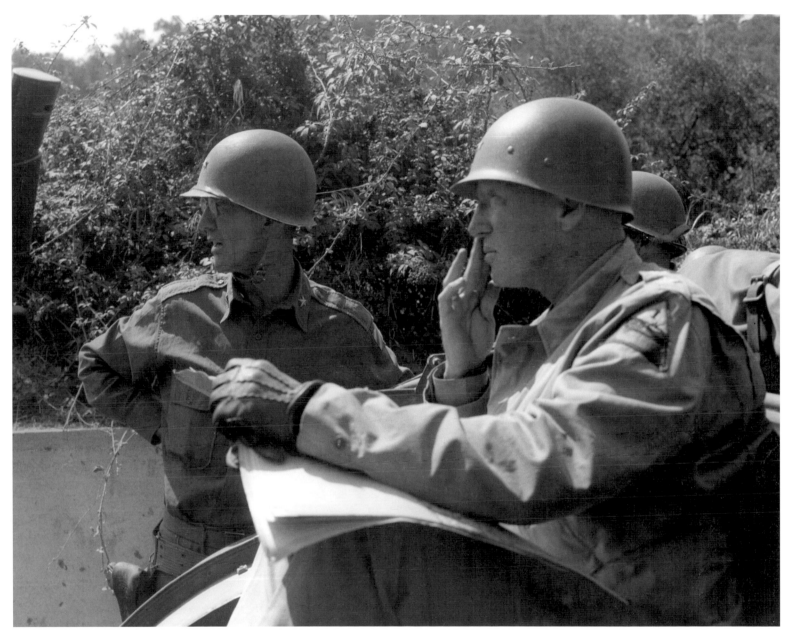

Patton discusses operations during the Sicily campaign with Brigadier General William W. Eagles, Deputy Commander 3rd Infantry Division, in August 1943. Eagles would later go on to command the 45th Infantry Division during the invasion of Southern France in August 1944. Though in a battle zone, Patton often wore the liner of the M-1 helmet, without the steel outer shell, because it was lighter and more comfortable for the neck.

Patton with Colonel Don Carleton, Chief of Staff 3rd Infantry Division, on August 15, 1943. Both men are wearing privately acquired combat boots, which was quite common among many senior officers. In the background between the two men is a one-star general, probably William W. Eagles, Deputy Commander of the division.

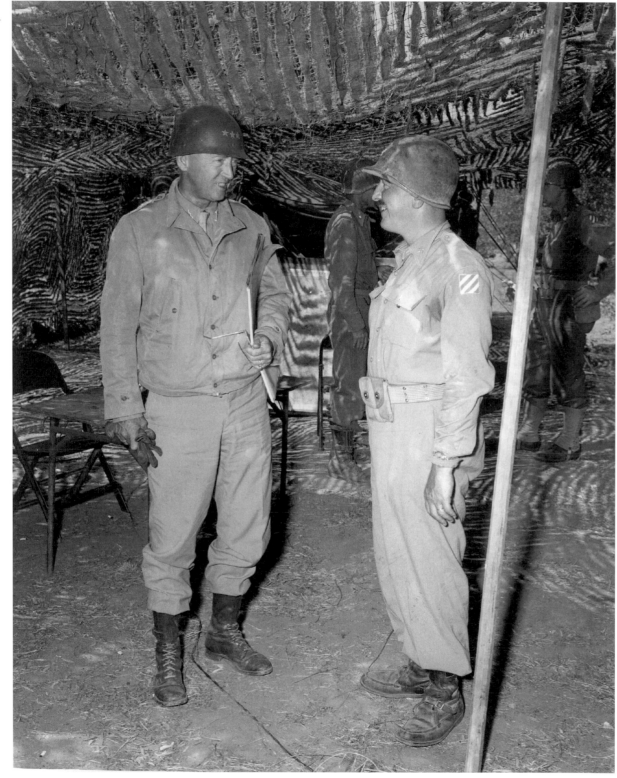

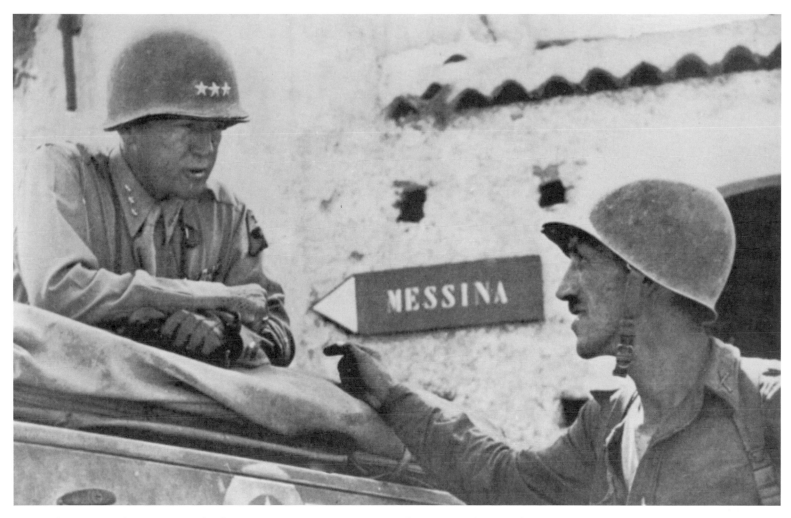

With Palermo secured, Patton turns his forces east to capture Messina, in early August 1943. Here he discusses the operations with Lieutenant Colonel Lyle Bernard, Commanding Officer 2nd Battalion, 30th Infantry Regiment, 3rd Infantry Division. It was his battalion, supported by other elements of the division, which made the first amphibious landing near Sant' Agata di Militello on August 6 and the follow-up landing at Brolo on August 11.

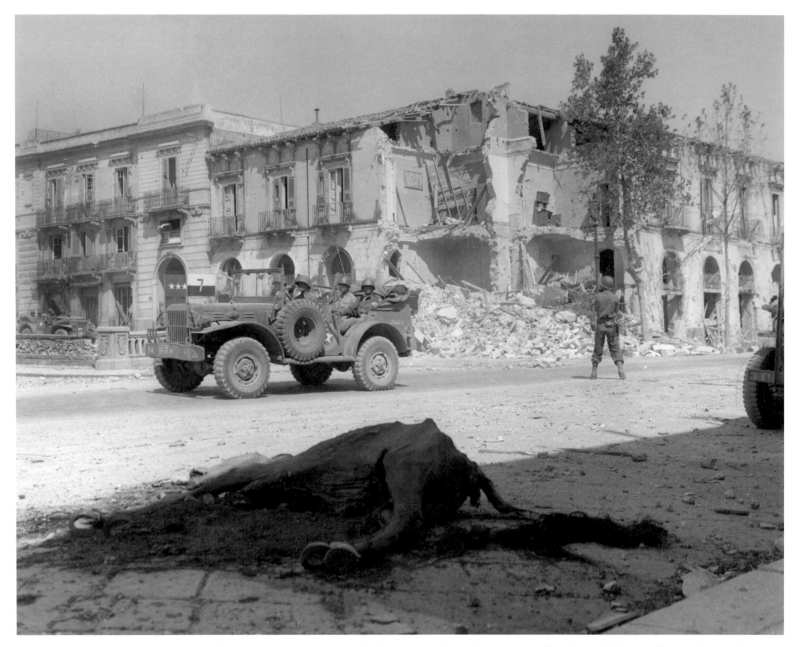

A triumphant Patton enters Messina in his command car, August 17, 1943, along with Major General Lucian Truscott, commander of the 3rd Infantry Division. Contrary to the movie *Patton,* Truscott acceded to Patton's order to launch the amphibious operation at Brolo, pointing out that even if he disliked the orders he would follow them. Patton softened and said, "'Dammit Lucian, I know that. Come on, let's have a drink—of your liquor.' We did. General Patton departed soon after in his usual good spirits" (Truscott, *Command Missions,* p. 235).

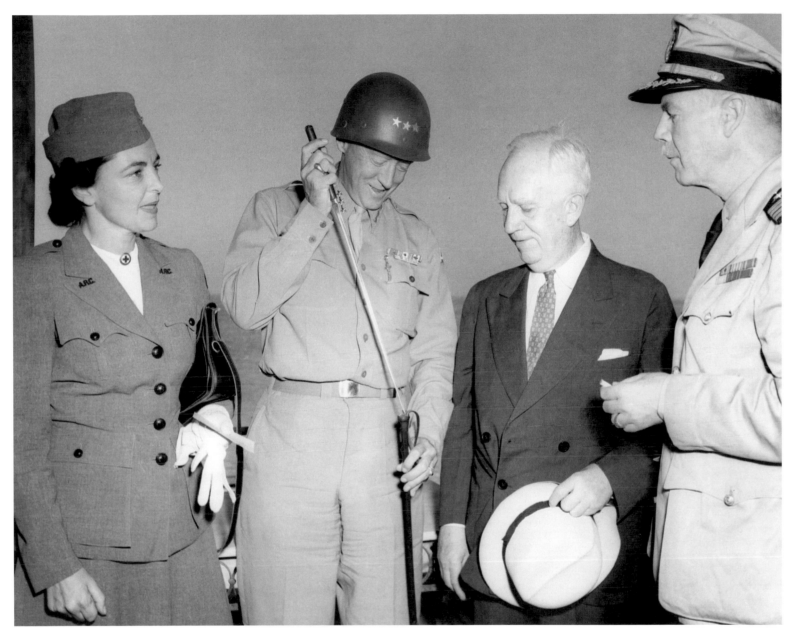

With the campaign in Sicily concluded, Patton got a chance to meet numerous visiting dignitaries, in this case personnel from the American Red Cross on September 12, 1943. From left to right are Mrs. William E. Stevenson, wife of the American Red Cross delegate to North Africa, Patton, Norman H. Davis, National Chairman of the ARC, and Captain Leonard Doughty, Commanding Officer U.S. Navy Operation Base, Palermo. Patton is examining a unique swagger stick!

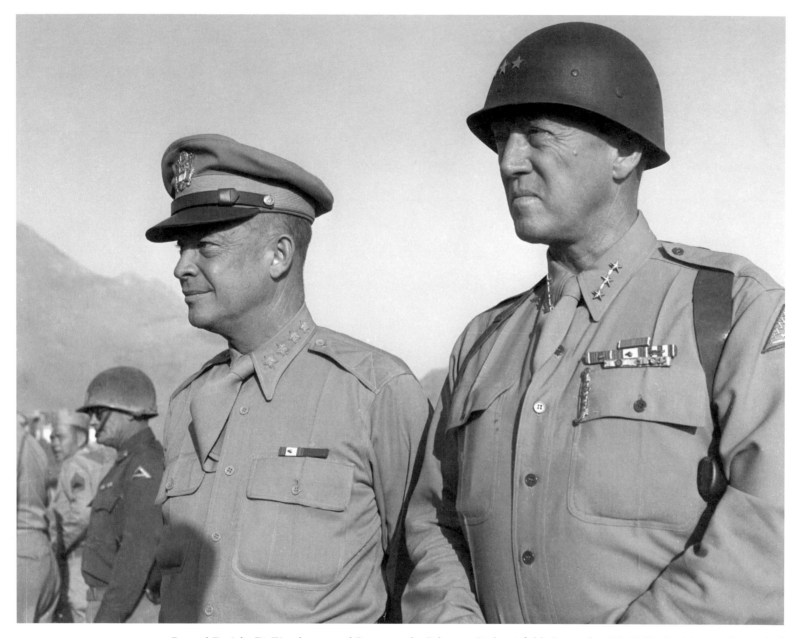

General Dwight D. Eisenhower and Patton at the Palermo, Sicily, airfield, September 17, 1943. By this time Patton had been privately reprimanded by Eisenhower for two incidents in which he slapped enlisted soldiers claiming battle fatigue. Although Patton was not required to go to each unit to make a personal apology, he did so, even if the apologies were somewhat vague in content. Reportedly, when he arrived at Major General Truscott's 3rd Infantry Division, the men began to chant "No, General, no, no," and refused to let him speak. Patton left with tears in his eyes.

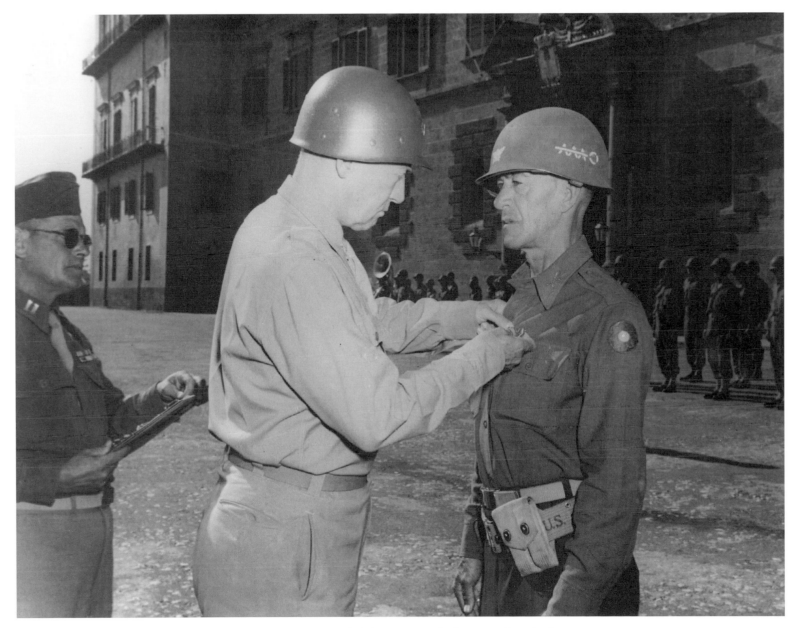

Colonel Harry "Paddy" Flint of St. Johnsbury, Vermont, is awarded the Distinguished Service Cross by Patton on September 19, 1943. Flint was a regimental commander with the 9th Infantry Division, and was a longtime friend of Patton's. He would later be killed in action during the Normandy invasion, July 24, 1944.

Patton cuts the first piece of the victory cake, baked on the occasion of the triumph of Patton's Seventh Army in Sicily. Sergeant T/5 Austin Smith of Macon, Georgia, holds the plate for Colonel "Paddy" Flint. Patton always ensured that those who helped an operation succeed received full credit and even publicity if possible.

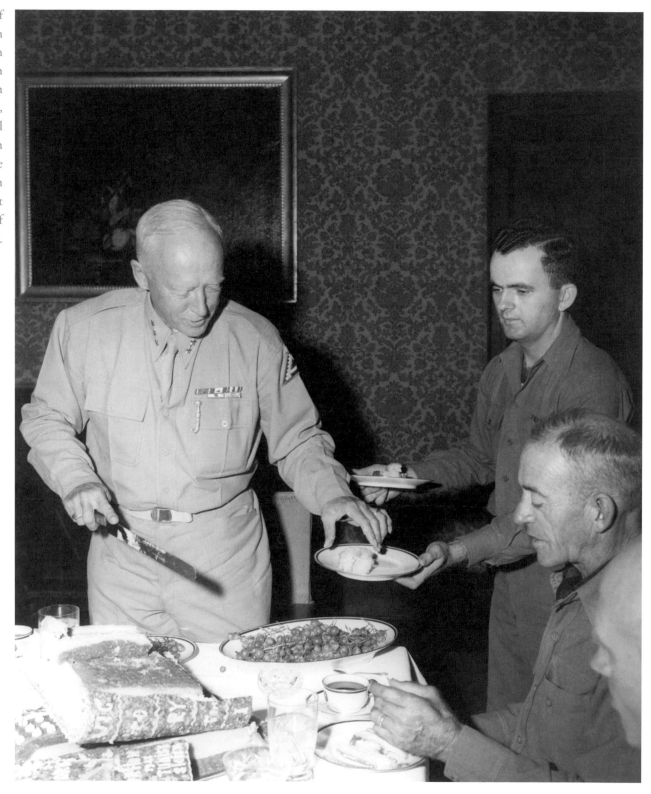

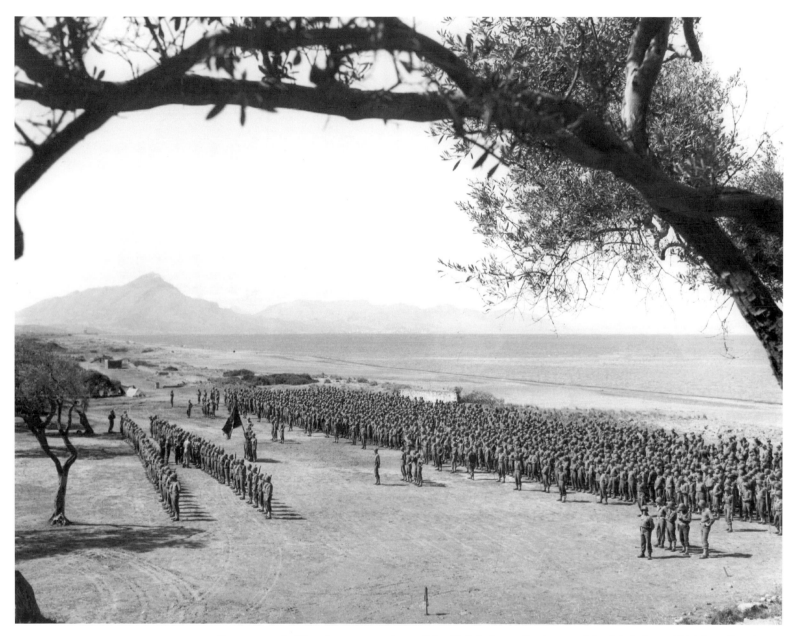

Patton awards Silver Stars to members of the 39th Infantry Regiment of the 9th Infantry Division, October 3, 1943, in Cefalu, Sicily. Noteworthy is how loose and relaxed the men are in formation during the presentation of the medals, especially in comparison with the U.S. Army of today, where soldiers stand at attention as the citations are read.

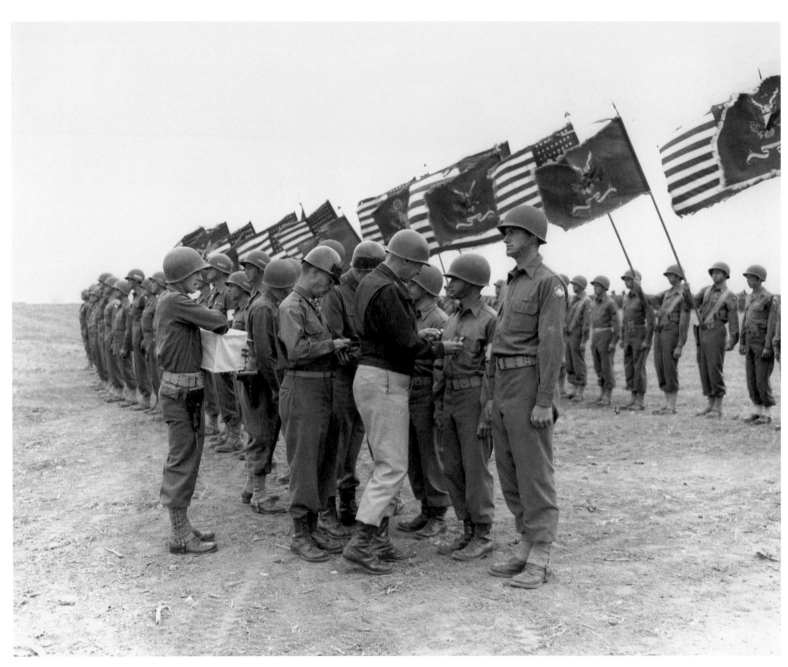

Patton presents the Soldier's Medal to Private First Class Thomas M. Yule, from Clinton, Massachusetts, Ponteolivia, Sicily, October 26, 1943. He was part of the 9th Medical Battalion, 9th Infantry Division. Of further interest here is the different kinds of boots worn by officers and men. Some were still wearing the older shoe with the canvas leggings, while others had the new M-1943 boot, or even the jump boots normally issued only to paratroopers. A censor has attempted to excise the 9th Division's shoulder patch.

Patton shakes hands with Bob Hope, as Jack Pepper, Francis Langford, and Tony Ramono look on, August 21, 1943. Although supportive of entertainment for the troops, Patton expected performers to wear the proper equipment in the field. In France, Patton would threaten to have Bing Crosby arrested for refusing to wear a helmet.

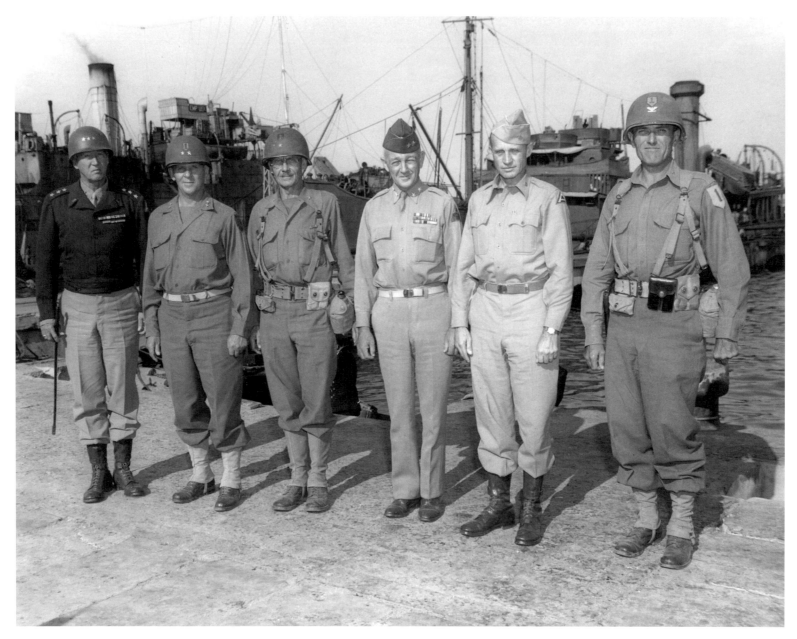

Patton on an inspection tour of the 1st Infantry Division as it prepares to leave Sicily, October 23, 1943. From left to right are Patton, Major General Clarence Huebner, the division commander, Brigadier General Andrews, the deputy commander, Major General Hugh Gaffey, Brigadier General Hobart Gay, and Colonel Willard G. Wyman.

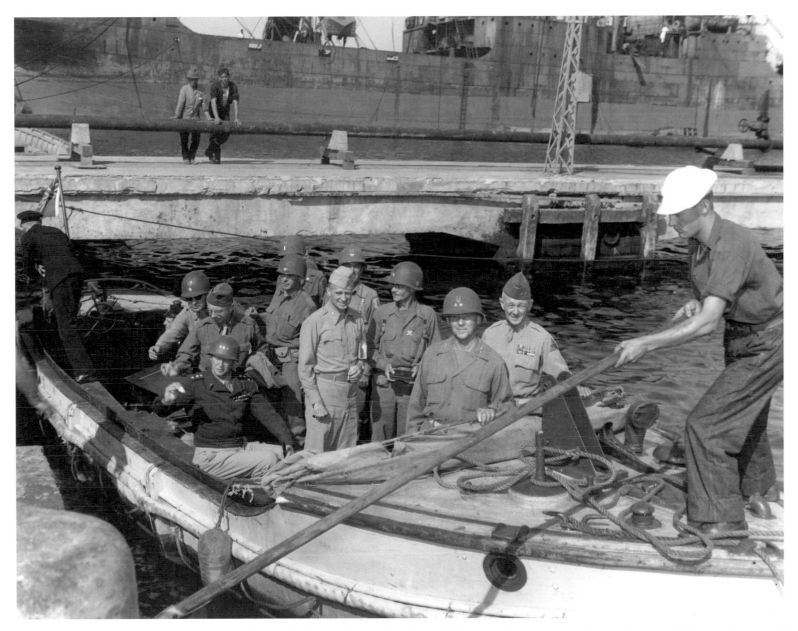

Patton and some of his staff officers, along with officers of the 1st Infantry Division, leave to inspect ship-borne elements of the division prepared to depart Sicily, October 23, 1943. Just behind the oar with two stars on his helmet is Major General Clarence Huebner, the division's commander. Over Huebner's right shoulder is Colonel Andrews, who has just received the Distinguished Service Cross, and over Huebner's left shoulder is Major General Hugh Gaffey.

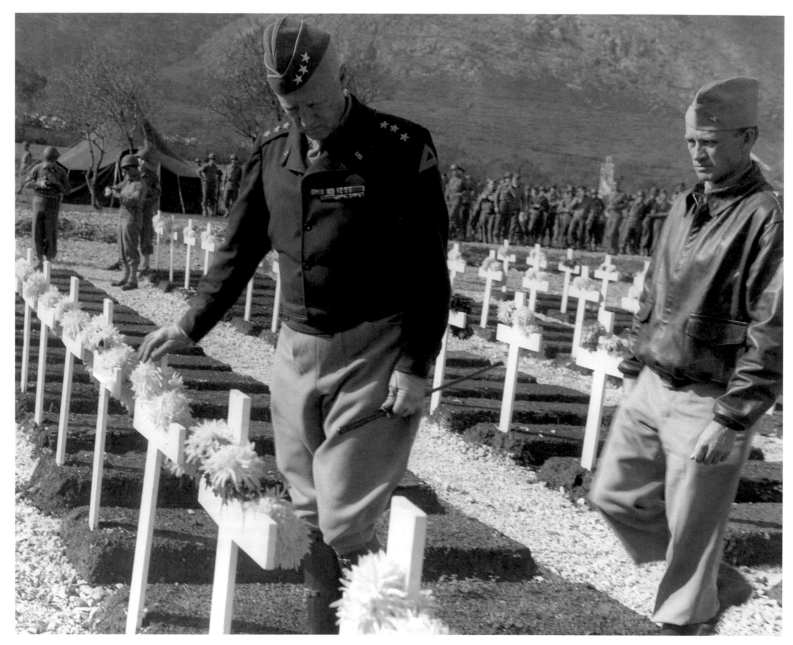

Patton, with Brigadier General Hobart Gay, at soldiers' graves during Armistice Day ceremonies at Military Cemetery #4, Palermo, Sicily, November 11, 1943. At this time, Patton was essentially unemployed, though used by General Eisenhower as a decoy for the Germans in the Mediterranean area. The fact that Patton could serve as a decoy demonstrates the level of respect the Germans had for him.

From left to right are Patton, Colonel Robert Sears, Brigadier General Hobart Gay, and Colonel Paul Harkins, at an Armistice Day ceremony at Military Cemetery #4, Palermo, Sicily, November 11, 1943.

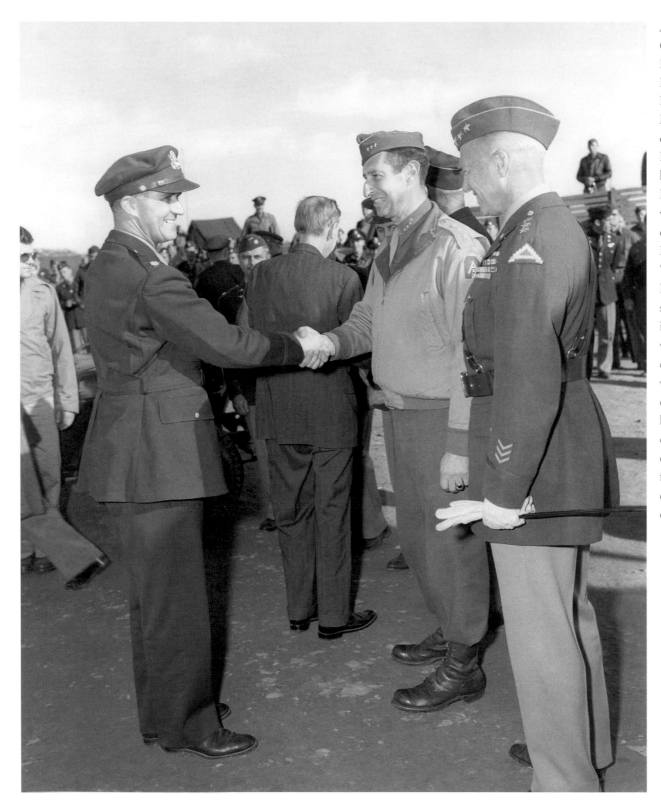

A meeting held at Castelvetrano, Sicily, December 8, 1943. Patton watches as Lieutenant General Mark Clark, commander of the newly formed Fifth Army, shakes hands with Major John Boettiger. In between, with his back to the camera, is President Roosevelt's advisor Harry "the Hop" Hopkins. Patton found it somewhat amusing that, in private conversations with him, Clark would criticize Eisenhower, while Eisenhower would criticize Clark. Neither knew of the other's conversations—Patton, contrary to myth, was far better at keeping confidences than many of his peers.

THE RISE OF AN ICON

(1944–1945)

There is little doubt that the campaign in Western Europe was Patton's ultimate and best destiny, and yet he almost missed it. Two incidents during the Sicily campaign in which he slapped enlisted soldiers suffering battle fatigue marred Patton's moment of triumph and nearly cost him his job. Nevertheless, pragmatic considerations outweighed all others, and Eisenhower kept him on, recommending Patton for an army command in the invasion of France, noting in a letter to Patton that he told invasion planners "that you were the best assault man we had" (Chandler, ed., *Eisenhower Papers,* III, p. 1473).

During the planning for what became known as Operation Overlord, Patton was assigned to command the Third Army, which was to follow the invasion launched June 6, 1944 (D-Day), to secure a foothold on the continent of Europe. As his staff planned for the primary mission to seize the Brittany Peninsula, Patton was also used as a decoy to convince the Germans that the invasion would occur at the narrowest part of the English Channel, the Pas de Calais. Known as Operation Fortitude, this extensive deception operation had Patton in command of the fictitious First United States Army Group, a ruse that sufficed to freeze one German army in the Pas de Calais until it was too late to push the Allies back to the sea in Normandy.

By late July 1944, the American forces were pushing out of Normandy, and Patton's Third Army became operational, attacking out of the beachhead and thrusting into Brittany. Frantic German efforts to stop this offensive at Mortain failed, and the German forces in France were plunged into a rout. By the end of August, Patton's Third Army had crossed the Seine River and had advanced beyond Paris, stretching toward the frontier of Germany. Supply problems caused by lack of foresight and logistical planning by Supreme Command leaders and staff, forced the Allied armies to cease their pursuit of the beaten German forces, allowing them to regroup along their Westwall fortifications, popularly known as the Siegfried Line. Meanwhile, Patton's troops fought mobile tank battles against some of the best armored formations

the Germans could put together in the fall of 1944, and then resumed their offensive in November, pushing right up to the German Saarland. But even as ultimate triumph seemed close to hand, disaster struck to the north, and Patton got his ultimate chance for battlefield glory.

The German Ardennes offensive, commonly known as the Battle of the Bulge, struck a thinly held area of the American lines on December 16, 1944. The best troops the Germans could assemble were thrown into one last attack in a desperate gamble to turn the tide of the war. Patton was now able to demonstrate what true mobile warfare principles were about, as he turned the core of his forces northward and launched a lightning counterattack into the southern flank of the German advance. Crushing the German attack in the Ardennes spelled the end of the German Army. By spring 1945, despite hard-fought battles to the Rhine River and beyond, Patton's Third Army pushed through central Germany and into Czechoslovakia. Patton's last war came to a close.

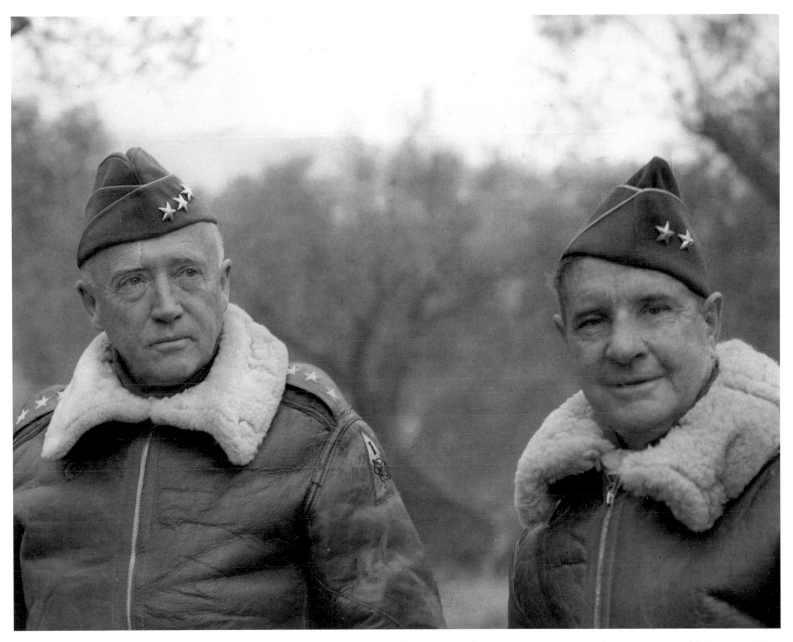

Patton with Major General Geoffrey Keyes at the Presenzano Area in Italy, January 8, 1944. Patton still has the I Armored Corps patch on his coat. He had just been relieved of command of the Seventh Army and was awaiting orders to assume command of the Third Army.

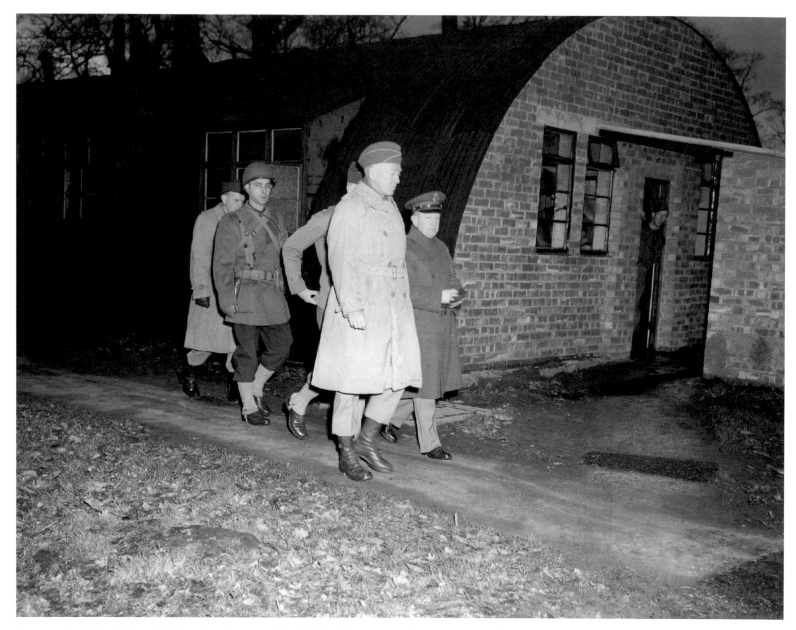

Patton with Colonel Harry R. Vaughan, Commanding Officer Western Base Section, engaged in an inspection tour of Toft Hall, Cheshire, England, January 29, 1944. General Eisenhower had promised Patton an army command for the assault on France late in 1943, and once in England Patton learned that his new command, the Third Army, was to seize Brittany after the initial landings at Normandy.

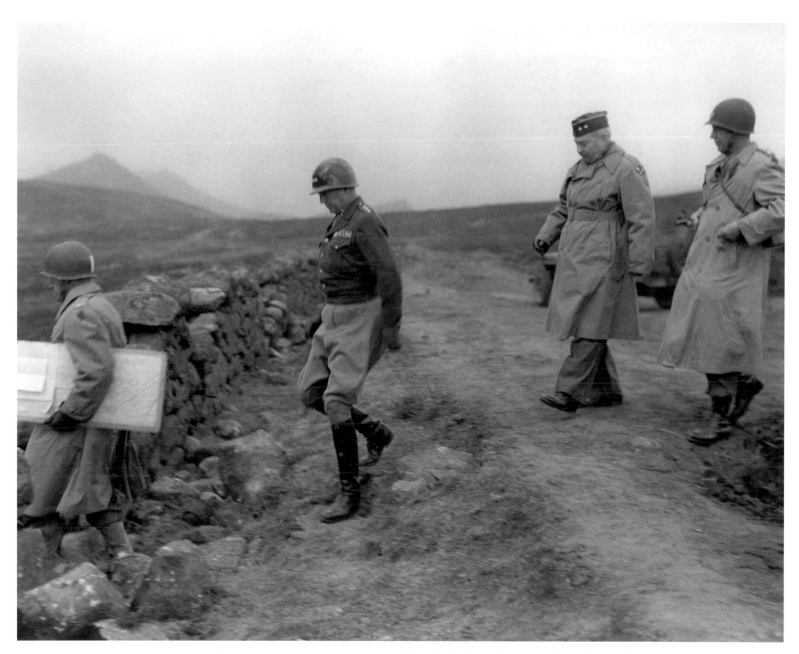

Patton making an inspection tour of the 10th Infantry Regiment, 5th Infantry Division, near Hilltown County Down, Northern Ireland, March 30, 1944. To Patton's right are Major General Wade Haislip, Commanding General XV Corps, and Major General Leroy Irwin, Commanding General 5th Infantry Division.

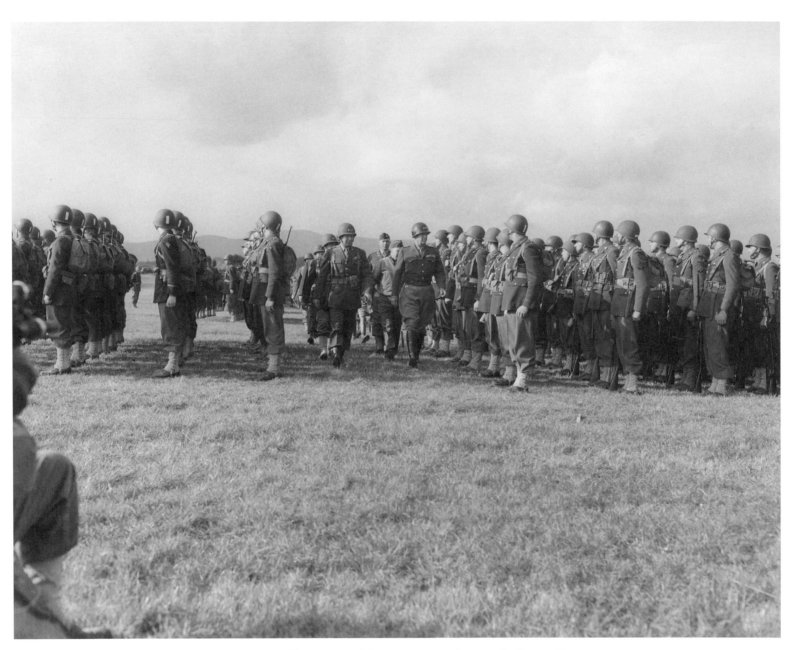

Patton inspects 5th Infantry Division troops as part of his command during a visit in Greencastle County Down, Northern Ireland, March 30, 1944. To Patton's right is Major General Leroy Irwin, Commanding General 5th Infantry Division, and behind him is Major General Wade Haislip, Commanding General XV Corps.

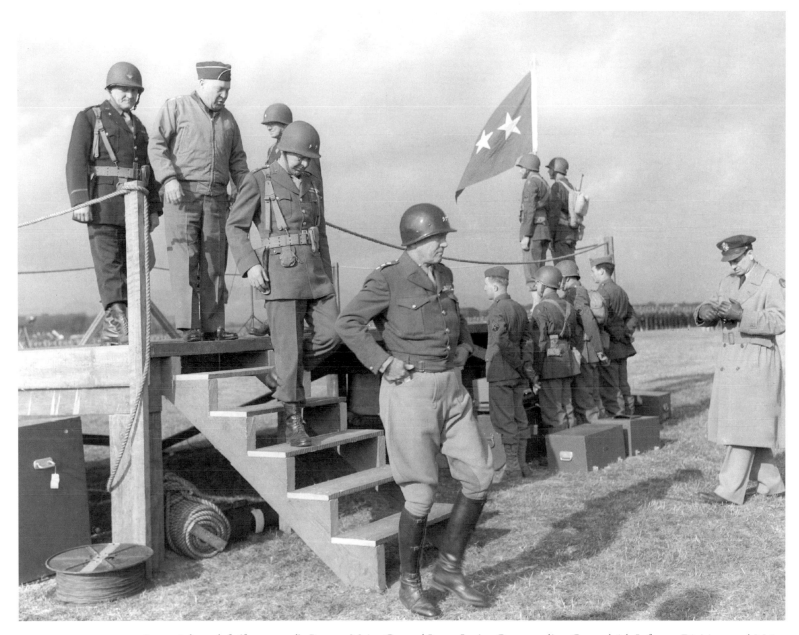

From right to left (foreground), Patton, Major General Leroy Irwin, Commanding General 5th Infantry Division, and Major General Wade Haislip, Commanding General XV Corps. They are leaving a reviewing stand immediately after receiving the pass and review from one of Irwin's units. The three generals offer an interesting contrast in uniforms. While the uniform of most in the lower ranks was standardized, that of general officers varied considerably. Irwin is wearing the standard dress uniform with the combat web gear.

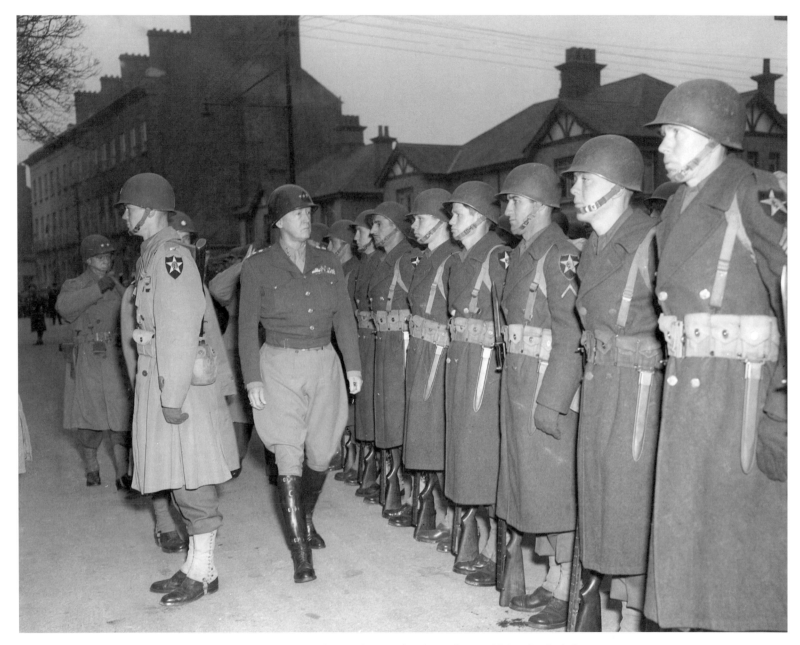

Patton inspects men of the 2nd Infantry Division in Armagh, Northern Ireland, April 1, 1944. To the far left is Major General Walter M. Robertson, Commanding General 2nd Infantry Division. The men have their rifles at order arms with fixed bayonets. Although Patton's peers sometimes mocked his style and uniforms, many rank-and-file soldiers later commented that Patton looked and acted like a real general.

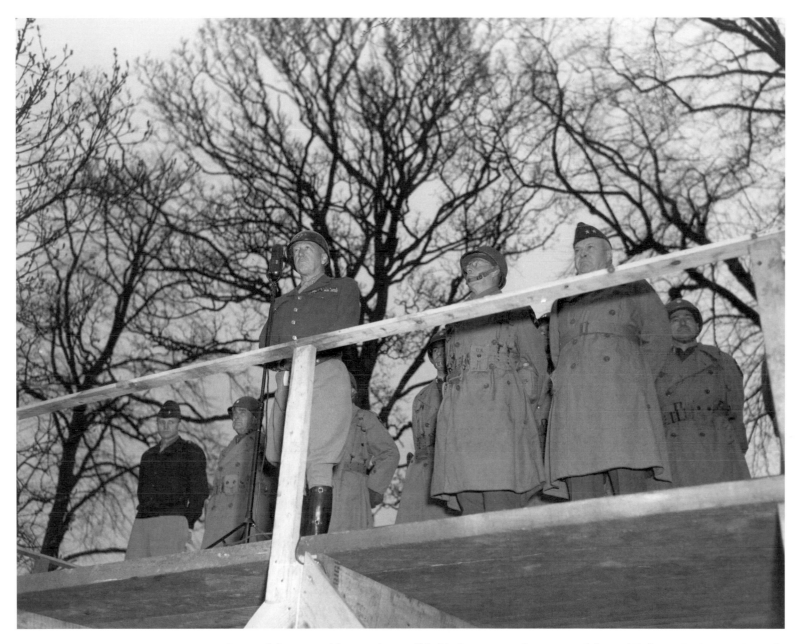

Patton delivers an address, quite possibly his famous speech, to men of the 2nd Infantry Division at Armagh, Northern Ireland, April 1, 1944. On the rostrum, left to right, are Patton, Major General Walter M. Robertson, Division Commander, and Major General Wade Haislip, Commanding General XV Corps. The faithful and ever-present Brigadier General Hobart Gay, a key member of Patton's staff, is at far left.

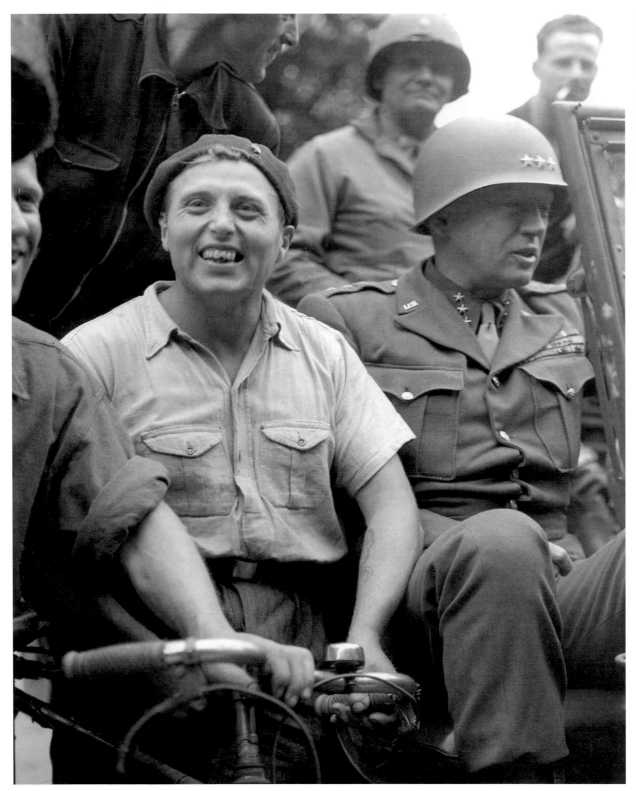

The invasion! Patton was in France by early July and already had his hand in some of the planning for ground operations. Here he is surrounded by local Frenchmen, probably operatives with the resistance known as the Maquis (the bush), July 19, 1944.

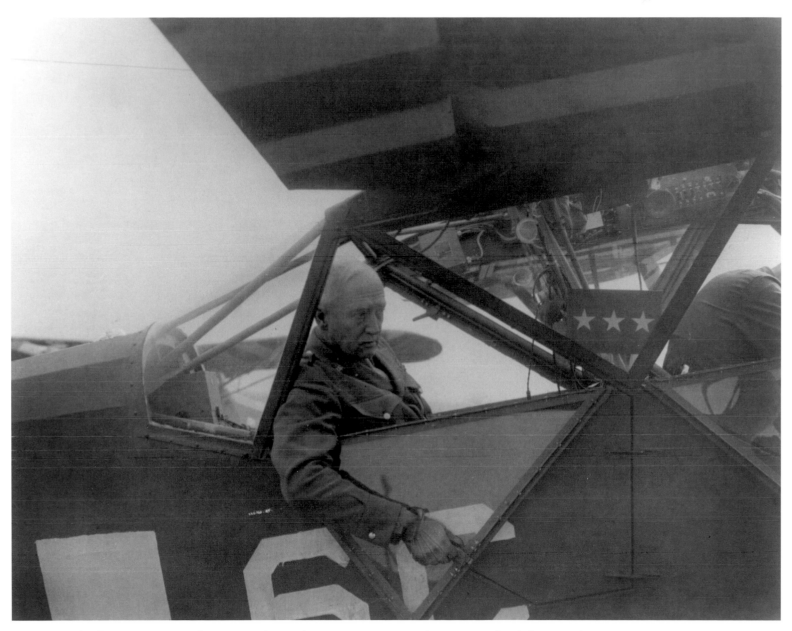

Patton in a Third Army L-5 Sentinel, sometime during the campaign in France. Patton was a firm believer in close air-ground cooperation. It was also not uncommon for him to engage in aerial reconnaissance himself. As he flew over the area where the Cobra aerial bombardment had occurred, Patton noted that the ground in the Meuse-Argonne area during World War I was far more scarred and pitted than the terrain he saw below.

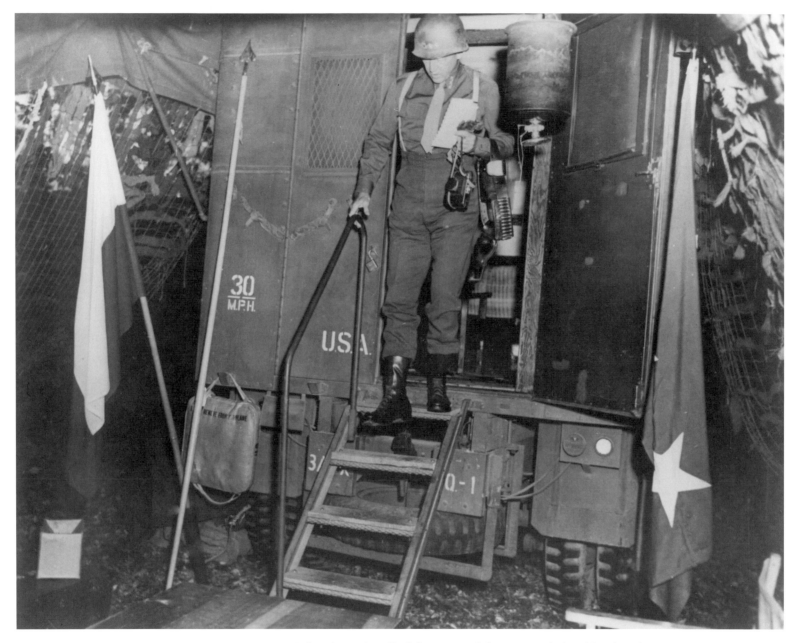

Operation Cobra thrust the Allied forces out of the Normandy beachhead, and once more put Patton back into the limelight as his Third Army drove into Brittany, their primary sector of responsibility. Here Patton leaves his mobile command post trailer with his pistol belt and camera in preparation for a day on the road. Because there were no specific trailers built as mobile command posts, this must be one of the myriad signal or quartermaster trailers normally used as mobile workshops and taken over by Patton's staff.

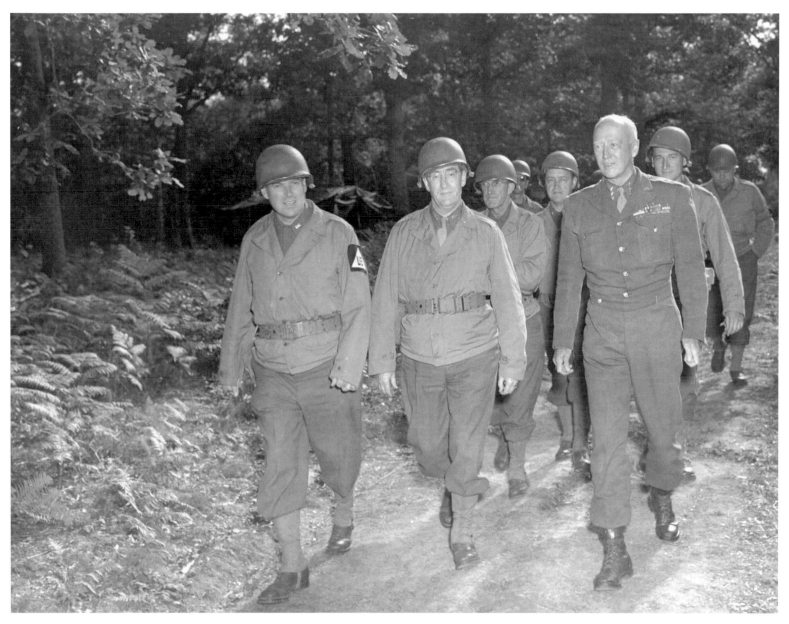

American labor leaders come for an inspection tour of the European war front to gain firsthand information about the usage of American-made combat equipment during the Third Army's dash across France. From left to right are David J. McDonald, President of the United Steel Workers Union, Pittsburgh, Pennsylvania; Sherman H. Delyrmple, President of the United Rubber Workers Union, Akron, Ohio; and Patton, on August 23, 1944. By this time, Patton's Third Army was closing in on Paris and the Seine River.

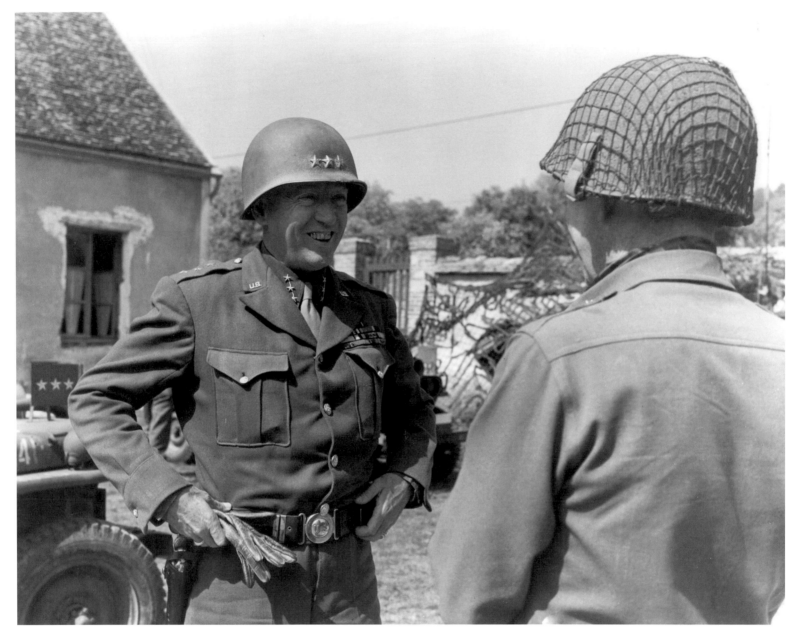

Patton with Major General Leroy Irwin, Commanding General 5th Infantry Division, during the Seine River crossing operations near Fontainebleau, France, around August 25, 1944. The original Overlord plan did not call for an Allied blitzkrieg across France, but once the German Army began to fall apart, Patton's Third Army was detailed to pursue. It is one of the myths of the campaign that there was no fuel available in France. The First Army under Lieutenant General Hodges had 18 times as much fuel to hand as Patton's force did. Much of this fuel was then handed over to the British, who were just beginning their eastward drive.

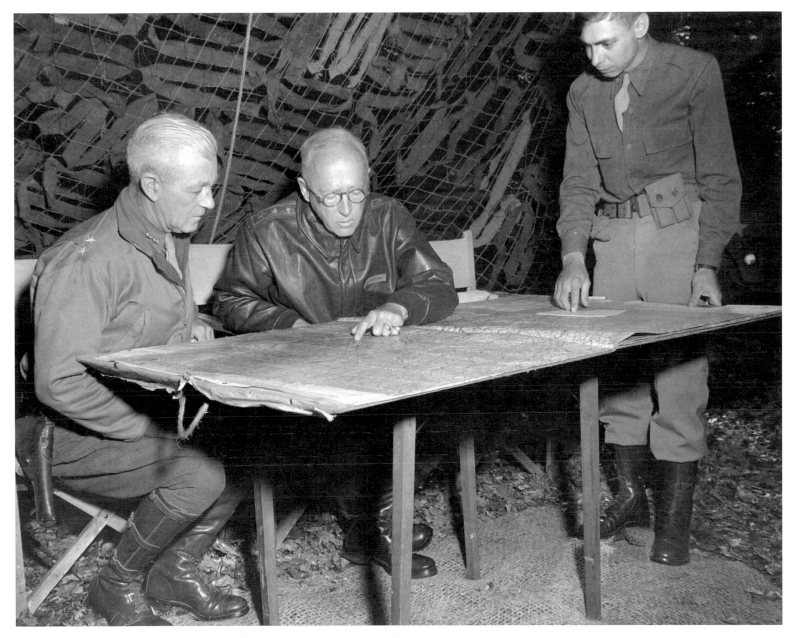

Patton and his Chief of Staff, Major General Hugh Gaffey, with intelligence officer Major M. C. Helfers, discuss German movements opposite the Third Army in the Seine River area, France, August 26, 1944. Patton's XV Corps was poised to liberate Paris, but at the last moment was transferred to Lieutenant General Courtney Hodges' First Army, denying Patton the publicity of taking the city. Major Chet Hansen, Lieutenant General Omar Bradley's aide, noted that "Patton is being given much credit for the advance and particularly for the taking of Paris though it was Hodges' army that took the city" (Chester B. Hansen, *Diaries* [Military History Institute, Carlisle Barracks, Pa.], August 29, 1944).

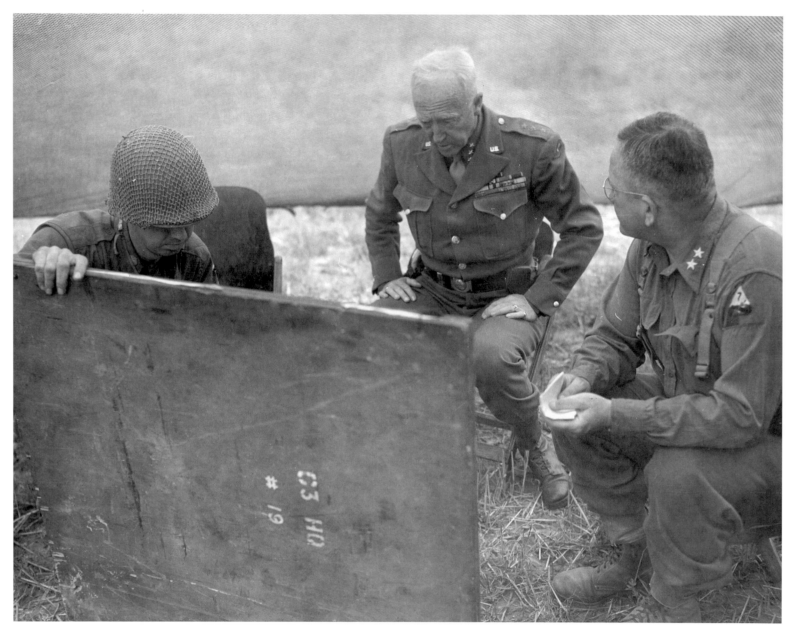

Tired and haggard, Patton discusses the pursuit across France with Major General Lindsay Silvester, Command General 7th Armored Division, probably on August 26, 1944. Patton was none too pleased with Silvester's performance as a combat commander. "I told Silvester very clearly that I was not satisfied with his division, either as to looks or progress, and that he had to do better at once" (Blumenson, *Patton Papers,* II, p. 529). Silvester was later relieved of command when his division came under Lieutenant General Courtney Hodges' First Army.

Patton and Omar Bradley, Commanding General 12th Army Group, during an inspection tour of Patton's far-flung command. They are returning from the Brittany Peninsula, probably in late August or early September 1944. During the pursuit Patton was forced to fly from one end of France to the other to visit his ground commanders, since he had troops fighting to the west in Brittany as well as along the German Westwall to the east.

Patton with the crew of a B-17 that was shot down by German antiaircraft fire during a bombing raid on the German aircraft engine factory at Sindelfingen. They were forced to bail out of their stricken plane and managed to be picked up by an element of Patton's fast-moving force. From left to right are Paul K. Bupp, copilot; H. L. Spencer, pilot; John P. Hensley, waist gunner; Harry J. McCrasseh, bombardier; L. G. Spillman, tail gunner; John L. Houk, radio operator; Thomas F. Jenkins, engineer; Jack Spratt, ball turret gunner; and Sargeant J. Ableman, navigator. One waist gunner is missing. The crew received a bronze star and was flown home in Patton's private C-47.

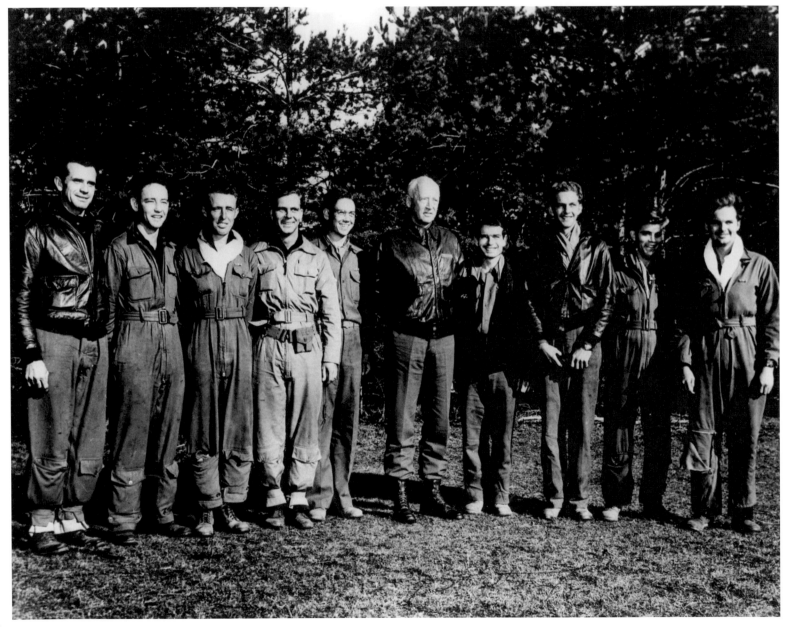

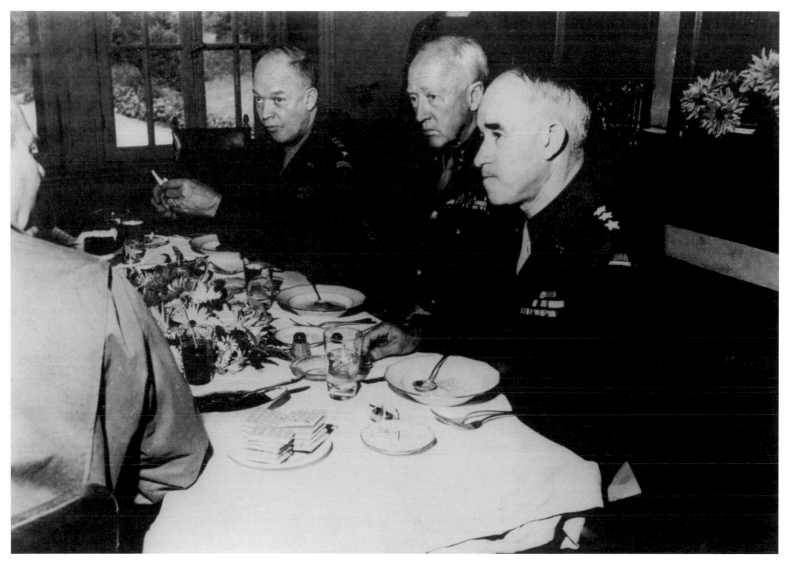

In France, Eisenhower, Patton, and Bradley confer over dinner, in late summer 1944. By this time Patton was becoming increasingly frustrated with Eisenhower's conduct of the campaign, in particular his favoritism toward the British.

Patton and Bradley compare trick Egyptian rings given them by Lieutenant General Carl Spaatz, Commanding General U.S. Strategic Air Forces in Europe, at Patton's headquarters, September 21, 1944. By this time the Allied drive eastward had stalled, largely because there were not enough trucks to move fuel from Normandy to the front. At one point during the pursuit, Patton's Third Army was making wide use of captured fuel and food to maintain the pace of their advance.

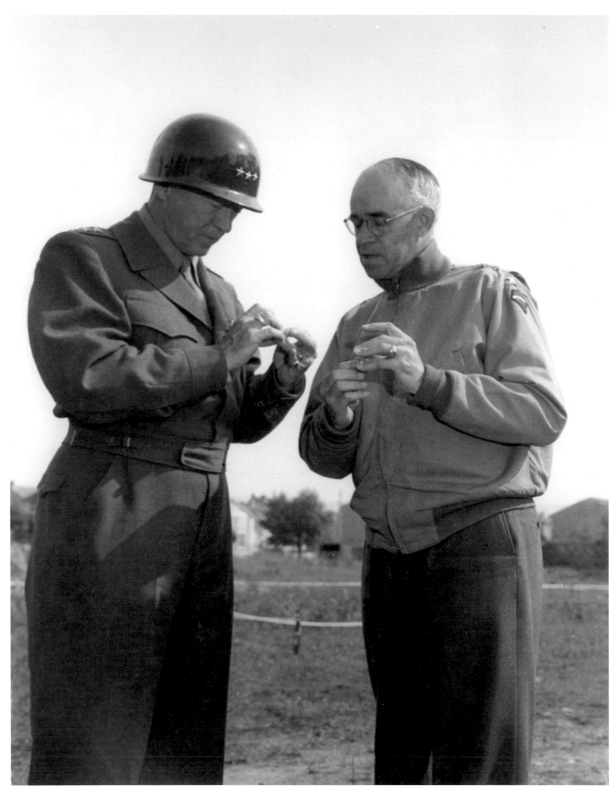

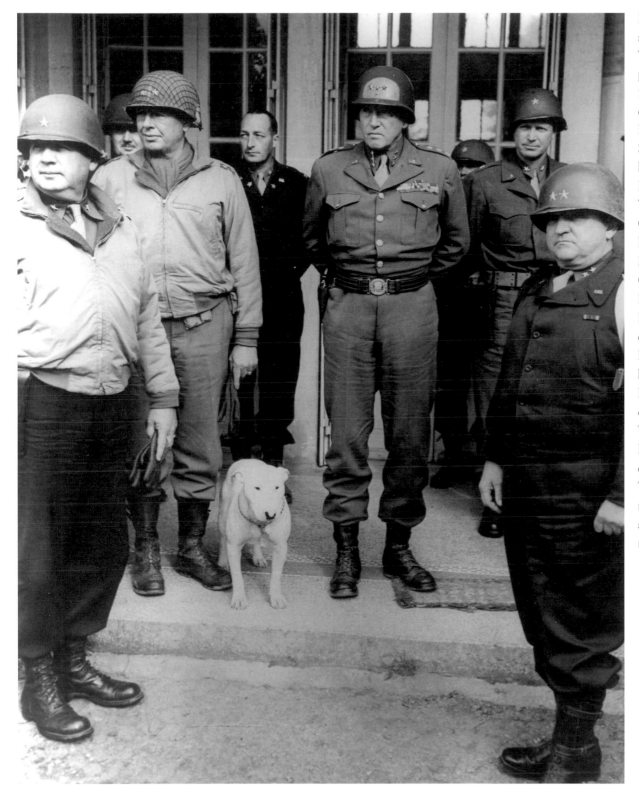

Patton with some of his staff and commanders at Third Army Headquarters, probably during the 5th Infantry Division's crossing of the Mosel River at Arnaville, in early September 1944. From left to right are: (probably) Brigadier General John Thompson, Commander CCB 7th Armored Division, Brigadier General Walter Muller, Patton's G-4, Major General LeRoy Irwin, 5th Infantry Division, Colonel Paul Harkins, Patton's Chief of Staff of Operations, Patton with dog Willie at his feet, Brigadier General Hobart Gay, Patton's Chief of Staff, and Major General Walton Walker, XX Corps. In a misunderstanding during the crossing, Thompson would be relieved of his command and reduced in rank, but reinstated after the war.

By October 1944, battle lines had become stable close to the German frontier. The XX Corps under Major General Walker therefore began the task of reducing the fortifications at Metz, while the XII Corps led by Major General Eddy slugged their way east of Nancy. Here Patton observes XII Corps operations along with Eddy, October 8, 1944.

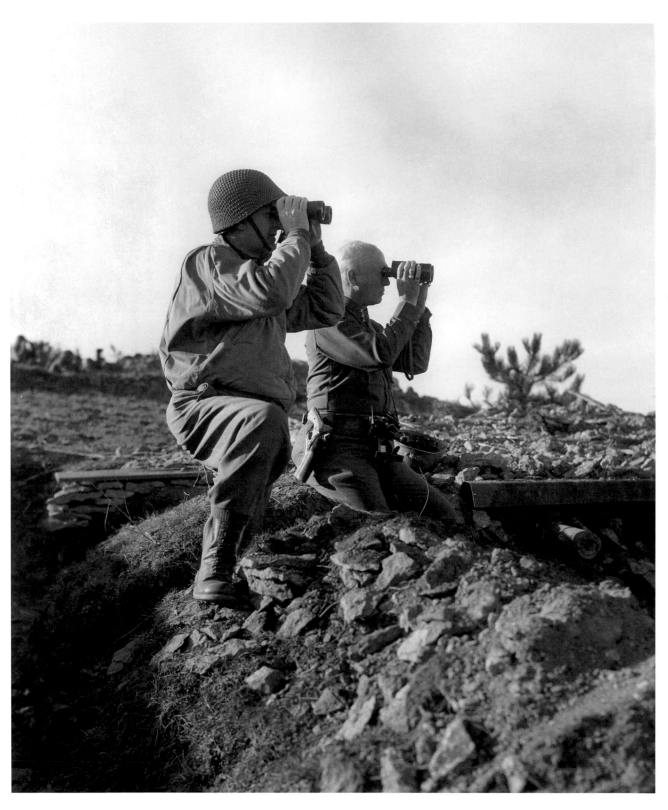

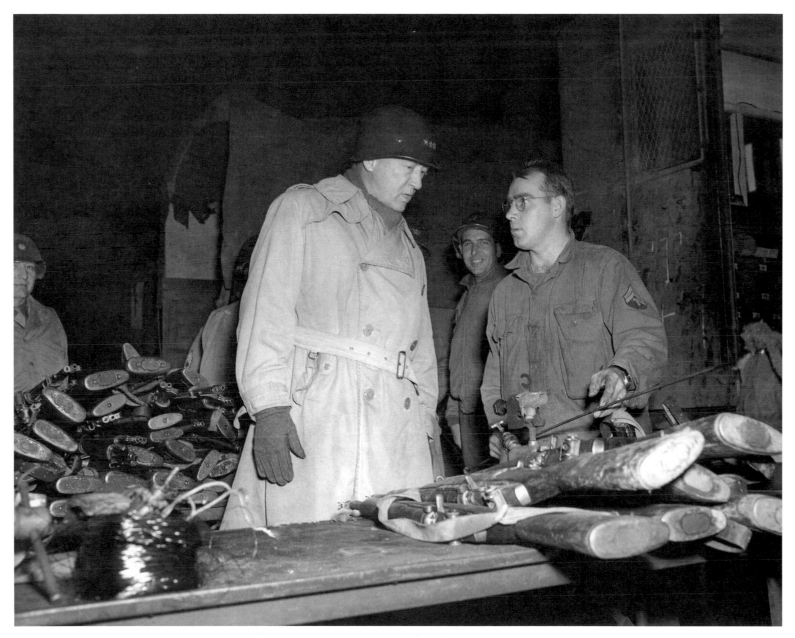

Patton discusses repair work on M-1 Garand rifles with Private Thomas Rayburn of Memphis, Tennessee, and Corporal John J. Reidy of Woodside, New York, on October 25, 1944. Keeping an army in the field required a constant stream of men, supplies, and weapons. Inoperative and battle-damaged equipment was sent to special depots for cannibalization and repair to be sent back to the front.

Ordnance Sergeant
Maurice Baker of
Providence, Kentucky,
explains to Patton the
means to inspect the
Continental radial
engines of M-4 Sherman
tanks, October 25, 1944.
Although many praise
the German tanks such
as the Panther and Tiger,
the M-4 Sherman ranks
as one of the great tanks
of the war. Because
maintenance shops
moved with the army,
American tank battalions
were typically able to
maintain an operational
readiness of over 95
percent, compared with
the German Panther
battalions' 74 percent.

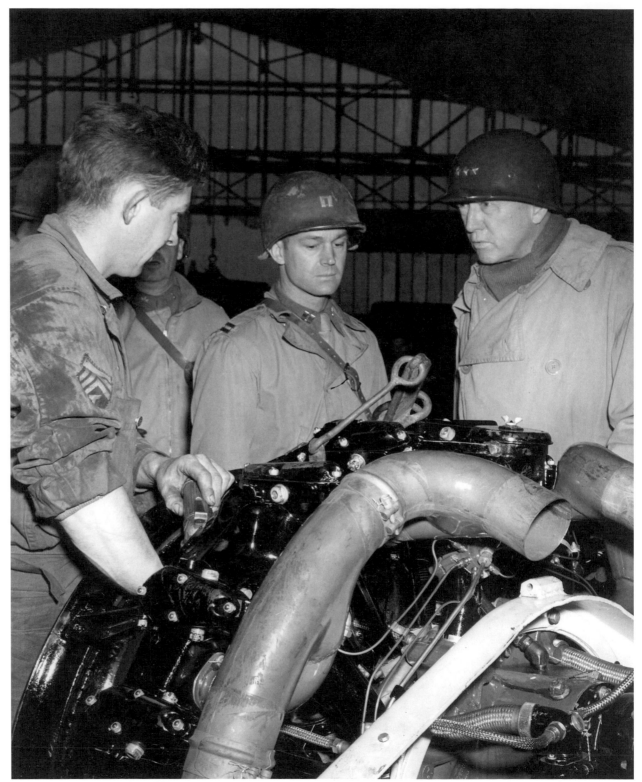

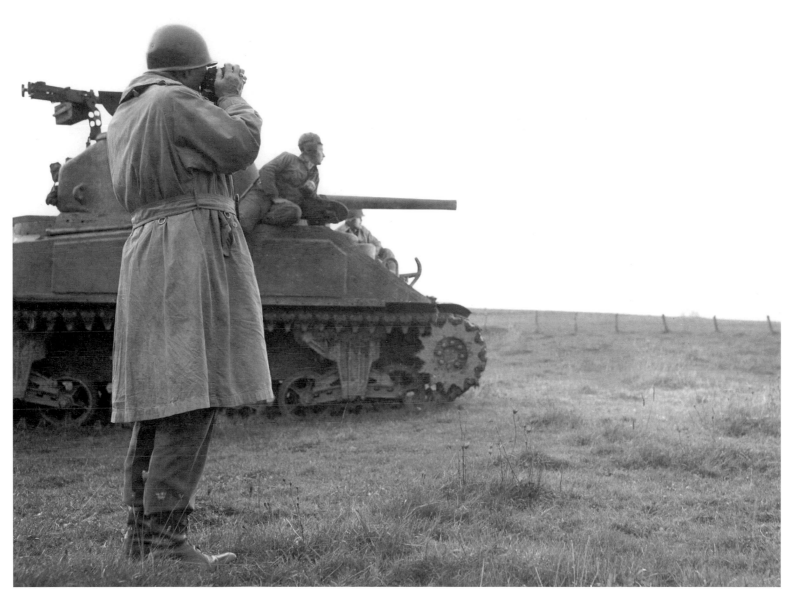

By late October, the Allied forces were preparing for their next operational surge eastward. Here Patton takes a photograph of a flame-throwing tank demonstration during the lull in the fighting (October 25, 1944).

Patton stands on a typical Lorraine street. While friendly to the people, Patton
considered Lorraine to be a wet and filthy region of Europe.

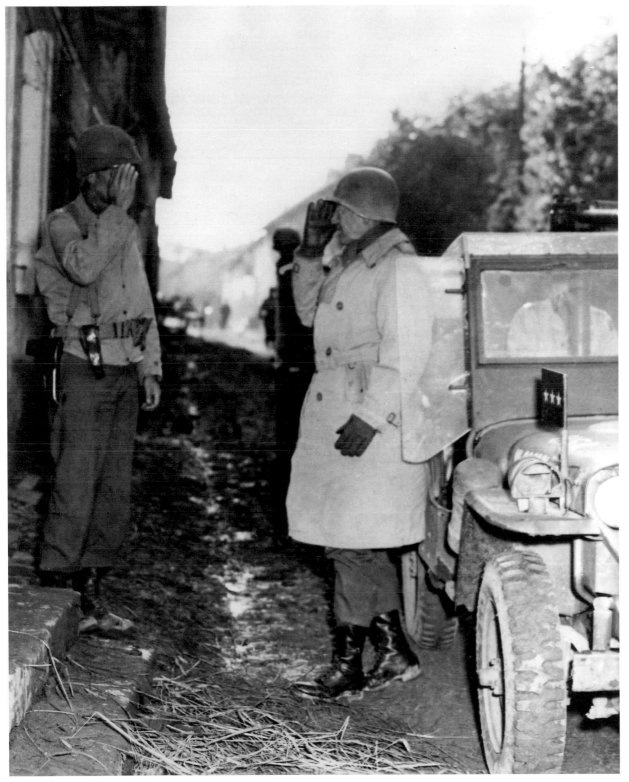

Patton salutes one of his subordinate commanders at a command post in a French village sometime in the fall of 1944. During the war, saluting in the field was still quite frequent except near the active front, where snipers looked for those who received salutes, indicating superior officers, to select as targets.

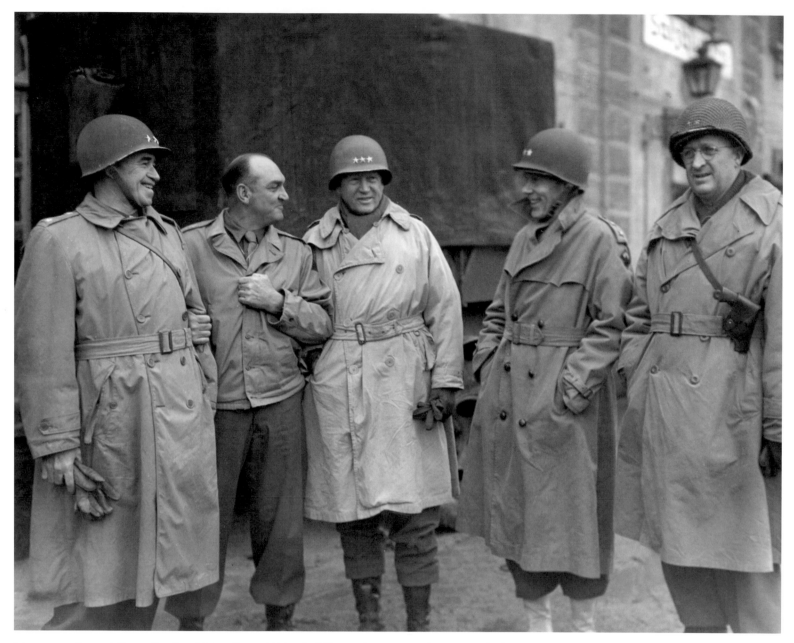

Lieutenant General Omar Bradley, Major General John S. "P" Wood, Commanding General of the elite 4th Armored Division, Patton, Major General Paul Willard, Commanding General 26th Infantry Division, and Major General Eddy, XII Corps, discuss the recent offensive planned to drive to the Saar, probably November 2, 1944, near Vie-Sur-Seille. Patton would soon be compelled to relieve Wood, whom he considered a close friend, for his constant quarrels with Eddy, who was his corps commander. While at West Point, Wood helped fellow students with their studies and thus received the moniker "P," for professor.

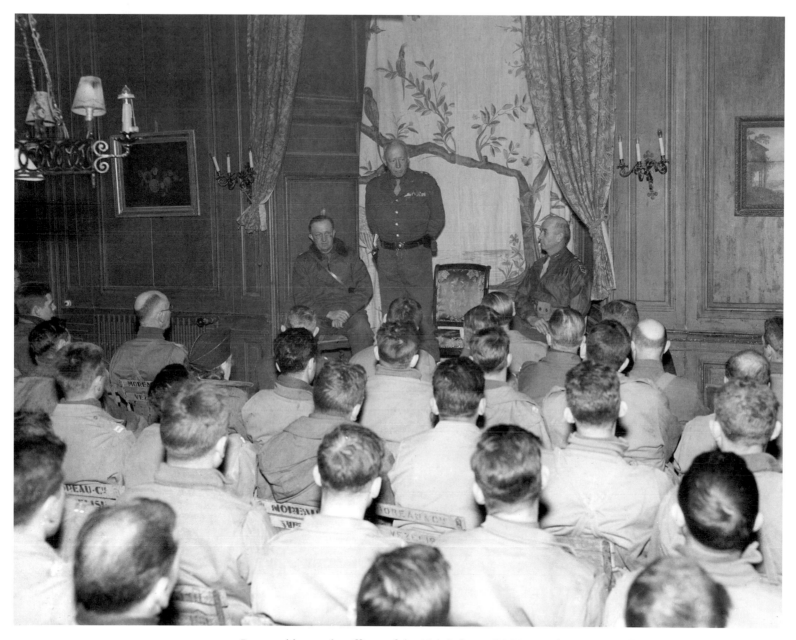

Patton addresses the officers of the 80th Infantry Division at their command post at Ville-Au-Val, France, November 3, 1944, about the coming Saarland offensive. To the left of Patton is Major General Manton Eddy, XII Corps, and to the right of Patton is Major General Horace L. McBride, Commanding General 80th Infantry Division. The offensive would start on November 8 in a driving rainstorm that caused the Mosel River to flood and led to the washing away of a number of bridges. Nevertheless, the Third Army advanced.

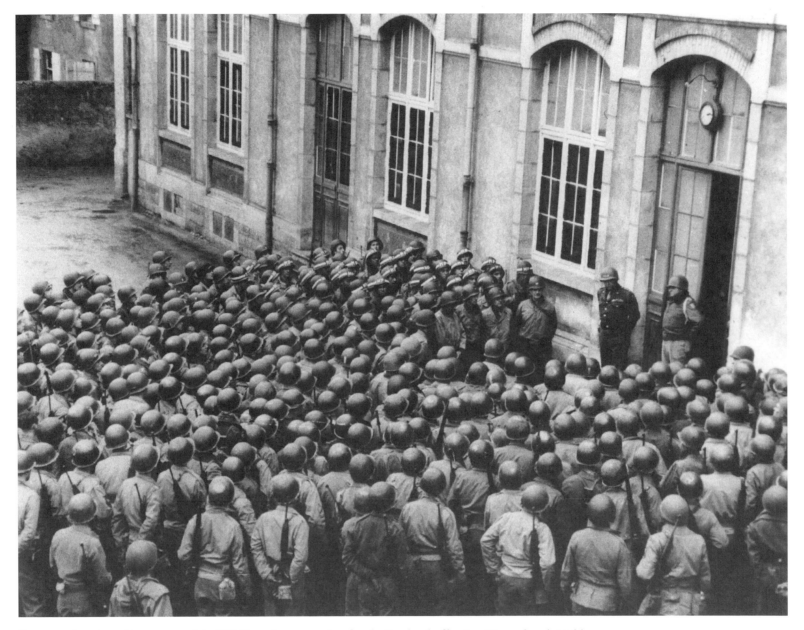

Patton praises the achievements of the XX Corps in preparation for the Saarland offensive, November 4, 1944.
To the right of Patton is the XX Corps Commander, Major General Walton Walker. Note the variety of weapons carried. Most of the men are armed with the M-1 Carbine, indicative of an officer. This was not always the case—the circumstances of combat caused many to alter regulations in the field for the needs of the moment.

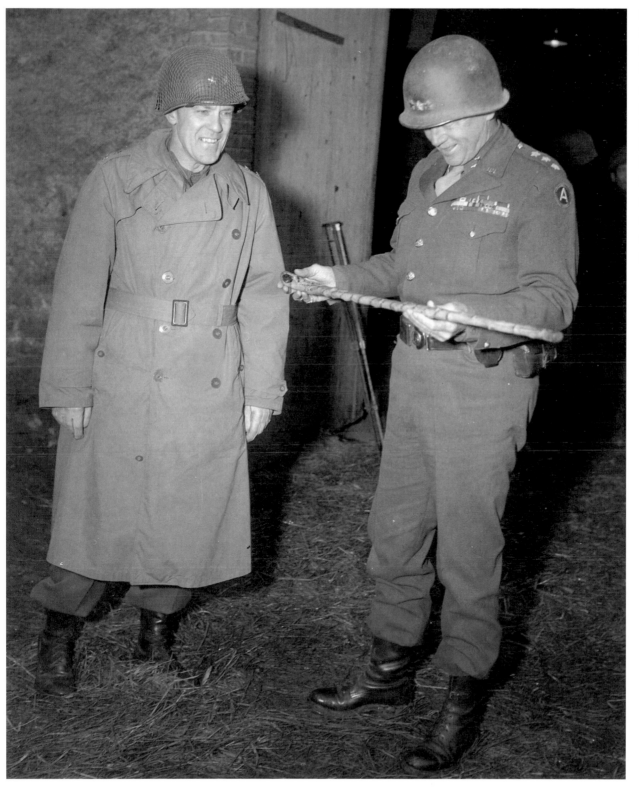

Major General Paul W. Baade, Commanding General 35th Infantry Division, shows a souvenir cane to a very pleased Patton, November 3, 1944. The names of French towns liberated by the division were inscribed diagonally around the circumference of the cane, and the cane was carried by Baade to the end of the war.

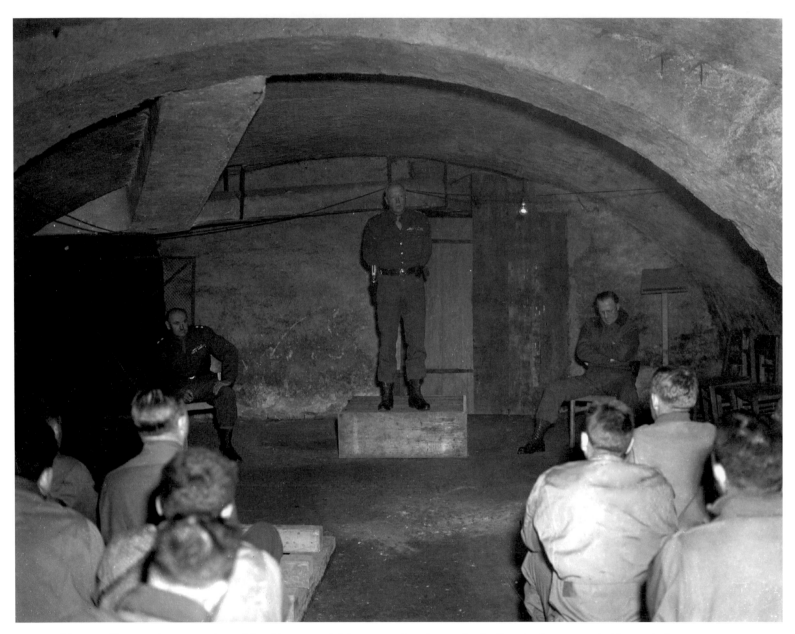

Patton addresses officers and commanders of the 6th Armored Division in the wine vault of a French chateau, probably just before the Saarland offensive that was to start November 8, 1944. When preparing for this offensive, Patton gave pep talks to all his divisions except the 4th and 6th Armored, because he believed there was nothing about war he could tell them that they did not already know. He soon heard that the men were hurt that he had ignored them, so he addressed them as well. From left to right are Major General Robert Grow, 6th Commander Armored Division, Patton, and Major General Manton S. Eddy, Commander XII Corps.

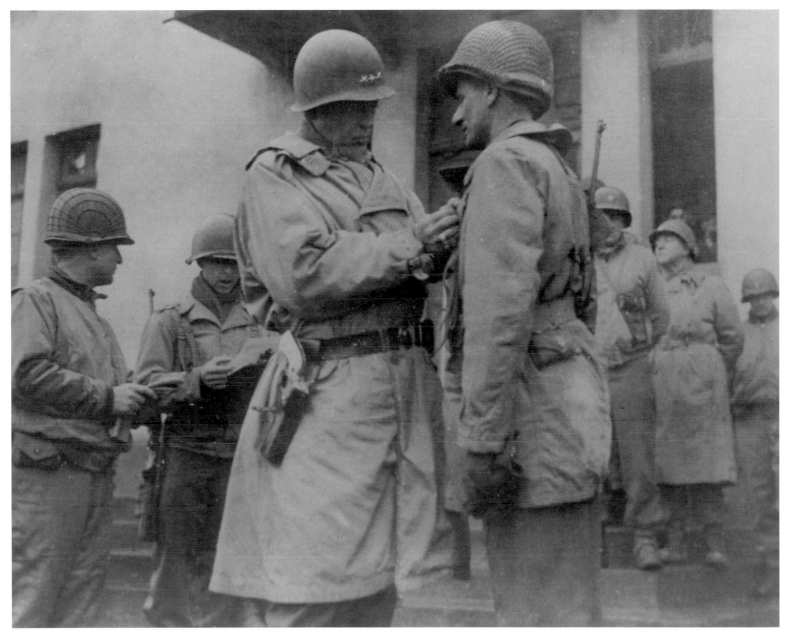

Patton decorates an officer somewhere in France late in 1944. To the left, another officer reads the citation. One of the myths regarding Patton was that he was overly harsh with subordinates. In reality, Patton built a strong sense of esprit de corps among his officers and men, especially his immediate staff.

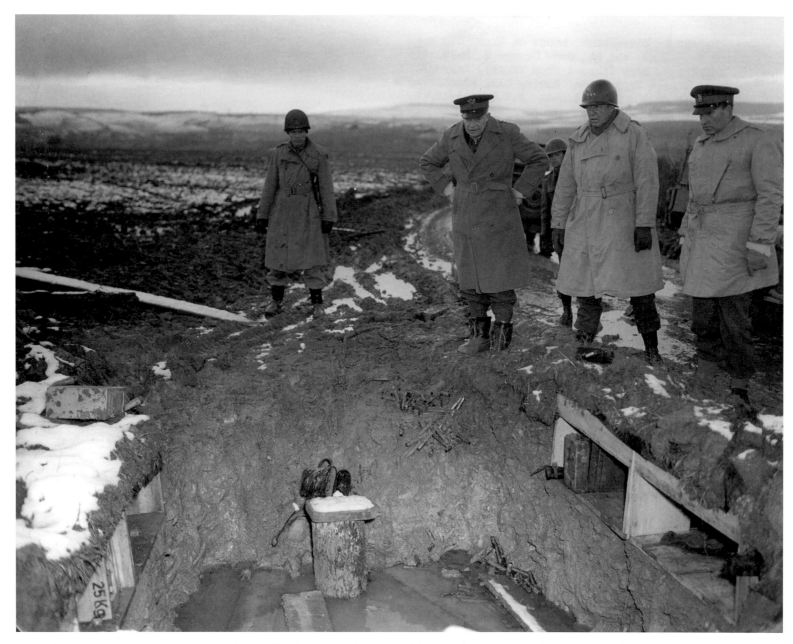

General Eisenhower and Patton inspect a German bunker, November 15, 1944. Note the water at the base of the combat position, a typical problem during the fighting of the autumn and winter of 1944. Patton had to issue instructions to ensure that his men continually changed socks while in the field to help eliminate trench foot. Of interest are the boots worn by Eisenhower. A close examination indicates they had been put on hastily so he could walk in the mud and not get his feet wet.

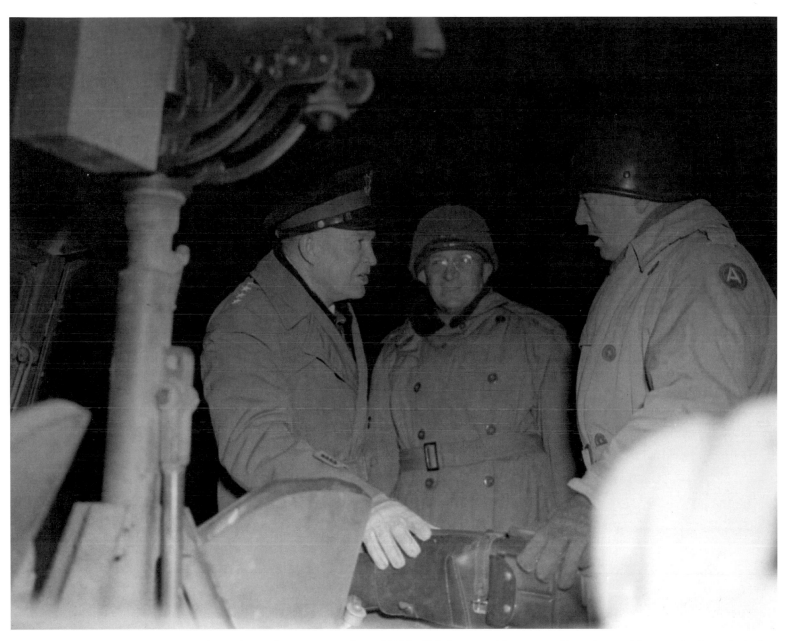

General Eisenhower, Major General Eddy, XII Corps, and Patton are discussing problems at the front, including ensuring that decorations and promotions are delivered in a timely manner, November 15, 1944. Patton noted that when Eisenhower arrived, the SHAEF Commander ensured he was "copiously photographed standing in the mud talking to soldiers" (Blumenson, *Patton Papers,* II, p. 574). Eisenhower, normally loath to getting too close to the front, was also very cognizant of the need for high-profile media coverage of his activities.

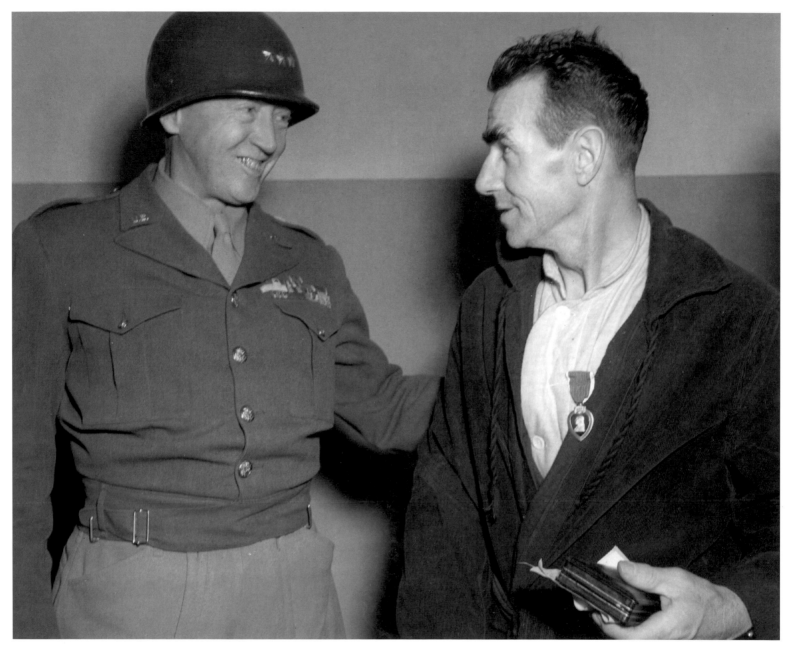

Patton with Colonel Ben Jacobs, who had just received a Purple Heart from General Eisenhower, November 15, 1944.

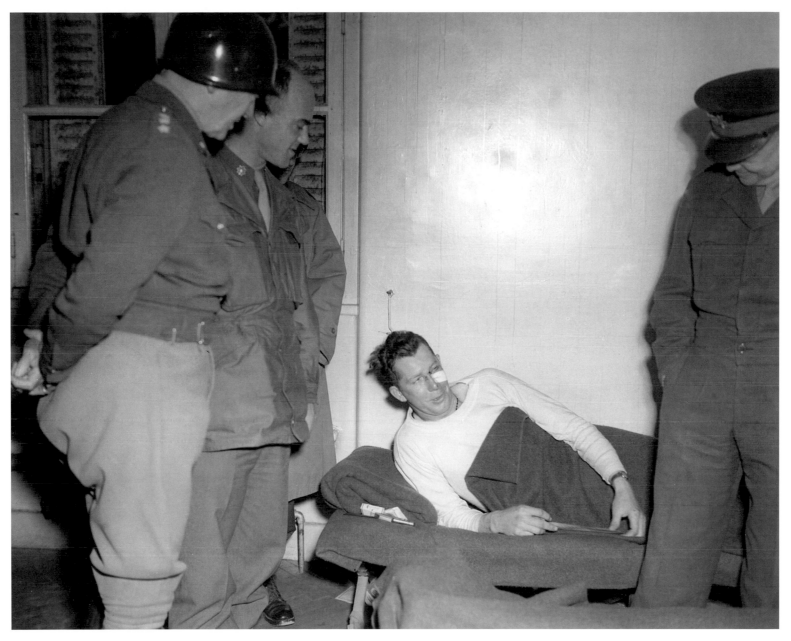

Patton, with General Eisenhower (right), converses with wounded Sergeant James Egan at the 12th Evacuation Hospital, November 16, 1944. Patton toured hospitals often to encourage the wounded.

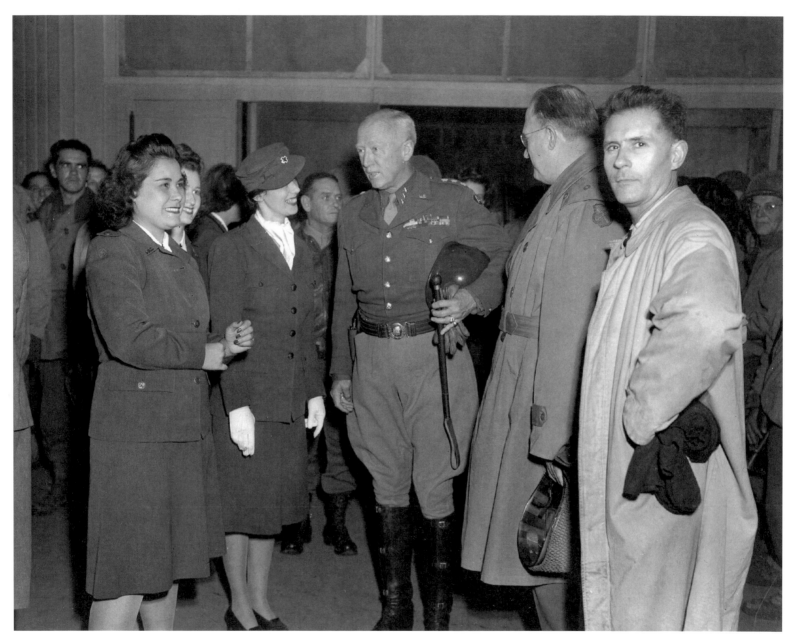

Patton and Major General Eddy, Commanding General XII Corps, converse with an American Red Cross hostess at the opening of a new Red Cross bar in Nancy, France, late in 1944. Earlier in the war Patton had written a letter to the ARC Service Club at Mostaganem to thank them for their support of his men. They responded in turn by saying they had never seen a "he man" general before. Needless to say, Patton's ego got a boost!

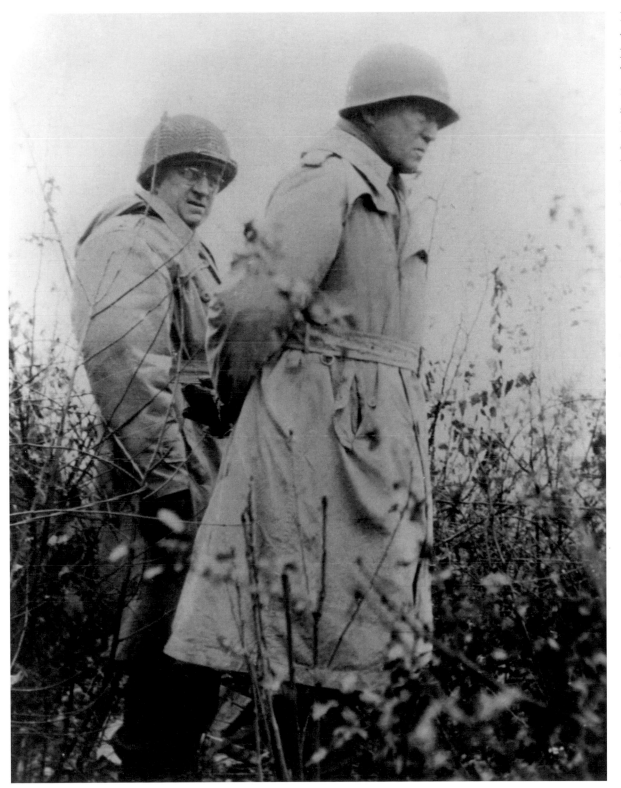

Patton on a visit to the front with Major General Eddy, XII Corps, autumn 1944. The approach of winter meant the start of the rainy season in Lorraine, and the inclement weather made offensive operations difficult. When Eddy suggested postponing the Saarland offensive, Patton asked Eddy to name his own successor. Eddy decided to launch the offensive as planned, which was successful. Meanwhile to the north, Lieutenant General Hodges' First Army waited for clear weather to launch their offensive with a massive aerial bombardment.

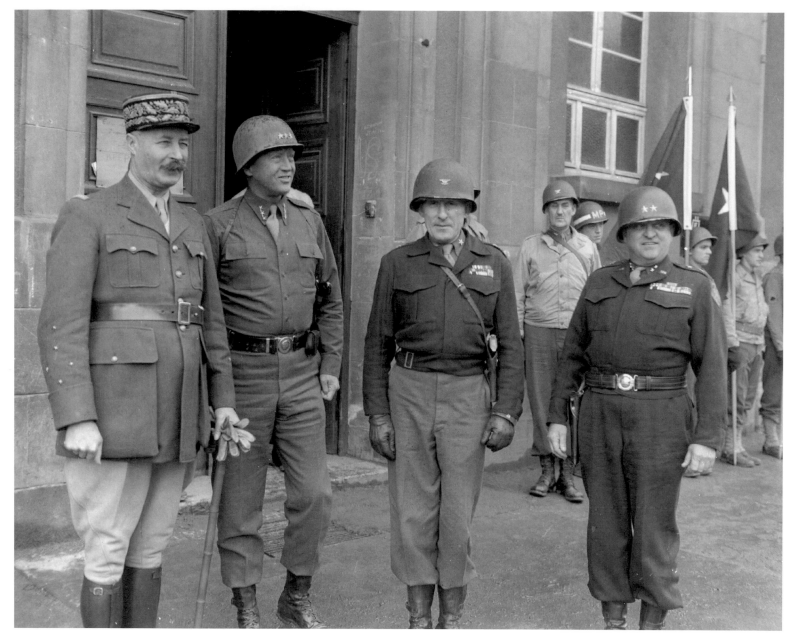

Patton with French general Henri Giraud visit the XX Corps Headquarters at Thionville, France, November 25, 1944. Between Patton and Major General Walton Walker, XX Corps Commander, is Colonel William Collier. Walker admired Patton greatly, and took great pains to model himself after his mentor. He would continue to serve through the Korean War, during which, ironically, he was killed in a vehicle accident.

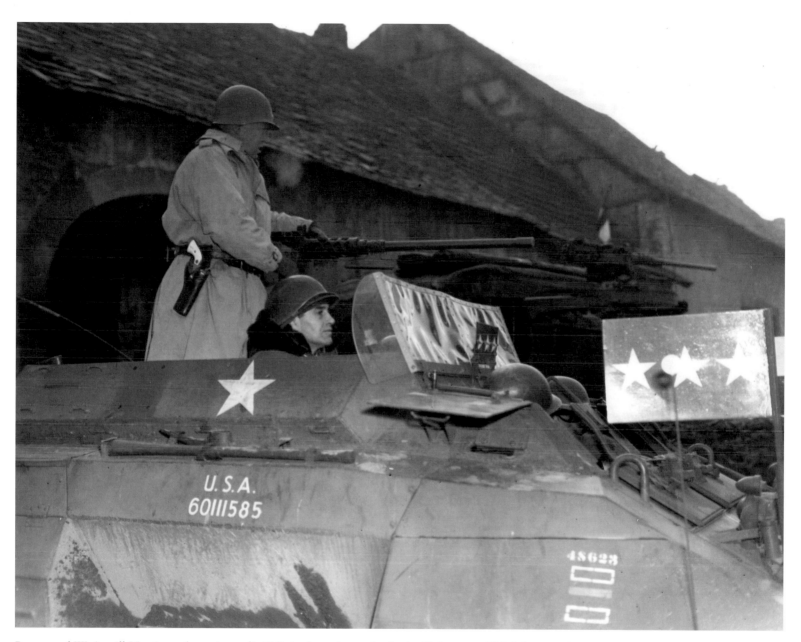

Patton and W. Averill Harriman (not pictured), U.S. Ambassador to the Soviet Union, tour Third Army units in an M-20 Armored Car, November 27, 1944. Harriman told Patton that "Stalin had praised the Third Army in the highest terms," telling Harriman that "the Red Army could not have conceived and certainly could not have executed the advance of the Third Army across France" (Blumenson, *Patton Papers,* II, p. 583).

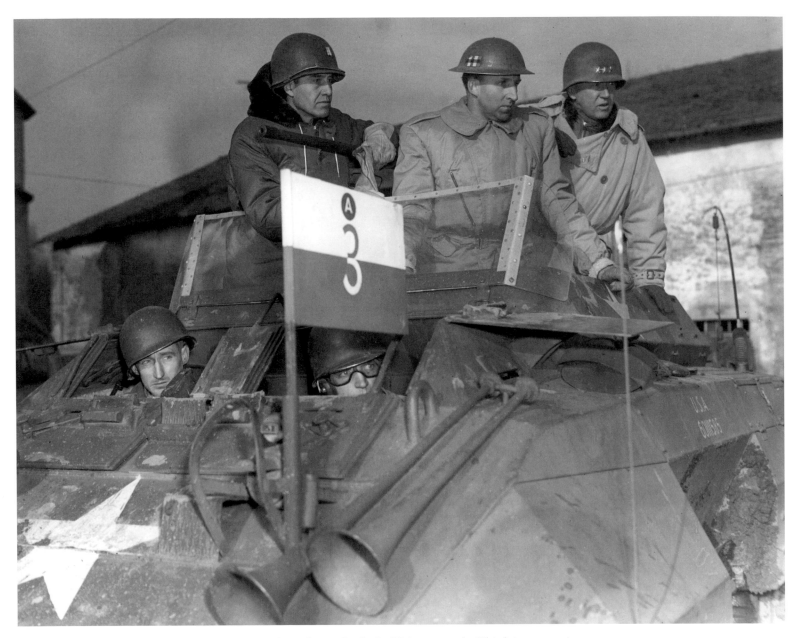

Patton and W. Averill Harriman (center), U.S. Ambassador to the Soviet Union, tour the Third Army area in an M-20 Armored Car, November 27, 1944. Patton's Third Army had smashed its way through German positions, swollen rivers, and a sea of mud as they pressed on to the German border. It is of interest that Harriman is wearing the early war "tin hat," not the M-1 helmet.

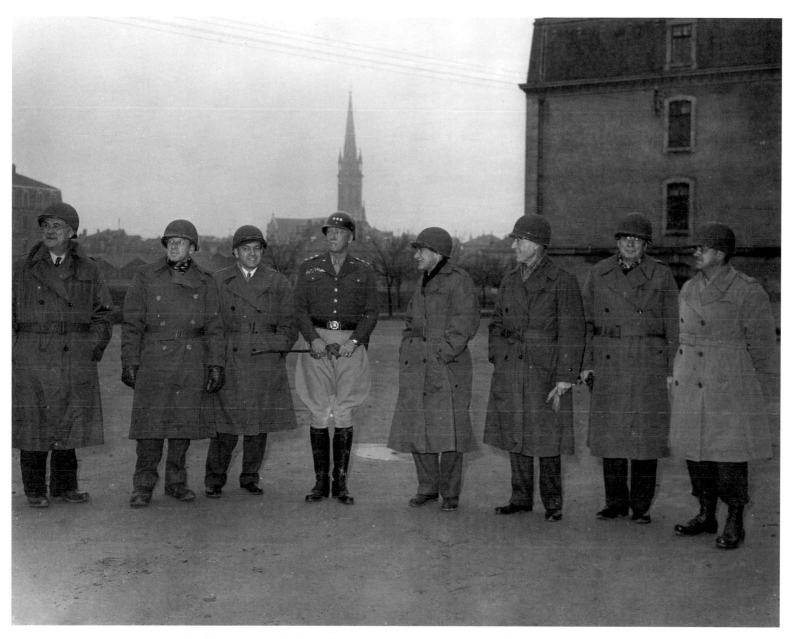

Leading American industrialists tour Patton's headquarters at Nancy, France, November 28, 1944. They are, right to left, Brigadier General A. J. Browning, who organized the visit; Duncan W. Fraser, president American Locomotive Corporation; Charles Kendrick, president Schlage Lock Company; Stuart Cramer, president Cramerton Mills; Patton; S. E. Skinner, president Oldsmobile Corporation; Frederick Crawford, president Thompson Products; and Clarence Stoll, president Western Electric Company.

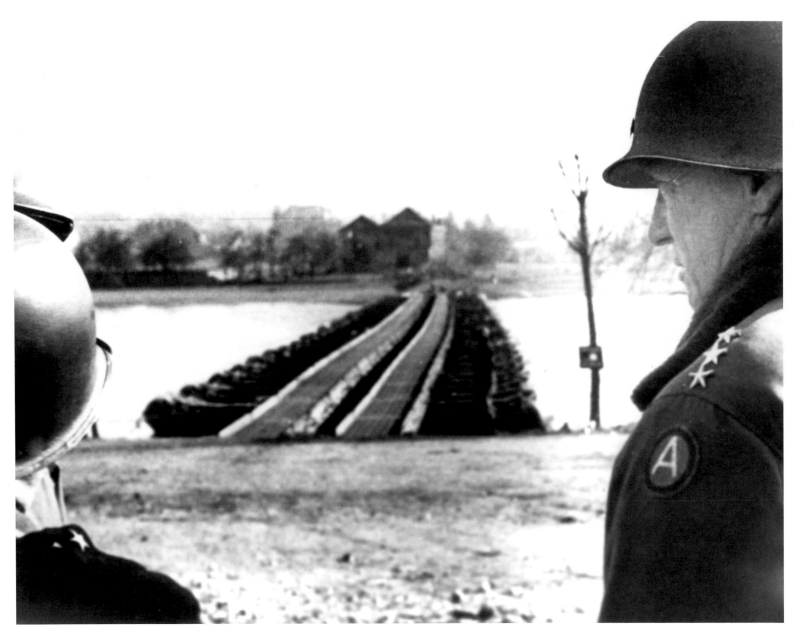

Mobility was critical for mechanized forces, and rivers could be show-stoppers of any rapid advance. Patton was careful to pre-position engineers forward when his forces were approaching any significant water obstacle. This photograph was probably taken late in 1944 as Patton's army closed in on the Saarland.

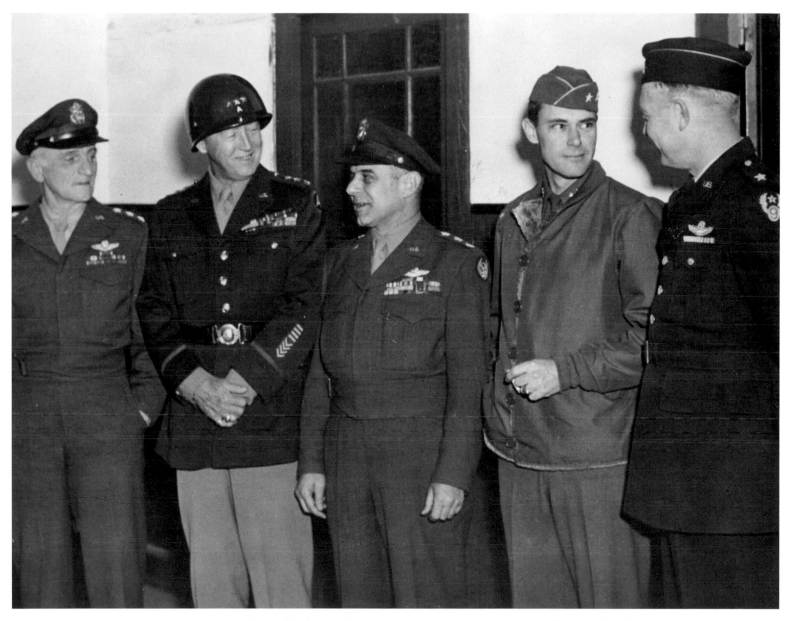

In December 1944, during the campaign in France, Patton meets with some of the leading personalities from the Army Air Corps to discuss problems of Allied aircraft strafing friendly troops. From left to right are Lieutenant General Carl "Tooey" Spaatz, Commander U.S. Strategic Air Forces Europe; Patton; Lieutenant General Jimmy Doolittle, Commander Eighth Air Force; Major General Hoyt Vandenberg, Commander Ninth Air Force; and Brigadier General Otto Weyland, Commander XIX Tactical Air Command. Ironically, upon leaving the meeting, the C-45s of the Air Corps generals were fired on by Third Army antiaircraft batteries.

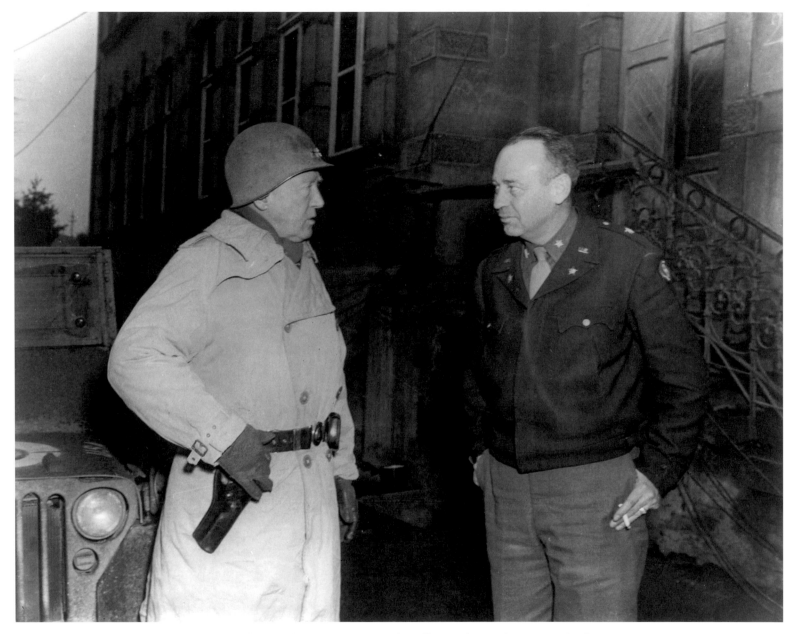

Patton with Colonel Paul Harkins, in December 1944. Harkins was a cavalry officer and Patton's Deputy Chief of Staff for Operations. He had been with Patton since Sicily and was an example of how Patton built intense loyalty among his staff officers. Harkins stayed with Patton to the end of the general's tenure with Third Army and was often privy to many of Patton's most private conversations.

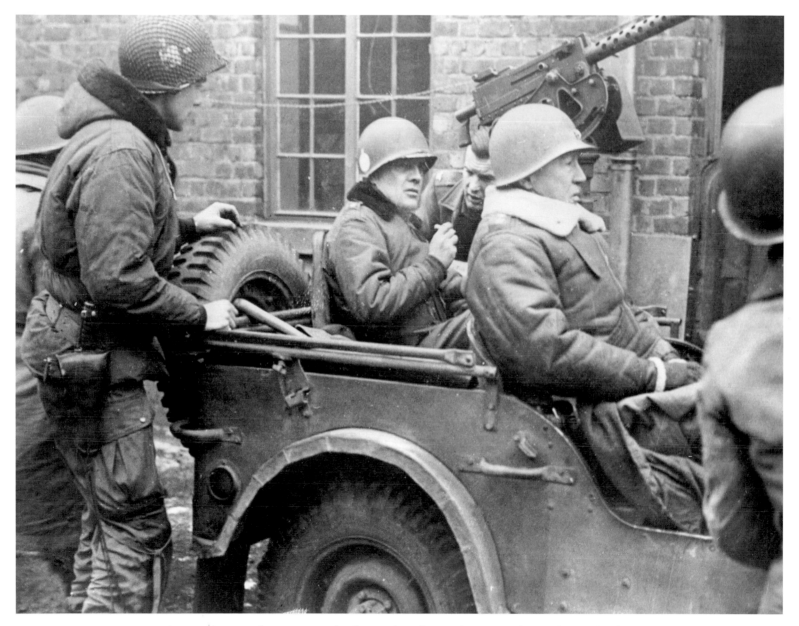

Patton glories in the moment as his forces relieve besieged Bastogne during the Battle of the Bulge, December 29, 1944. While many know that the 101st Airborne Division defended the town, few know that other units including the 10th Armored Division were instrumental in stiffening the defense. Today the town of Bastogne displays an M-4 Sherman in the center of town to commemorate their liberation.

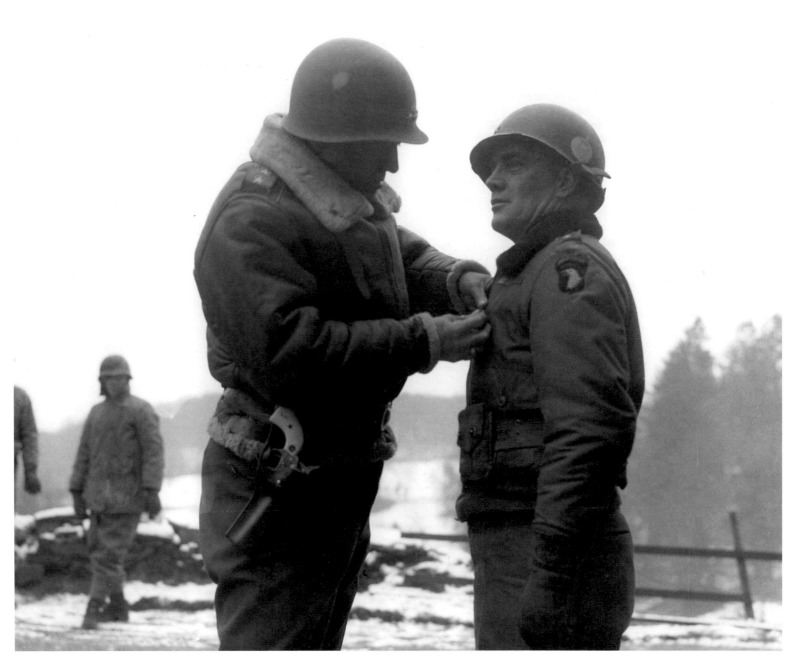

Patton pins the Distinguished Service Cross on Brigadier General Anthony McAuliffe, then acting commander of the 101st Airborne Division during its stand to hold the surrounded town of Bastogne, Belgium, December 29, 1944. The German Ardennes Offensive, popularly known as the Battle of the Bulge, gave Patton's Third Army a chance to once more excel in what they did best—offensive combat.

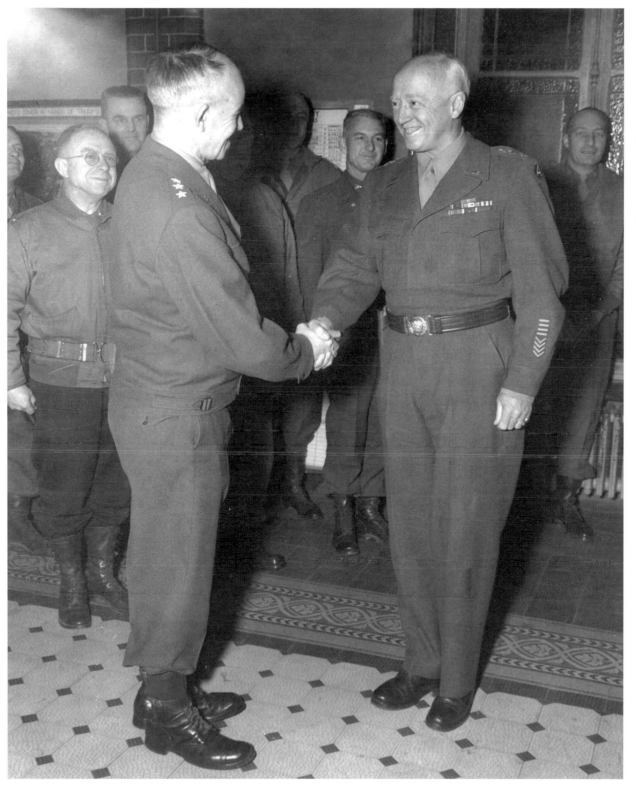

Lieutenant General Omar Bradley, Commanding General 12th Army Group, congratulates Patton after awarding him with an oak leaf cluster to his Distinguished Service Medal at Patton's headquarters in Luxembourg, December 29, 1944. By this time the German offensive in the Ardennes was rapidly collapsing and Patton was already thinking of driving east into Germany.

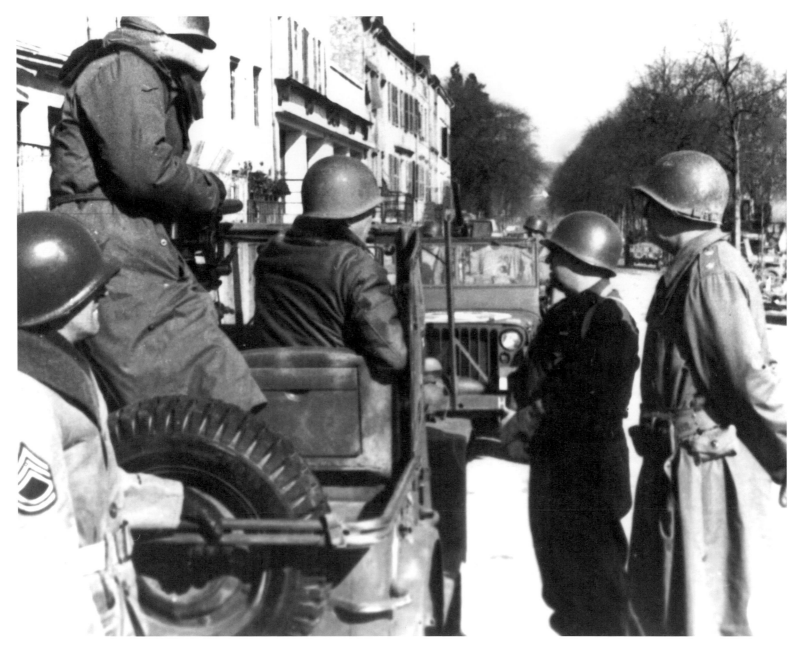

Patton talks with Major General Walton Walker, XX Corps. Though not dated, this photograph was probably taken during the XX Corps' drive toward Trier, in February 1945. When Trier was captured by elements of the 10th Armored Division, Patton received a message from SHAEF directing him to bypass the city. He cabled back that he had already taken it and asked, "Do you want me to give it back?" (D'Este, *Patton,* p. 708).

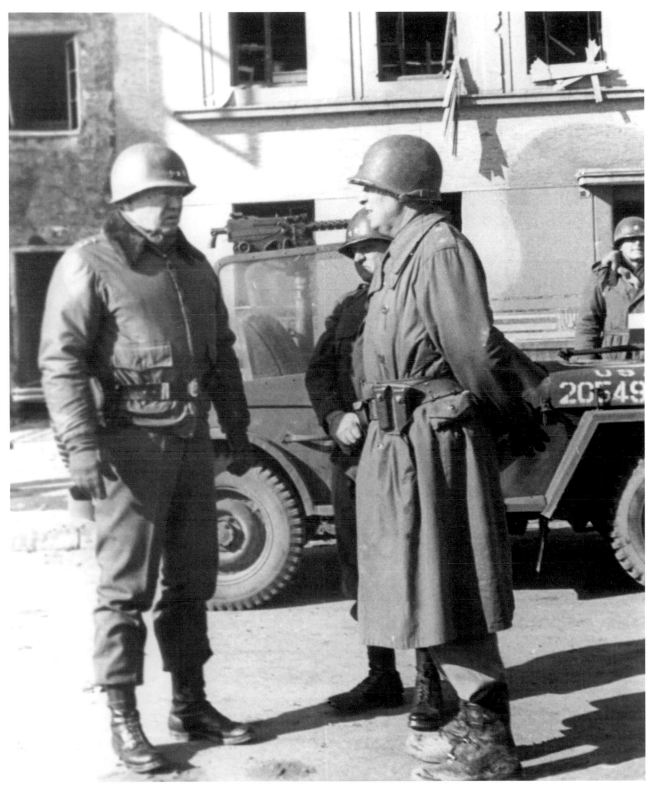

Patton with Major General Walton Walker, XX Corps, who is behind a staff officer, probably during the XX Corps' drive on Trier. Although Patton was not pleased with the performance of the 10th Armored Division, he was very happy with Walker. "Fooled them again," Patton wrote his wife on March 1, 1945. "I had to beg, lie, and steal to get a chance to take [Trier]. In spite of being fat, Walker is good" (Blumenson, *Patton Papers,* II, p. 649).

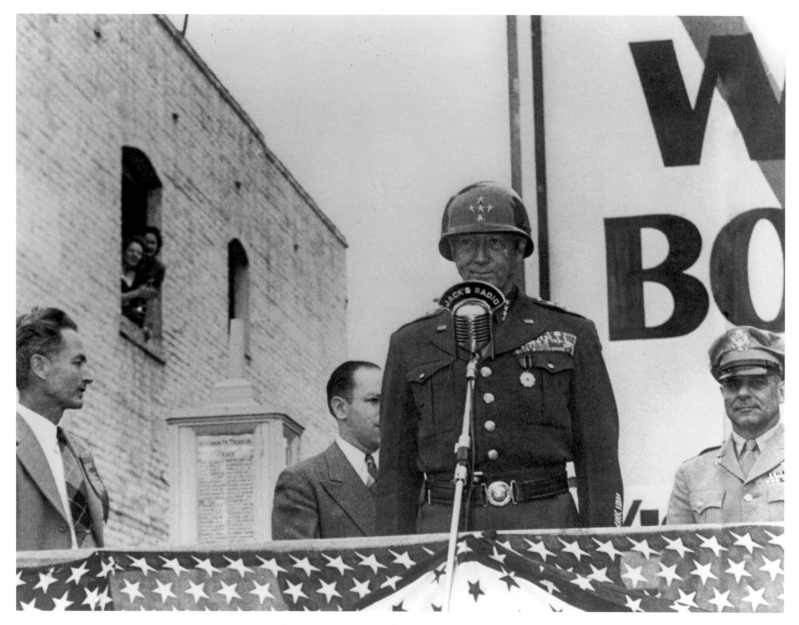

General Patton at a wartime bond broadcast in Great Britain, with General Jimmy Doolittle to the right. This would have been just at the end of the war. Despite the fact that Patton had difficulties with British commanders, he was well liked by the British people.

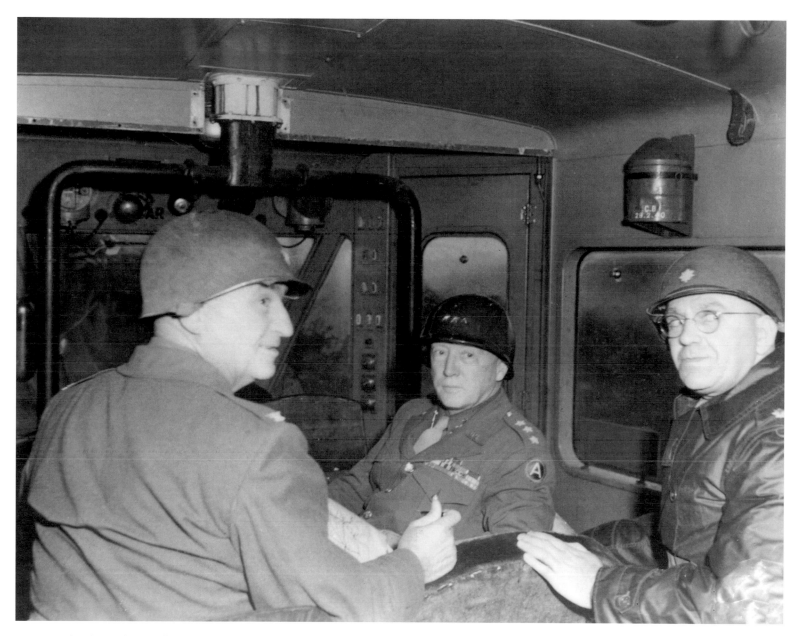

Patton with others of his staff riding on a train, probably early in 1945. As usual, Patton's uniform is immaculate.

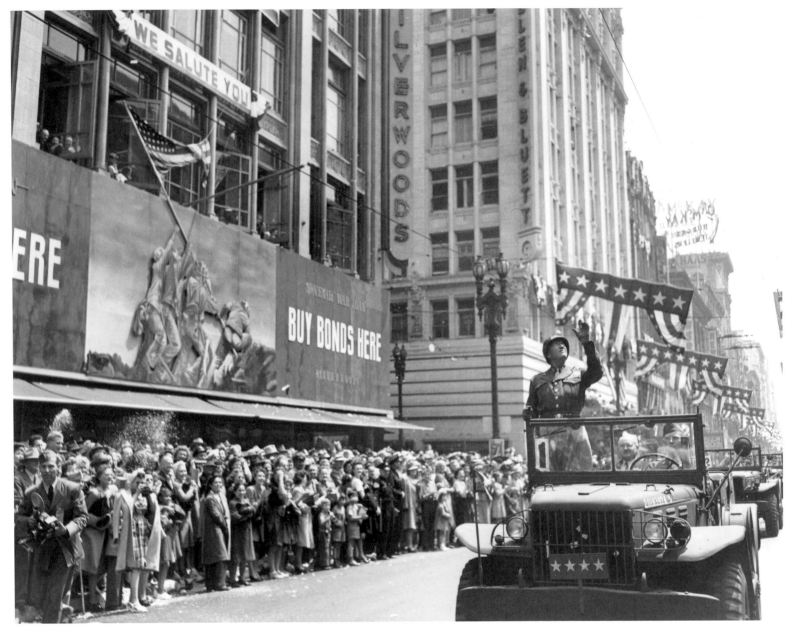

Patton returns to the United States to a hero's welcome, shown here in Los Angeles, California, June 9, 1945. After the parade he gave a speech in which one of his remarks was misunderstood and twisted by some in the media, to imply that Patton had stated that soldiers killed in action died because of their own stupidity.

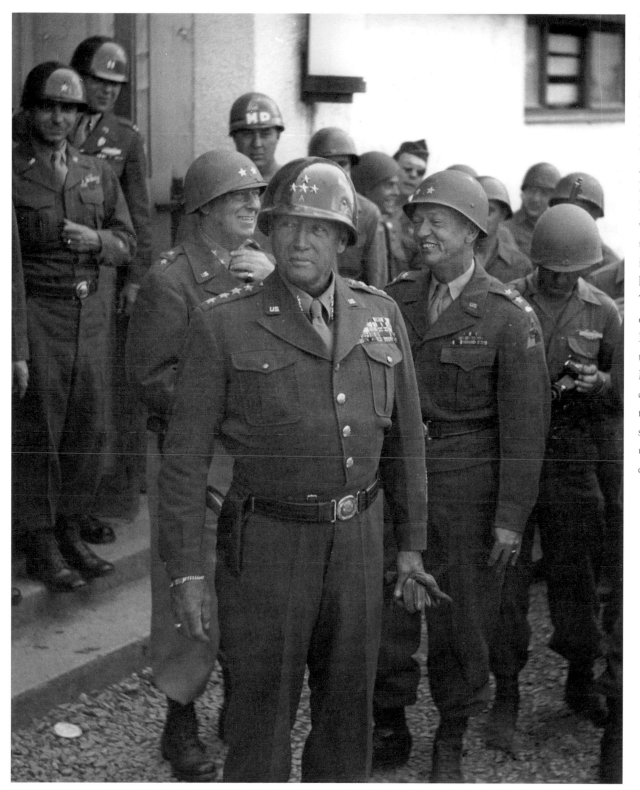

Patton, along with Major General William Morris and Major General Fay Pickett, at the Olympic Stadium in Garmisch-Partenkirchen during Pickett's assumption of the command of the 10th Armored Division from Morris, July 15, 1945. Both Morris and Pickett wear the new narrow green tabs on their epaulettes indicative of a combat leadership position. The green tabs were an outgrowth of General Eisenhower's suggestion to General George C. Marshall that leaders in combat units, in contrast to those in service units, should receive a special recognition for their efforts.

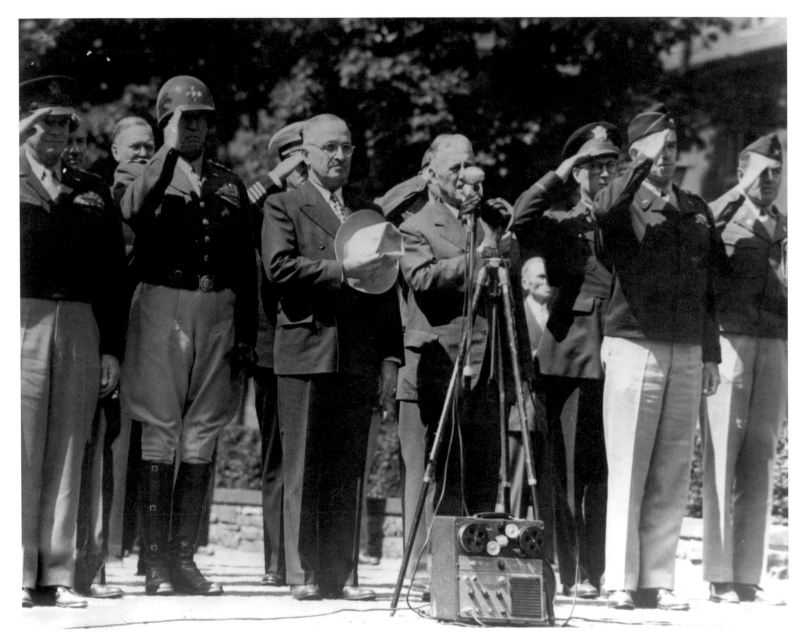

Patton had now fought his last war, but was still hoping for a command in the Pacific. From left to right are General of the Army Dwight Eisenhower, Patton, President Harry S. Truman, Secretary of War Henry L. Stimson, and General Omar Bradley at a postwar ceremony in Berlin, July 21, 1945. The United States flag used for the ceremony was the same one flying over the U.S. Capitol in Washington, D.C., when Pearl Harbor was bombed, December 7, 1941, and was later raised over liberated Rome, Italy, July 4, 1944.

Patton at a ceremony for the XXI Corps and 8th Armored Division at the Pilsen, Czechoslovakia, airfield, September 14, 1945. He had once written General Marshall that he wanted a combat command in the Pacific because he knew this was his last war. However, as the weeks passed he realized that he would not receive such a posting. As he settled into the task of being the military governor of Bavaria, he confided to his wife that "it is hell to be old and passé and know it" (Blumenson, *Patton Papers,* II, p. 736).

Patton's 1939 Cadillac "75," a vehicle designed to handle the rough roads of Europe. Through five years of war Patton had traveled without mishap thanks to his excellent driver, Master Sergeant John Mims. But with the war concluded, Mims had returned to the United States, and Patton found himself relying on a series of unknown and inexperienced drivers taken from the Third Army motor pool duty roster.

Patton's 1939 Cadillac "75," with Private First Class Horace Woodring at the wheel, departed Bad Nauheim, Germany, around 9:00 A.M. on December 9, 1945, for a day of hunting. Riding with Patton was Brigadier General Hobart Gay. After touring the restored Roman fort of Saalburg in the Taunus Mountains north of Bad Homburg, the car was passing through a suburb of Mannheim when it collided with a 2½-ton truck. Nobody was seriously injured except Patton, who had broken his neck. As Gay went to get medical aid, Patton was heard saying, "This is a helluva way to die" (D'Este, *Patton,* p. 785).

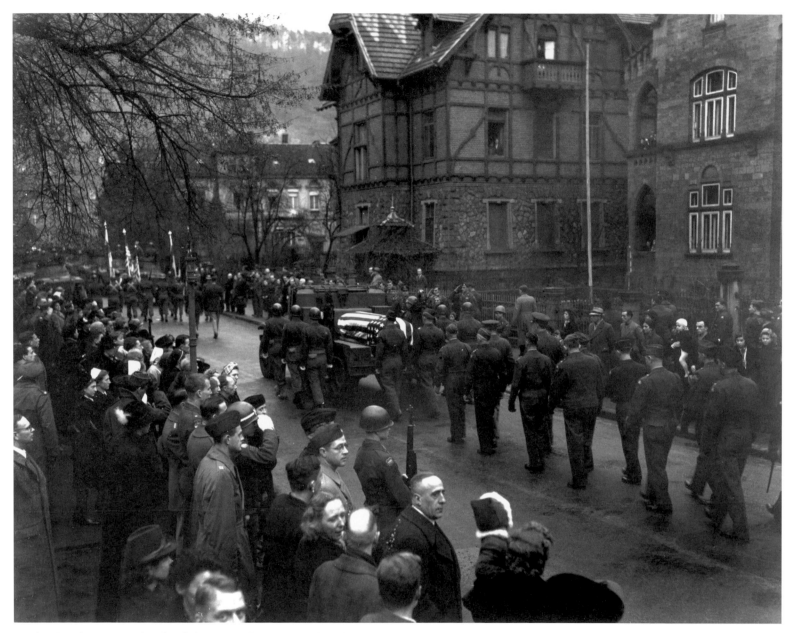

Twelve days later Patton lost his fight to stay alive. Patton's flag-draped casket, mounted on a halftrack, proceeds through the streets of Heidelberg, Germany, December 23, 1945. It is followed by eleven flag officers as honorary pallbearers. From there the casket was taken by train to Luxembourg, where Patton was buried in the American Cemetery at Hamm with many of his beloved Third Army men who died during the Battle of the Bulge.

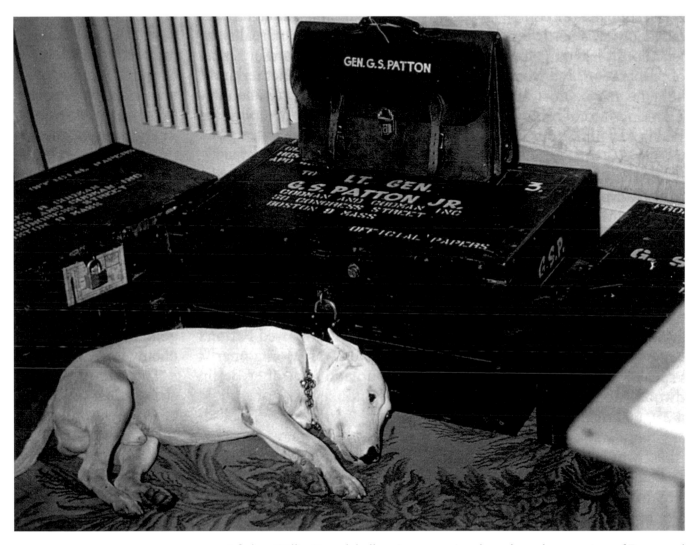

A forlorn Willie, Patton's bull terrier companion throughout the campaigns of France and Germany, awaits his return to the United States along with his master's baggage. Patton's effects were sent to the business address of his aide, Colonel Charles Codman, while Willie returned to Patton's home of Green Meadows, in Massachusetts.

Today Patton's grave marker is located at the Hamm Cemetery, on the outskirts of Luxembourg, and overlooks the grave markers of many from his Third Army who died in combat during the Battle of the Bulge. The graves stand as a stark reminder of the cost of war and the price of freedom.

Beatrice Patton at the dedication of the M-48 Patton tank, July 1, 1952. As a new design, the M-48 eliminated items from earlier tanks such as the bow machine gun. Though the initial design used a gasoline engine, the M-48A3 and later models were powered by a diesel. The last version of the M-48, the A5, was just recently retired from the U.S. Army inventory in National Guard units, while many are still in use today by other armies the world over.

Beatrice Patton, assisted by R. T. Keller, manager of the Chrysler tank plant at Newark, Delaware, dedicates the first M-48 Patton medium tank, July 1, 1952. The M-48 marked a significant advance in tank mobility, firepower, and protection. It weighed 46 tons, was armed with a 90mm gun, and could move at speeds up to 35 m.p.h.

Beatrice Patton with military nurses at a luncheon for women in the Armed Forces, May 13, 1953. Beatrice was a constant support for her husband throughout his career, and continued to lend her name and prestige to various military events after her husband's death.

Captain George S. Patton IV as the Commanding Officer of Company A, 140th Tank Battalion, 40th Infantry Division, during his service in the Korean War, April 23, 1953. He is flanked by one of his crewmen, Private First Class Barnard D. Preskey of Baltimore, Maryland. After his father died in 1945, George S. Patton IV had his name changed, dropping the "IV," and becoming known henceforward as George S. Patton.

Colonel Jimmy Totten and his wife, Ruth Ellen Patton Totten, present a portrait of General Patton to Major General James E. Moore, Commandant of the Army War College, Carlisle, Pennsylvania, on May 17, 1954. Colonel Totten was at that time a student at the college, and would later achieve the rank of major general.

Major George S. Patton IV at the dedication ceremony for the new layout of Patton's grave marker in the American Cemetery in Hamm, Luxembourg, July 4, 1960. Patton's grave was originally placed within the rank and file of his men as he preferred, but the constant stream of visitors began to wear out the grass around it and the neighboring graves. It was then decided to move the marker to a more isolated location to protect the overall beauty of the cemetery. It is indeed a fitting tribute to this great commander.

The memorial statue of General George S. Patton, Jr., seen today in Ettelbruck, Luxembourg. The sculpture depicts him at the height of his fame while commanding the Third Army during the Battle of the Bulge and is a copy of the one at West Point.

Notes on the Photographs

These notes, listed by page number, attempt to include all aspects known of the photographs. Each of the photographs is identified by the page number, photograph's title or description, photographer and collection, archive, and call or box number when applicable. Although every attempt was made to collect all available data, in some cases complete data was unavailable due to the age and condition of some of the photographs and records.

II **ADDRESSING OFFICERS**
Patton Museum
P 6-38

VI **A FIERY SPEECH**
Patton Museum
P 9-68

X **PATTON AT THE VIRGINIA MILITARY INSTITUTE**
Patton Museum
P 1-31

2 **COL. GEORGE S. PATTON**
Patton Museum
P 1-6

3 **"DON BENITO" BENJAMIN WADE DAVIS**
Patton Museum
P 1-2

4 **PATTON'S FATHER, GEORGE SMITH PATTON**
Patton Museum
P 1-9

5 **INFANT**
Patton Museum
P 1-23

6 **GEORGE S. PATTON, JR., AT SEVEN**
Patton Museum
P 1-14

7 **GEORGE AND SISTER ANNE**
Patton Museum
P 1-11

8 **GEORGE AND NITA AT LAKE VINEYARD, CALIFORNIA**
Patton Museum
P 1-130

9 **PATTON FAMILY**
Patton Museum
P 1-18

10 **PATTON FAMILY AT LAKE VINEYARD**
Patton Museum
P 1-25

11 **THE PATTON, AYER, AND BANNING FAMILIES**
Patton Museum
P 1-133

12 **PATTON AT AGE 17**
Patton Museum
P 1-28

13 **VISITING FAMILY**
Patton Museum
P 1-29

14 **184-POUND BLACK SEA BASS**
Patton Museum
P 1-113

15 **PATTON AT AGE 19**
Patton Museum
P 1-112

16 **PATTON'S GRADUATION AT WEST POINT**
Patton Museum
P 1-103

17 **PATTON IN 1909**
Patton Museum
P 1-33

18 **WEST POINT FOOTBALL TEAM, 1909**
Patton Museum
P 1-34

19 **NEWLYWED**
Patton Museum
P 1-47

20 **UNITED STATES' OLYMPICS**
Patton Museum
P 1-50

21 **USE OF THE SABER**
Patton Museum
P 1-63

22 **MOUNTED SERVICE SCHOOL**
Patton Museum
P 1-76

23 **PUNITIVE EXPEDITION**
Patton Museum
P 1-89

24 **PATTON**
Patton Museum
P 1-88 B

25 **PATTON WITH BURN WOUND**
Patton Museum
P 1-116

26 **TANK CORPS**
Patton Museum
P 1-91

27 **TANK SCHOOL IN BOURG, FRANCE**
Patton Museum
P 1-92 B

28 **PATTON FAMILY IN 1919**
Patton Museum
P 1-97

29 **STONEWALL CONFEDERATE CEMETERY**
Patton Museum
P 1-96

30 PATTON
Patton Museum
P 1-93

32 THE CAVALRY
Patton Museum
P 2-7

33 TROOP I, 3RD CAVALRY
SQUADRON, 3RD CAVALRY
REGIMENT AT FORT MYER,
VIRGINIA
Patton Museum
P 2-1

34 RIDING
Patton Museum
P 2-2

35 RIDING WITH FAMILY
AT SOUTH HAMILTON,
MASSACHUSETTS
Patton Museum
P 2-3

36 PATTON FAMILY PORTRAIT
Patton Museum
P 2-4

37 WAR DEPARTMENT POLO
TEAM
Patton Museum
P 2-6

38 U.S. ARMY WAR
COLLEGE, SEPTEMBER
1931
Patton Museum
P 2-15

39 PATTON GIVING BEATRICE
AWAY
Patton Museum
P 2-10

40 LIEUTENANT COLONEL AND
MRS. PATTON
Patton Museum
P 2-14

41 COLONEL PATTON
Patton Museum
P 2-16

42 THE PATTON FAMILY AT
QUARTERS #8, FORT
MYER, VIRGINIA
Patton Museum
P 2-18

43 16TH FIELD ARTILLERY
Patton Museum
P 2-12

44 COLONEL PATTON WITH
LT. JAMES W. TOTTEN
AND RUTH ELLEN
Patton Museum
P 2-22

45 BRIGADIER GENERAL
Patton Museum
P 4-2

46 MAJOR GENERAL PATTON
AS THE COMMANDER, 2ND
ARMORED DIVISION
Patton Museum
P 4-3

47 STUDYING A MAP
Patton Museum
P 4-10

48 PATTON AND LT. COL.
MARK CLARK
Patton Museum
P 4-15

49 IMPROMPTU REPORT
Patton Museum
P 4-9

50 PATTON SEATED
Patton Museum
P 4-17

51 PATTON ADDRESSING
INFANTRY
Patton Museum
P 4-20

52 PATTON ADDRESSING
2ND ARMORED DIVISION
PERSONNEL
Patton Museum
P 4-24

53 ARMORED FORCE
CONFERENCE
Patton Museum
P 4-28

54 PATTON WITH JUNIOR
OFFICERS
Patton Museum
P 4-22

55 PATTON WATCHES THE
CONSTRUCTION
Patton Museum
P 4-42

56 PATTON BRIEFS HIS MEN
AT FORT BENNING
Patton Museum
P 4-25

57 PATTON BEING
INTERVIEWED
Patton Museum
P 4-32

58 CLASSIC PHOTOGRAPH OF
PATTON
Patton Museum
P 4-34

60 CRITTENBERGER AND
PATTON
Patton Museum
P 5-1

61 AT WAR
Patton Museum
P 4-41

62 TOUGH TRAINER
Patton Museum
P 5-6

63 MAP BRIEFING FROM
PATTON
Patton Museum
P 5-5

64 WESTERN TASK FORCE
Patton Museum
P 5-32

65 REVIEWING INITIAL
REPORTS
Patton Museum
P 5-35

66 PATTON AND GENERAL
AUGUSTE PAUL NOGUES
Patton Museum
P 5-21

67 PATTON AND FRENCH
GENERAL AUGUSTE PAUL
NOGUES
Patton Museum
P 5-18

69 PATTON AND GENERAL
NOGUES
Patton Museum
P 5-15

70 GUARD OF HONOR AT
NOGUES' HEADQUARTERS
Patton Museum
P 5-38

71 MOROCCO
Patton Museum
P 5-29

72 CASABLANCA CONFERENCE
Patton Museum
P 6-4

73 COMMAND IN MOROCCO
Patton Museum
P 6-2

74 B-25 Mitchell Bomber
Patton Museum
P 6-16

75 Officers
Patton Museum
P 6-17

76 Saying Good-bye
Patton Museum
P 6-19

77 En Route to the II Corps in Tunisia
Patton Museum
P 6-21

78 Now at the Front
Patton Museum
P 6-24

79 Fighting for El Guettar, Tunisia
Patton Museum
P 6-26

80 Promoting Patton
Patton Museum
P 6-27

81 Lieutenant General George S. Patton, Jr.
Patton Museum
P 6-35 B

82 Patton in an M3A1 Scout Car
Patton Museum
P 6-22

83 Receiving the Silver Star
Patton Museum
P 6-31

84 82nd Airborne Division
Patton Museum
P 6-40

85 Well-kept Secret
Patton Museum
P 6-43

86 Patton During Orgas's Inspection
Patton Museum
P 6-41

87 Patton up Front
Patton Museum
P 6-37

88 Preparing for the Sicily Invasion
Patton Museum
P 6-46

89 Patton with Commander Harry Butcher, Oujda, North Africa
Patton Museum
P 6-49

90 Presented with the Seventh Army Flag
Patton Museum
P 5-34

91 En Route to Sicily
Patton Museum
P 6-51

92 Tense Moments
Patton Museum
P 6-54

93 Ashore at Gela, Sicily
Patton Museum
P 6-62

94 Barge Carrying Patton
Patton Museum
P 6-68

95 Patton's Transport
Patton Museum
P 6-65

96 Patton and His Chief of Staff, Brig. Gen. Hobart Gay
Patton Museum
P 6-71

97 On the Gela Beach, Sicily
Patton Museum
P 6-72

98 Patton on the Gela Beach, Sicily
Patton Museum
P 6-75

99 Patton Moving Through Gela, Sicily
Patton Museum
P 6-82

100 Earlier Photo of Patton
Patton Museum
P 6-93

101 Capture of Palermo
Patton Museum
P 6-87

102 Patton Discusses the Fall of Palermo
Patton Museum
P 6-92

103 Operations
Patton Museum
P 6-88

104 Patton Addresses 1st Infantry Division Troops
Patton Museum
P 7-2

105 Affinity
Patton Museum
P 7-3

106 Patton and British General Bernard Montgomery
Patton Museum
P 7-6

107 Patton and Montgomery Leaving
Patton Museum
P 7-11

108 Montgomery Bids Farewell
Patton Museum
P 7-13

109 Differing Uniform
Patton Museum
P 7-14

110 General Dwight Eisenhower Visits Patton's Headquarters
Patton Museum
P 7-17

111 Classic View of Patton
Patton Museum
P 7-22

112 Results of Operations
Patton Museum
1927.93.00

113 Dead Italian Soldier
Patton Museum
1927.95.00

114 Elements of the 2nd Armored Division
Patton Museum
1927.97.00

115 Patton Discusses Operations
Patton Museum
P 7-23

116 PATTON WITH COLONEL DON CARLETON
Patton Museum
P 7-25

117 FOCUS ON CAPTURING MESSINA
Patton Museum
P 7-40

118 PATTON TRIUMPHANT
Patton Museum
P 7-26

119 VISITING DIGNITARIES
Patton Museum
P 7-29

120 GENERAL DWIGHT D. EISENHOWER AND PATTON AT PALERMO, SICILY, AIRFIELD
Patton Museum
P 7-32

121 DISTINGUISHED SERVICE CROSS
Patton Museum
P 7-37

122 VICTORY CAKE
Patton Museum
P 7-39

123 PATTON AWARDS SILVER STARS
Patton Museum
P 7-41

124 SOLDIER'S MEDAL TO PFC. THOMAS M. YULE
Patton Museum
P 7-46

125 PATTON SHAKES HANDS
Patton Museum
P 7-48

126 INSPECTION TOUR
Patton Museum
P 7-51

127 INSPECTING SHIP-BORNE ELEMENTS
Patton Museum
P 7-50

128 ARMISTICE DAY CEREMONIES
Patton Museum
P 7-52

129 ARMISTICE DAY CEREMONY
Patton Museum
P 7-53

130 MEETING
Patton Museum
P 7-54

133 PATTON WITH MAJOR GENERAL GEOFFREY KEYES
Patton Museum
P 8-1

134 INSPECTION TOUR OF TOFT HALL
Patton Museum
P 8-2

135 INSPECTION TOUR
Patton Museum
P 8-9

136 PATTON INSPECTING 5TH INFANTRY DIVISION
Patton Museum
P 8-10

137 LEAVING A REVIEWING STAND
Patton Museum
P 8-7

138 2ND INFANTRY DIVISION
Patton Museum
P 8-14

139 PATTON DELIVERS AN ADDRESS
Patton Museum
P 8-18

140 THE INVASION
Patton Museum
P 8-23

141 THIRD ARMY L-5 SENTINEL
Patton Museum
P 8-28

142 OPERATION COBRA
Patton Muscum
P 8-30

143 AMERICAN LABOR LEADERS
Patton Museum
P 8-33

144 PATTON WITH MAJOR GENERAL LEROY IRWIN
Patton Museum
P 8-36

145 PATTON AND HIS CHIEF OF STAFF
Patton Museum
P 8-34

146 TIRED AND HAGGARD
Patton Museum
P 9-39

147 PATTON AND OMAR BRADLEY
Patton Museum
P 8-37

148 PATTON WITH THE CREW OF A B-17
Patton Museum
P 8-42

149 EISENHOWER, PATTON, AND BRADLEY
Patton Museum
P 8-40

150 PATTON AND BRADLEY
Patton Museum
P 8-44

151 PATTON STAFF AND COMMANDERS
Patton Museum
P 8-45

152 BATTLE LINES
Patton Museum
P 8-55

153 REPAIR WORK ON M-1 GARAND RIFLES
Patton Museum
P 8-61

154 M-4 SHERMAN TANKS
Patton Museum
P 8-62

155 FLAME-THROWING TANK DEMONSTRATION
Patton Museum
P 8-64

156 LORRAINE
Patton Museum
P 9-41

157 PATTON SALUTES
Patton Museum
P 8-74

158 DISCUSSION
Patton Museum
P 9-20

159 OFFICERS OF THE 80TH INFANTRY DIVISION
Patton Museum
P 9-1

160 PRAISES
Patton Museum
P 9-3

161 MAJOR GENERAL PAUL W. BAADE
Patton Museum
P 9-5

162 ADDRESSING OFFICERS
Patton Museum
P 8-76

163 PATTON DECORATES AN
OFFICER
Patton Museum
P 9-12

164 GENERAL EISENHOWER
AND PATTON INSPECT A
GERMAN BUNKER
Patton Museum
P 9-16

165 DISCUSSING PROBLEMS AT
THE FRONT
Patton Museum
P 9-17

166 PATTON WITH COLONEL
BEN JACOBS
Patton Museum
P 9-28

167 CONVERSING WITH
WOUNDED SERGEANT
Patton Museum
P 9-19

168 OPENING OF NEW RED
CROSS BAR
Patton Museum
P 9-18

169 PATTON IN AUTUMN 1944
Patton Museum
P 9-40

170 PATTON WITH FRENCH
GENERAL HENRI GIRAUD
Patton Museum
P 9-21

171 THIRD ARMY AREA
Patton Museum
P 8-68

172 PATTON AND W. AVERILL
HARRIMAN
Patton Museum
P 8-71

173 LEADING AMERICAN
INDUSTRIALISTS TOUR
Patton Museum
P 9-24

174 MOBILITY
Patton Museum
P 8-84

175 CAMPAIGN IN FRANCE
Patton Museum
P 5-30

176 PATTON WITH COLONEL
PAUL HARKINS
Patton Museum
P 9-27

177 BATTLE OF THE BULGE
Patton Museum
P 9-31

178 DISTINGUISHED SERVICE
CROSS
Patton Museum
P 9-29

179 LIEUTENANT GENERAL
OMAR BRADLEY
Patton Museum
P 9-35

180 PATTON TALKING
Patton Museum
P 7-61

181 PATTON WITH MAJOR
GENERAL WALTON
WALKER, XX CORPS
Patton Museum
P 6-96

182 WARTIME BOND
BROADCAST
Patton Museum
P 9-44

183 TRAIN RIDE
Patton Museum
P 9-53

184 A HERO'S WELCOME
Library of Congress
208-pu-154f-5

185 OLYMPIC STADIUM
IN GARMISCH-
PARTENKIRCHEN
Patton Museum
P 9-71

186 POSTWAR CEREMONY IN
BERLIN
Patton Museum
A 11-43

187 CEREMONY FOR THE XXI
CORPS AND 8TH ARMORED
DIVISION
Patton Museum
A 12-9

188 PATTON'S 1939 CADILLAC
"75"
Patton Museum
GSP 19-18 Img 004

189 ACCIDENT
Patton Museum
GSP 19-12 Img 003

190 PATTON'S DEATH
Patton Museum
A 13-44

191 WILLIE
Patton Museum

192 PATTON'S GRAVE MARKER
Rodgers Collection

193 BEATRICE PATTON
Patton Museum
P 3-5

194 DEDICATION OF THE FIRST
M-48 PATTON MEDIUM
TANK
Patton Museum
P 3-6

195 BEATRICE PATTON WITH
MILITARY NURSE
Patton Museum
P 3-3

196 CAPTAIN GEORGE S.
PATTON
Patton Museum
P 3-12

197 PORTRAIT OF GENERAL
PATTON
Patton Museum
P 3-10

198 PATTON'S GRAVE MARKER
Patton Museum
P 3-14

199 MEMORIAL STATUE OF
GENERAL GEORGE S.
PATTON, JR.
Rodgers Collection

FOR FURTHER READING

Allen, Col. Robert S. *Lucky Forward: The History of Patton's Third U.S. Army.* New York: Vanguard Press, 1947.

Blumenson, Martin. *The Patton Papers,* vols. I-II. Boston: Houghton Mifflin Company, 1972.

———. *Breakout and Pursuit, United States Army in World War II, the European Theater of Operations.* Washington, D.C.: Office of the Chief of Military History, Department of the Army, 1961.

Carafano, James Jay. *After D-Day, Operation Cobra and the Normandy Breakout.* Boulder, Colo.: Lynne Rienner Publishers, 2000.

Codman, Col. Charles R. *Drive.* Boston: Little, Brown and Company, 1957.

Coffman, Edward M. *The Regulars: The American Army 1899–1941.* Cambridge, Mass.: Belknap Press, 2004.

Cole, Hugh. *The Ardennes: the Battle of the Bulge, United States Army in World War II, the European Theater of Operations.* Washington, D.C.: Center of Military History, U.S. Army, 1972.

———. *The Lorraine Campaign, United States Army in World War II, the European Theater of Operations.* Washington, D.C.: Center of Military History, U.S. Army, 1984.

D'Este, Carlo. *Patton: A Genius for War.* New York: HarperCollins, 1995.

Forty, George. *The Armies of George S. Patton.* London: Arms and Armour Press, 1996.

Fox, Don M. *Patton's Vanguard: The United States Army Fourth Armored Division.* Jefferson, N.C.: McFarland & Company, 2003.

Garland, Albert, and Howard Smyth. *Sicily and the Surrender of Italy, United States Army in World War II, the Mediterranean Theater of Operations.* Washington, D.C.: Office of the Chief of Military History, Department of the Army, 1993.

Gillie, Mildred H. *Forging the Thunderbolt.* Harrisburg, Pa.: Military Service Publishing Co., 1947.

Green, Michael and Gladys. *Patton: Operation Cobra and Beyond.* Osceola, Wis.: MBI Publishing Company, 1998.

———. *Patton and the Battle of the Bulge.* Osceola, Wis.: MBI Publishing Company, 1999.

Hastings, Max. *Overlord: D-Day, June 6, 1944.* New York: Simon and Schuster, 1984.

Hoffman, George. *Through Mobility We Conquer: The Mechanization of US Cavalry.* Lexington: University Press of Kentucky, 2006.

Hofmann, George, and Donn Starry, eds. *Camp Colt to Desert Storm: The History of U.S. Armored Forces.* Lexington: University Press of Kentucky, 1999.

Howe, George. *Northwest Africa: Seizing the Initiative in the West, United States Army in World War II, the Mediterranean Theater of Operations.* Washington, D.C.: Office of the Chief of Military History, Department of the Army, 1993.

Koch, Brig. Gen. Oscar. *G-2: Intelligence for Patton.* Atglen, Pa.: Schiffer Publishing, 1999.

Nye, Roger H. *The Patton Mind.* Avery Publishing Group, n.d.

Patton, Gen. George S., Jr. *War as I Knew It.* New York: The Great Commanders, 1994.

Province, Charles. *Patton's Third Army: A Chronology of the Third Army Advance August 1944 to May 1945.* New York: Hippocrene Books, 1992.

———. *The Unknown Patton.* New York: Bonanza Books, 1983.

Stanton, Shelby L. *World War II Order of Battle.* New York: Galahad Books, 1991.

Truscott, Lucian K., Jr. *Command Missions: A Personal Story.* Novato, Calif.: Presidio, repr. 1990.

Wallace, Gen. Brenton G. *Patton and His Third Army.* Mechanicsburg, Pa.: Stackpole Books, 2000.

Weigley, Russell. *Eisenhower's Lieutenants.* Bloomington: Indiana University Press, 1981.

Young, Dale. *Treat 'Em Rough: The Birth of American Armor, 1917-20.* Novato, Calif.: Presidio, 1990.